68
(50)
10-13

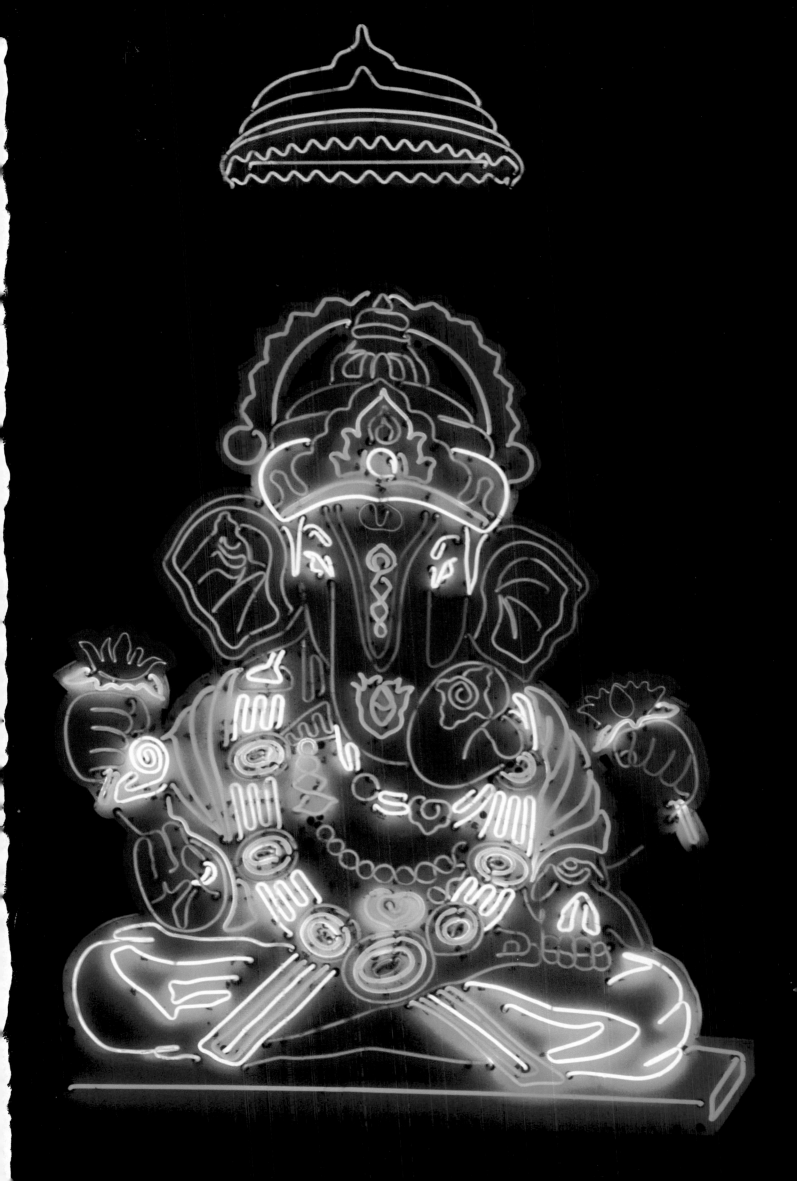

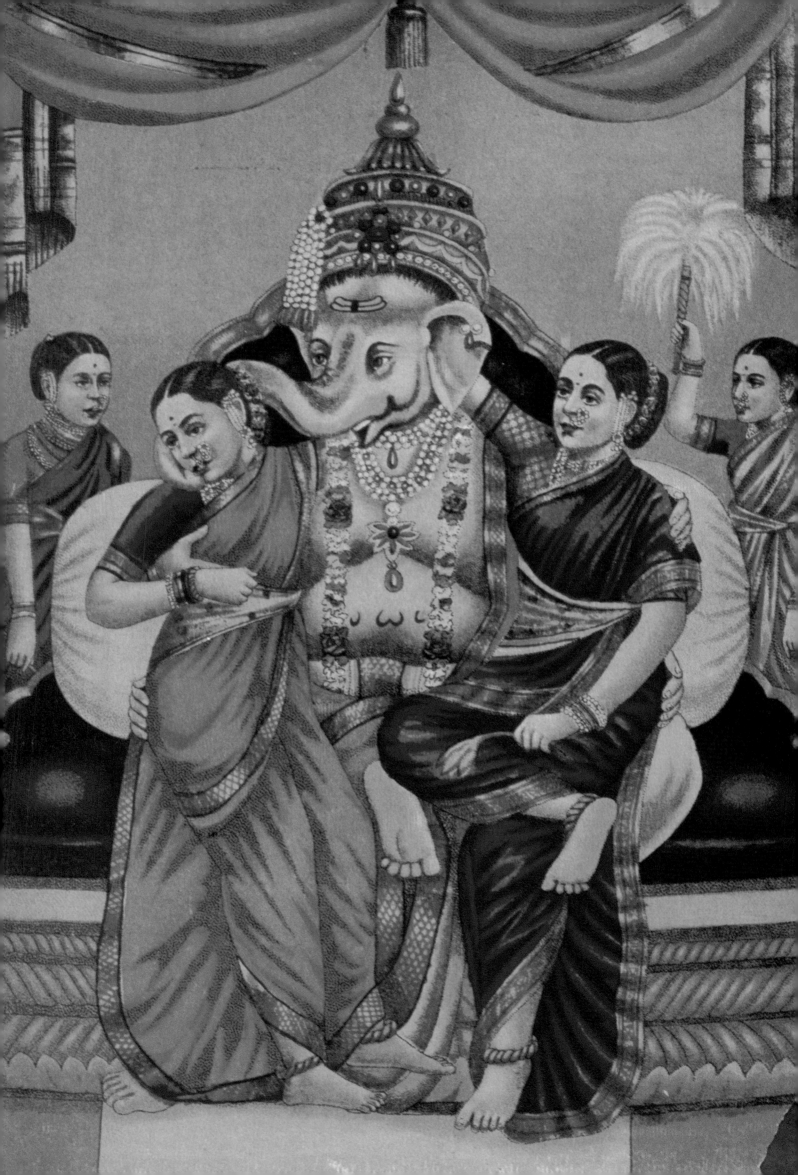

Eternal Ganesha

Text by Gita Mehta

The Vendome Press

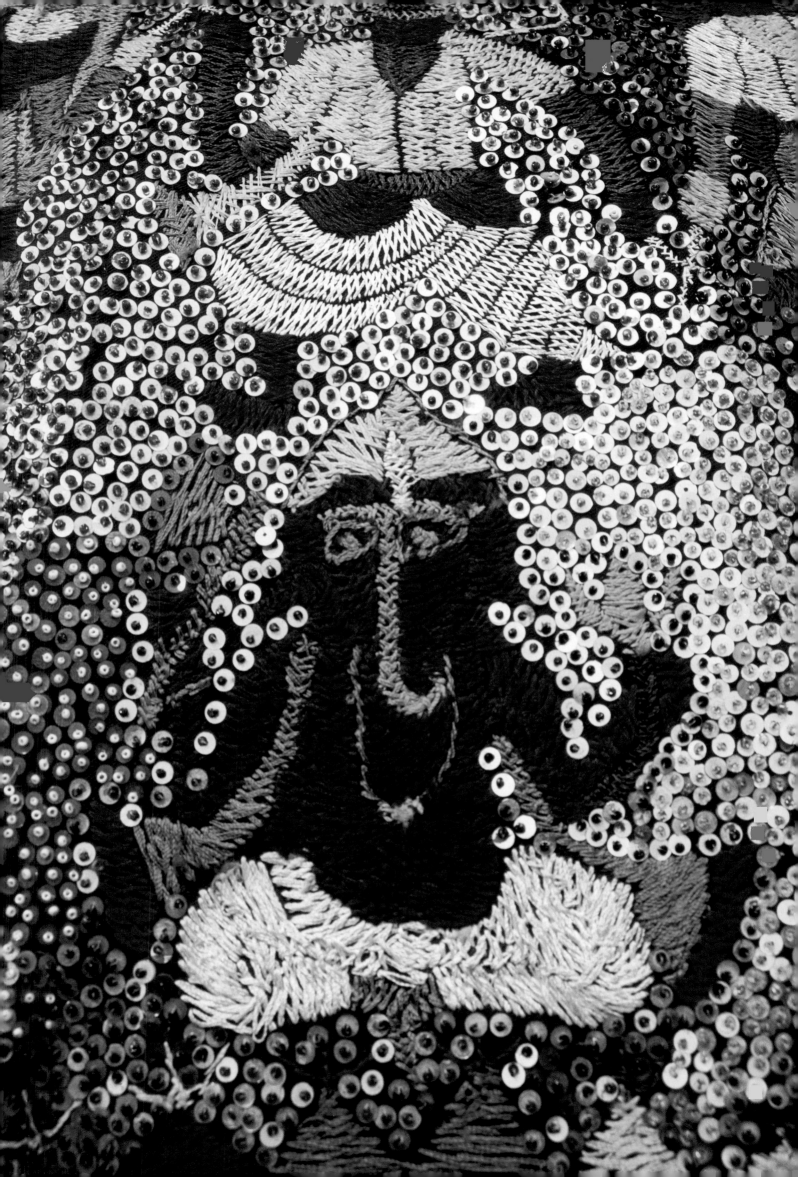

for Leela

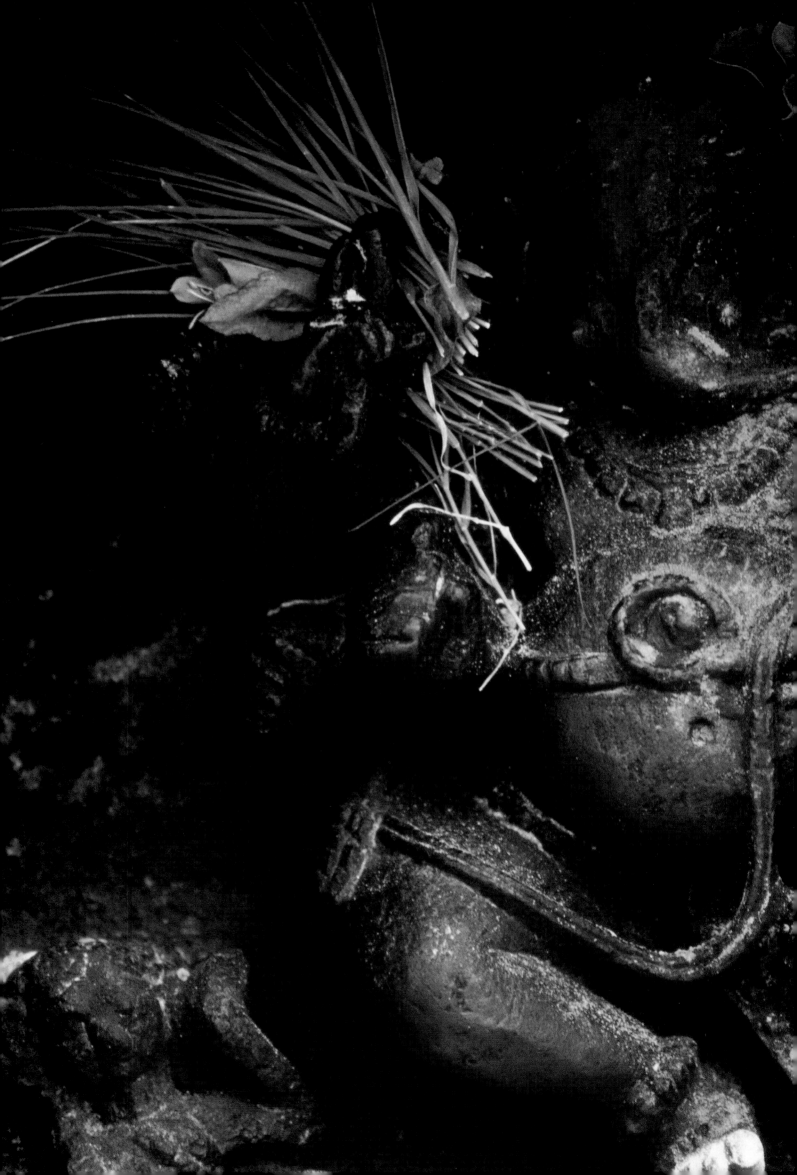

Contents

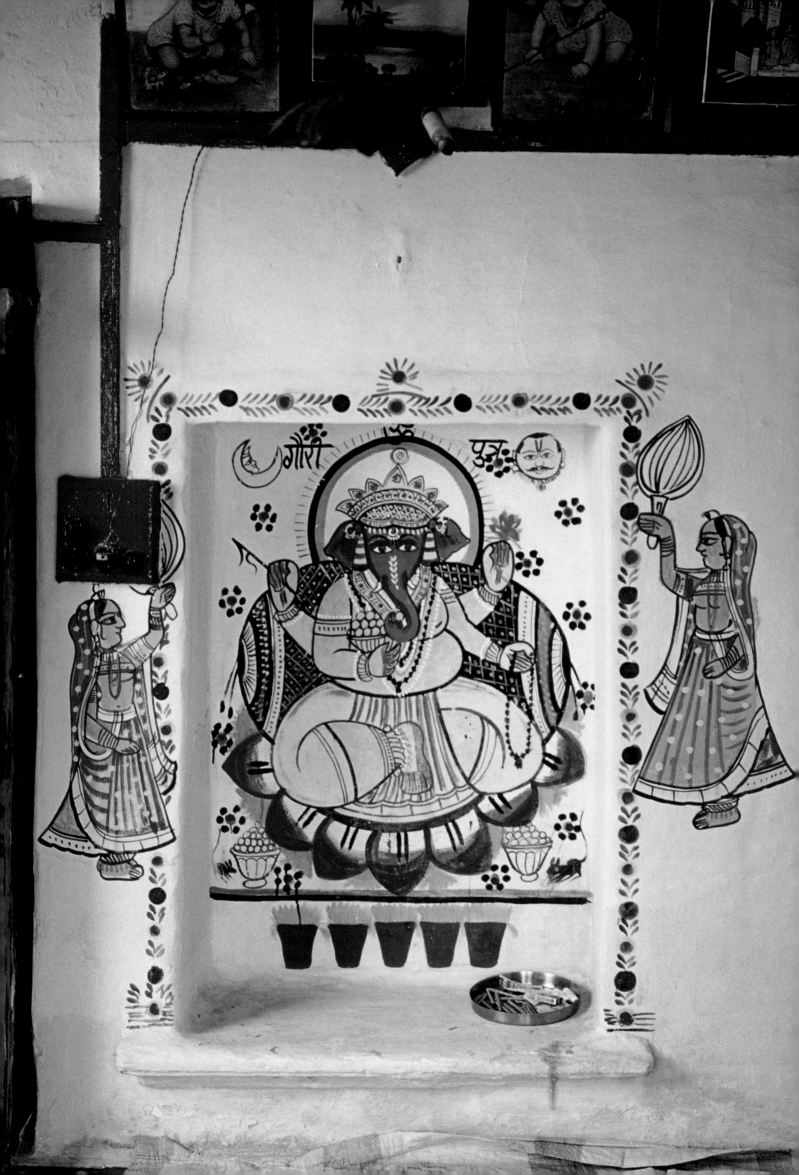

Om Ganapati namaya

Ganesha

At his command Lord Brahma creates the universe.
At his command Lord Vishnu maintains the universe.
At his command Lord Shiva destroys the universe.
And Agni, Lord of Fire
Burns in the three worlds.

At his command
The Sun journeys the heavens,
The Lord of the Air instructs the winds
The Lord of the Waters controls the tides
He pervades the universe.

A stranger to India might find it hard to believe such awesome powers could be attributed to a pot-bellied Hindu god with an elephant's head, one plump hand filled with sweets, improbably riding on a small mouse. Indians, on the other hand, need no convincing that Ganesha pervades the universe. They see him everywhere. On rickshaws and wedding invitations. On protective medallions and rockets. On cyber cafes and cigarettes. On hippy handbags and village walls and the clapper boards of Bollywood films, inescapably there.

As a deity Ganesha presides over every religious ritual in the Hindu calendar. Millions of Hindus carry his name or one of its many variations, often Ganapati or Vinayaka. Those names are invoked at each event in a Hindu's life—when the foundation stone is laid for a building, when the first step is taken on a journey, when the harvesting of crops commences. From birth to

Opposite: Wall painting, Udaipur, Rajasthan

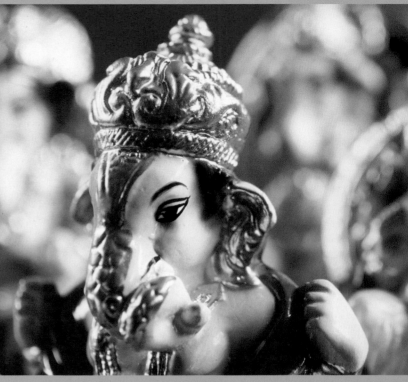

rebirth, from the brazen kitsch of modern religious festivals to ancient Hinduism's secret rites, Ganesha permeates the entire spectrum of Hindu experience.

Of course Indians profess many different faiths and not every Indian is a Hindu. Yet Ganesha is universally loved, a symbol of good fortune when he is not a god. Perhaps he evokes such love because he has no forbidding aspects, only endearing ones expressed in names like The Long-Eared, The Single-Tusked, The Pendant-Bellied, The Pitcher of Prosperity. Or it may be his benign nature defined by such titles as the Remover of Obstacles, the Granter of Boons, the Lord of Beginnings, the Guarantor of Success. Whatever the reasons, there is hardly an Indian house or office without an image of Ganesha.

Somehow the incongruous figure with the elephant head and corpulent body balancing on a mouse has transcended religion to become India's icon of protection. Smiling benignly behind his elephant trunk, he is the Guardian of the Indian home, and his image is prominently displayed above the lintels of Indian doorways to ensure only good fortune enters the house. To further guarantee the family's prosperity Indian housewives might offer Ganesha grains of rice while chanting:

> Thou of the curled trunk and great belly
> Free my family's path of obstacles and hindrances.

Above left: Ganesha painted on a finger nail; *above right:* Festival of India, Ganesha Chaturthi; *opposite:* Lord Ganesha, Mumbai; *overleaf:* Jaisalmer Fort Post Office, Jaisalmer, Rajasthan

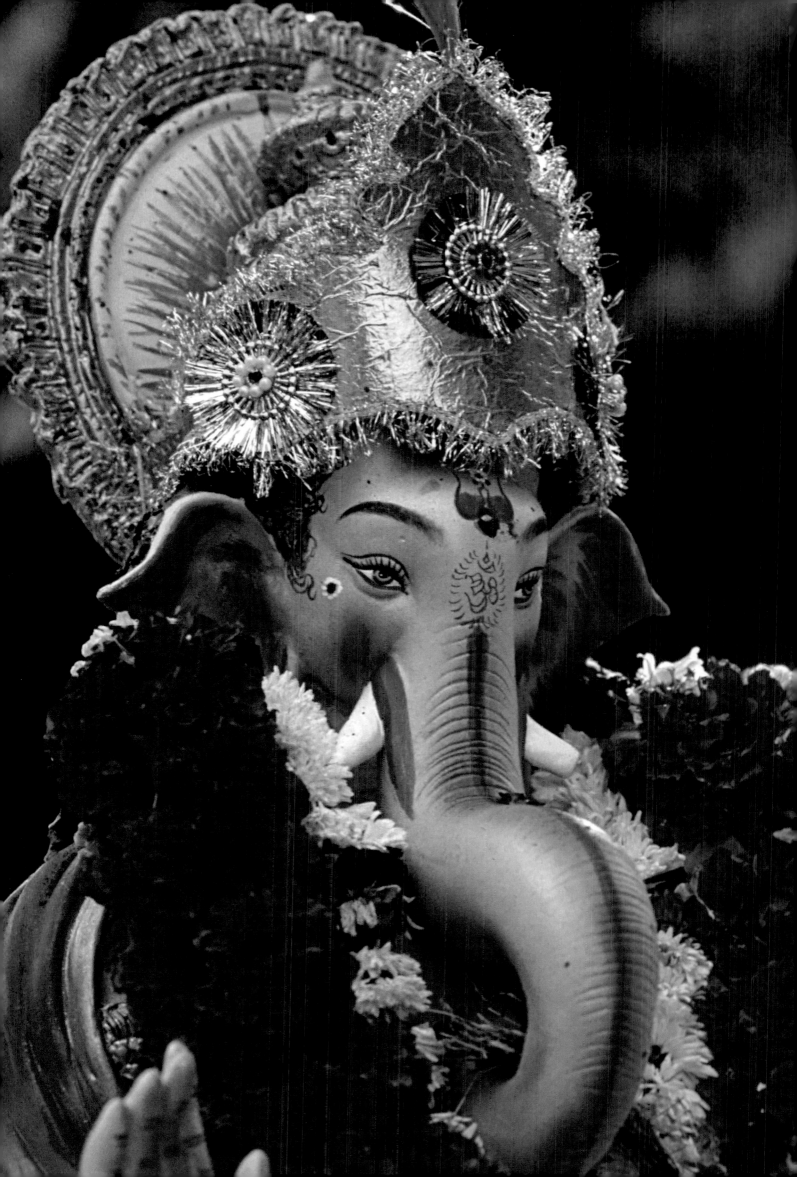

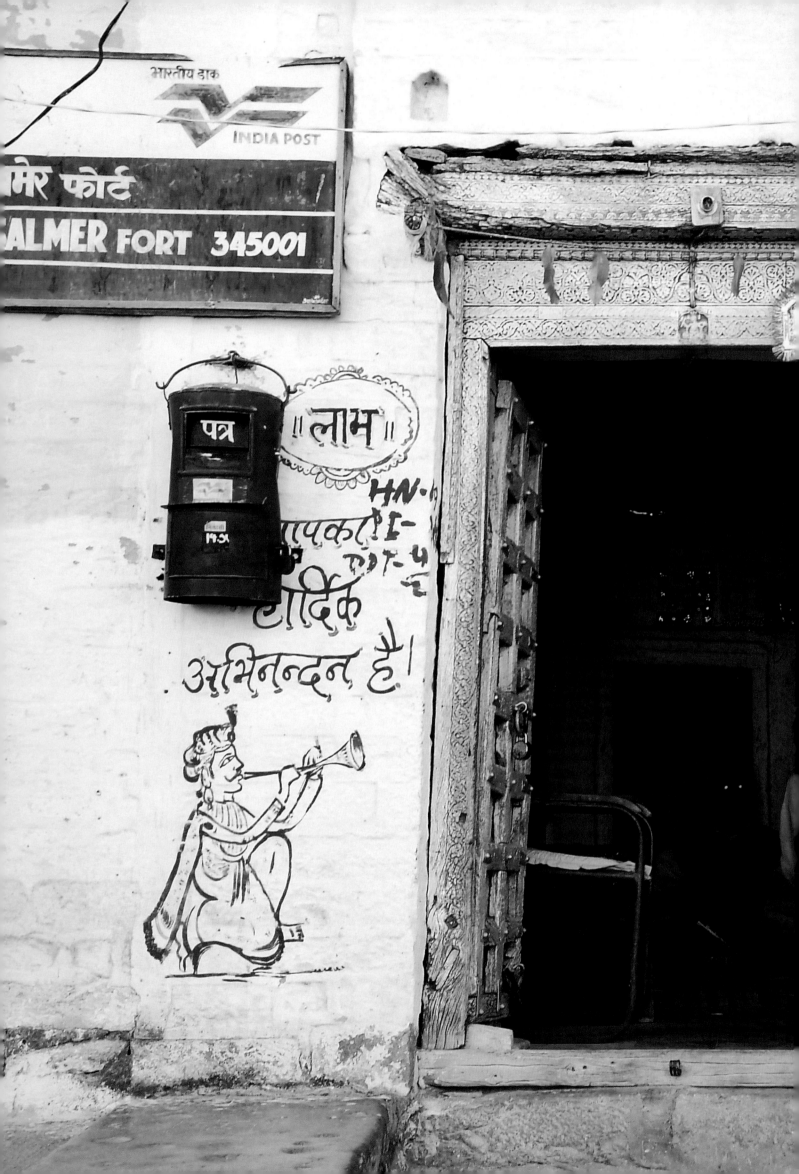

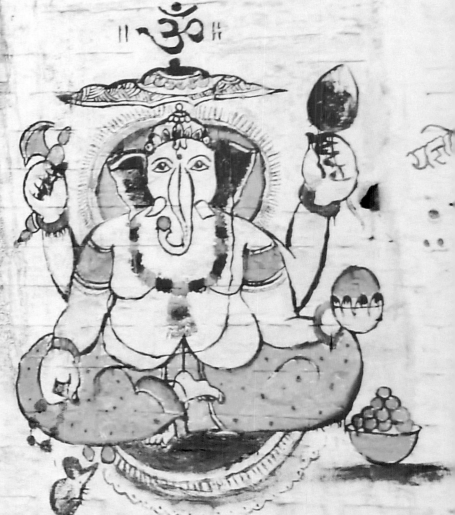

म 87
(।3।

॥सुख॥

शुभ विवाह
यशोवर्धन
संग
सपना

5.2.2003

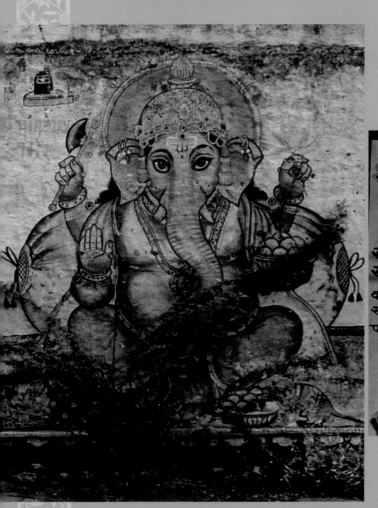

The rice offering continues a tradition which goes back to 3000 B.C. and the Indus Valley civilization when Indians first used elephants to clear the forests for agriculture. Ancient Indus Valley seals show India's early farmers worshipped an elephant-headed god as their Lord of Farming, his trunk symbolic of the plough, his belly of a bursting granary. Later Ganesha was worshipped as the Lord of Water, his festival celebrated in the season of rains in hope of bountiful harvests. Today when the majority of Indians still depend on agriculture for survival it is hardly surprising that Ganesha, Lord of Farming and Lord of Water, is still worshipped as India's Lord of Prosperity.

Unsurprisingly, the Lord of Prosperity also attracts the deep devotion of the business community. Yesterday's traders may have become today's venture capitalists but neither would dream of engaging in financial speculation without the protection of their favorite deity, the Guarantor of Success. To insure Ganesha's sympathetic intercessions they place coins before his image and stamp his picture on the first page of new account

Above left: Lord Ganesha wall painting, Udaipur, Rajasthan, India; *top right:* wall painting, Jaisalmer, Rajasthan

ledgers. Embarking on some complicated banking maneuver, canny Indian entrepreneurs pray,

> Great Lord, I stand before you, not knowing which way to turn.
> I lay my confusions at your feet.
> Fill me with judgment and discrimination.

Judgment and discrimination are only two aspects of Ganesha's wisdom. He is the Lord of Learning, encompassing all knowledge. As such he is the special god of India's vast student population. Many students believe if they slice a closed text book with a Ganesha medallion the book will fall open at the very topic on which they will be examined, and before entering an examination hall cautious students might recite the Ganesha prayer,

> You who are perfect knowledge,
> Who are absolute awareness,
> Who are supreme intelligence,
> Guide me in my hour of need.

Then there are India's sybarites, less interested in Ganesha's wisdom than in his belly, his Pitcher of Prosperity. Happily for them that great belly and the dimpled hand holding sweets are signs not just of the god's magnanimity but also of his gluttony, a welcome break in a civilization that accords its highest honors to ascetics. They find further consolation in the myth which describes how Ganesha was once careening down a path astride his mouse, busily stuffing his trunk with sweets when a reptile crossed the road. The mouse suddenly reared up. Ganesha was thrown from the mouse's back and landed on the ground with such impact his belly burst wide open. Displaying divine insouciance Ganesha gathered up his spilled entrails, shoved them back into his belly and tied up the makeshift arrangement with the offending snake, which is why images of Ganesha show a serpent entwined around his bursting belly—a permanent reminder that spiritual awareness is not necessarily negated by the good life.

To make sure they share in the good life, Indian gourmands are in the habit of offering sweets and spoonfuls of milk to their Pitcher of Prosperity. Everyone else makes elaborate food

offerings to the greedy god during the days of his birthday festival, Ganesha Chaturthi. Since the offerings are devoured later by equally greedy devotees, Ganesha's festival diet offers devotees an opportunity to scale new heights of excess. Gallons of milk are offered to him. Elaborate sweets are baked for him. Special savories are fried for him. Sometimes he is actually made of food himself—sugared almonds, cashew nuts, raisins being popular ingredients.

Remarkably Ganesha can be fashioned from any substance, making him unique among Indian gods. This has earned him a special place in the hearts of India's artists. Craftsmen of every faith can create their own Ganesha images without attracting accusations of sacrilege or inviting attacks on their creative ingenuity. Recently a Pune sculptor named Akule constructed a seven-foot-high Ganesha idol made entirely from peanuts, boasting that in the past he had also fashioned Ganesha idols out of wood, chalk, rice, matchsticks, and even discarded rubber tires.

But then, Ganesha is infinitely adaptable. In the most humble hut a Ganesha idol might consist of a simple triangle made of mud with a streak of vermilion on its apex. In the jungle a twisted root with wild flowers as an offering will suffice. In a wealthy home an intricately carved Ganesha might be clothed in silk garments and wear a jeweled crown on his elephant head. Each image holds identical sanctity.

Poor or rich, illiterate or scholar, anyone can invoke Ganesha. He requires no priest as intermediary. Maybe this explains why he is worshipped by diehard partisans of Hinduism's many antagonistic denominations. Hinduism, the predominant faith of Indians, is more a series of philosophical enquiries than a conventional religion but its essential tolerance has not prevented religious demagogues from creating the sectarian strife which elsewhere has set Roman Catholic against Protestant Christian, or Sunni Muslim against Shia Muslim. Indeed, some of India's most savage wars have been fought between followers of the God Shiva and those who follow the God Vishnu. Yet both worship the universal pacifist, Ganesha.

Opposite: A Ganesha made of green bananas, Ganesha Festival; *overleaf:* Ganpati Festival, Mumbai

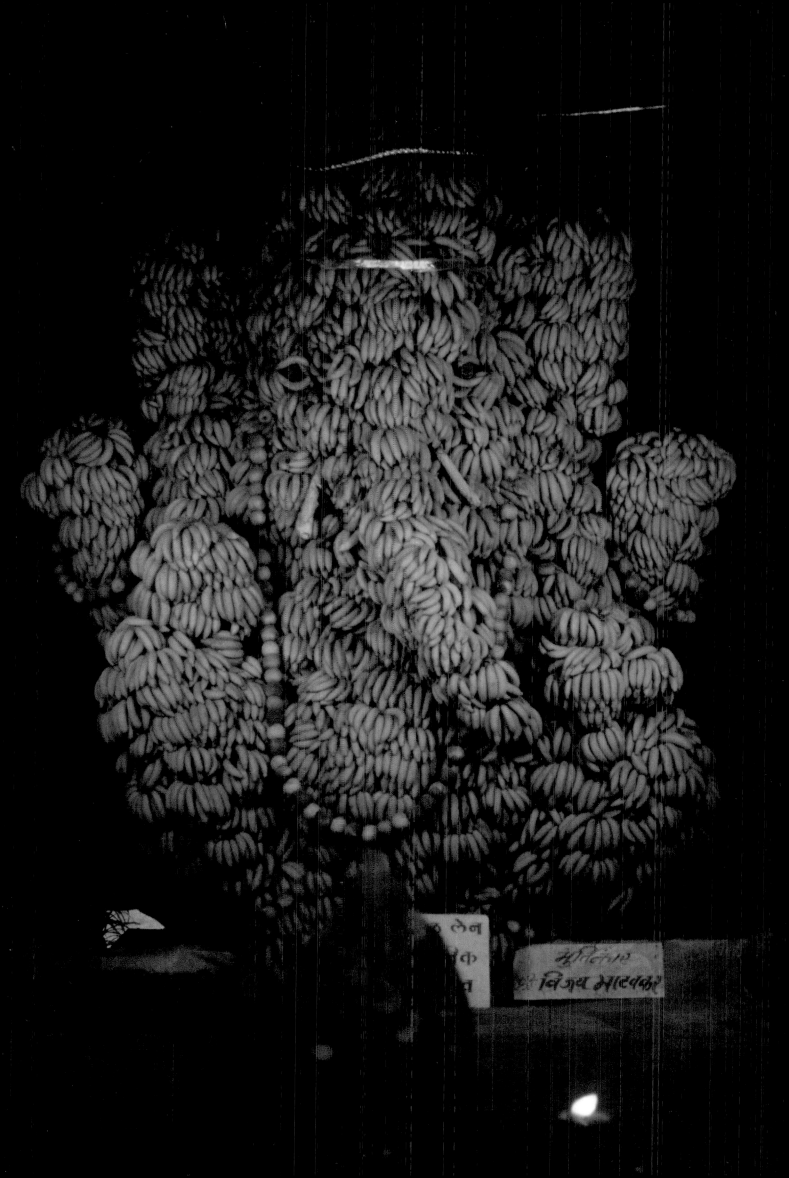

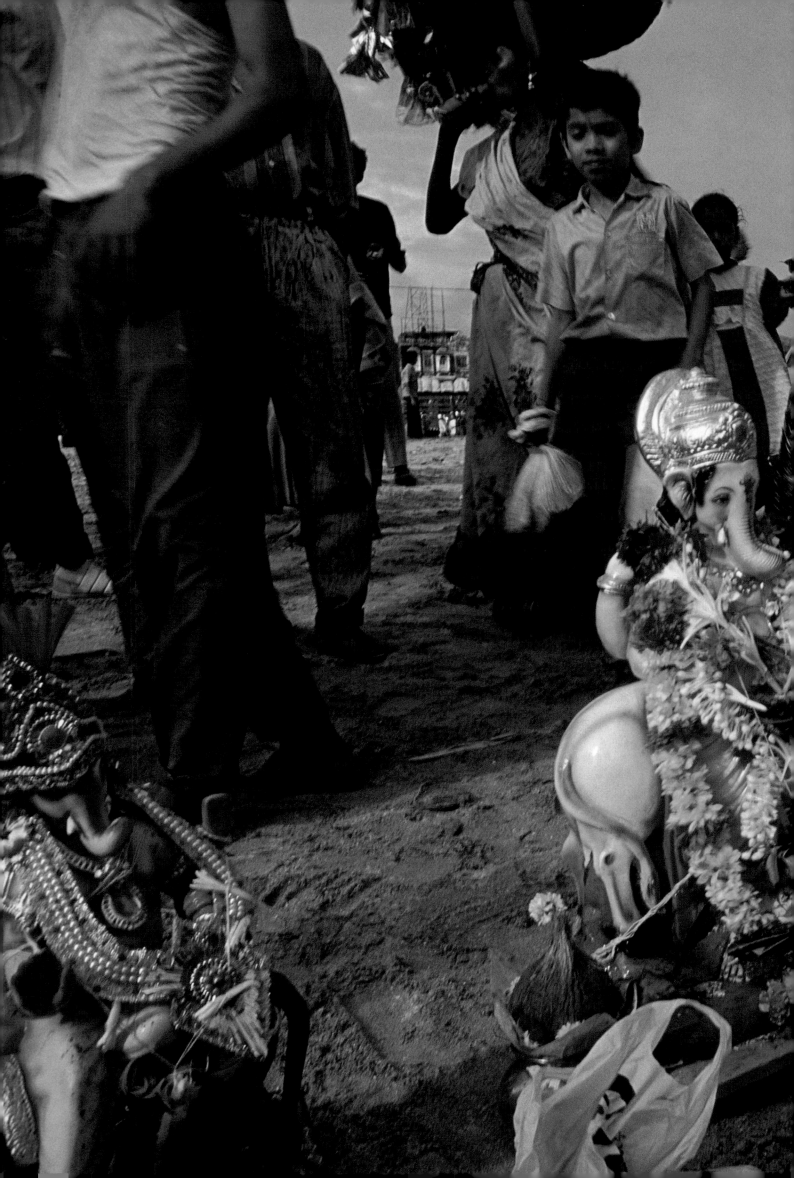

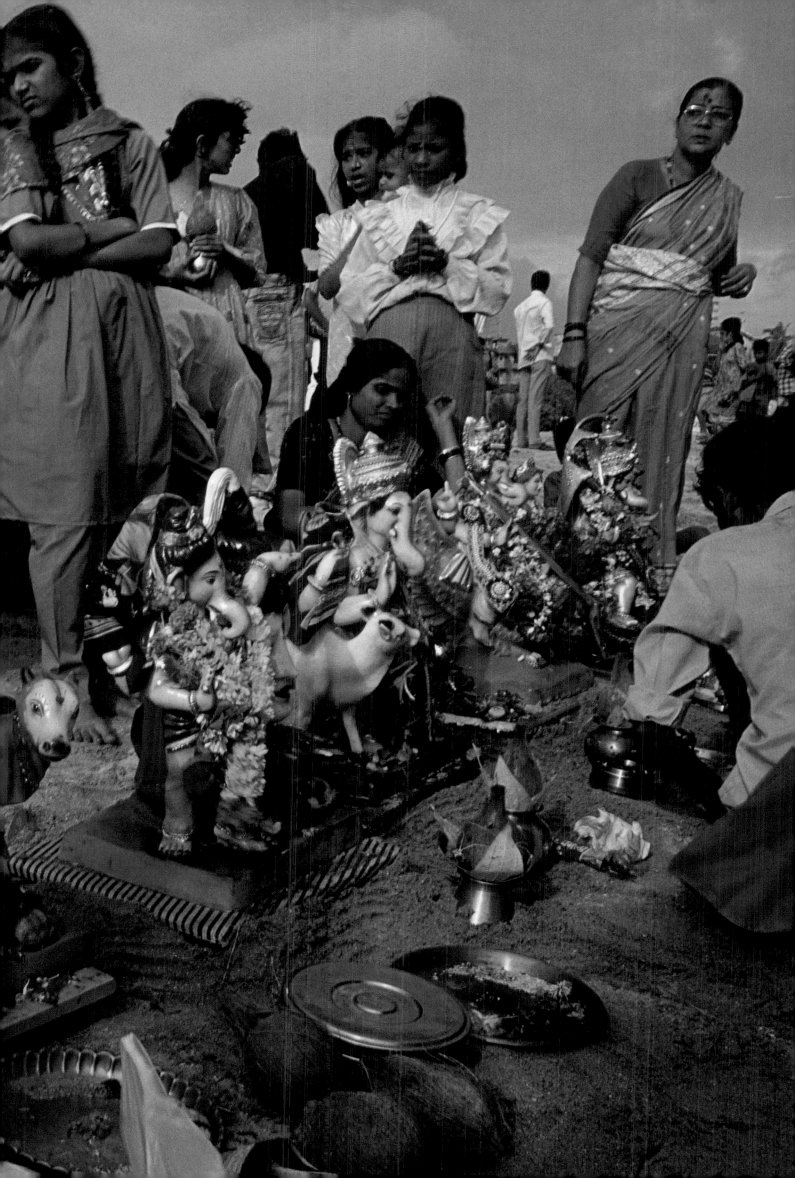

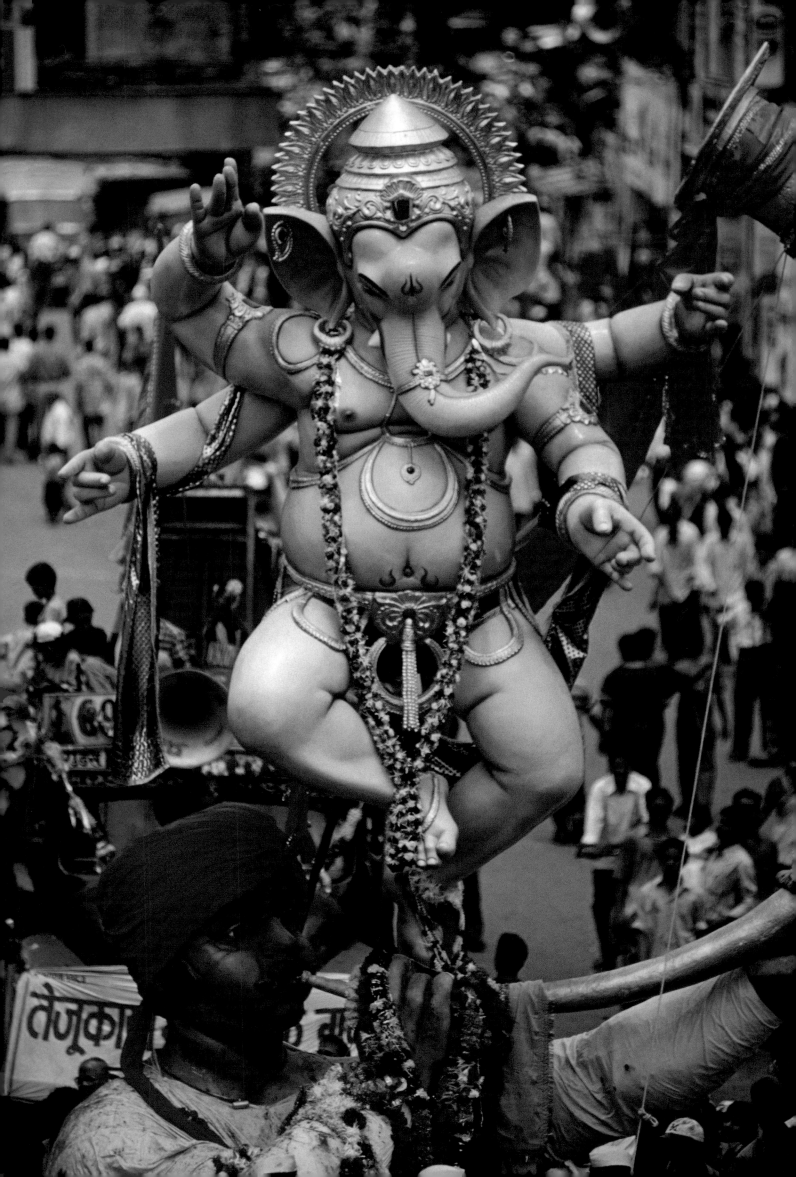

Whether he is made of cow dung or diamonds, Ganesha is the quintessentially egalitarian god. Since he transcends religious divisions as well as caste and class divides, Ganesha has proved invaluable to India's political leaders. Sometimes politicians have used Ganesha as a symbol of national purpose. Sometimes they have used him to spearhead social change. During the early years of the Indian nationalist movement Ganesha was even used to launch a successful challenge to the British Empire.

One memorable political movement took place in the 1890s during Ganesha Chaturthi, the birthday festival that culminates in the immersion of Ganesha's idols to symbolize the cycle of death and re-birth. At that time Indians were restricted to their homes, banned by egregious colonial laws from congregating in public and so the immersion of Ganesha idols took place in the privacy of the home. At the end of the nineteenth century, in the city of Bombay, the Indian leader Lokmanya Tilak urged his fellow Indians to defy the British Empire's ban on public meetings and bring their Ganesha idols out of their homes. Hoping to turn Ganesha's immersion ceremony into a weapon against the might of imperial power, Tilak called on Indians to take their idols in procession to Chowpatty, a beach in the very heart of Bombay, and physically immerse them in the Arabian Sea.

Tens of thousands of Indians rallied to Tilak's call, towing their Ganesha images on carriages or handcarts to the beach where nationalist leaders exhorted the crowds to join the struggle for Indian independence. The paralyzed British authorities feared a religious riot might spread across the sub-continent if they interfered. Consequently, over successive years the Ganesha festival became defiantly more political. Marquees and stages appeared across the city where revolutionary themes thinly disguised as religious allegory were enacted and nationalists made stirring speeches against colonialism, waving banners blazoned with Tilak's slogan, "Freedom is my birthright and I shall have it."

In a free India, on that same Chowpatty beach Tilak's original gesture of defiance has swollen into a festival celebrated by

Opposite and overleaf: Ganesha Festival, Mumbai, Maharashtra

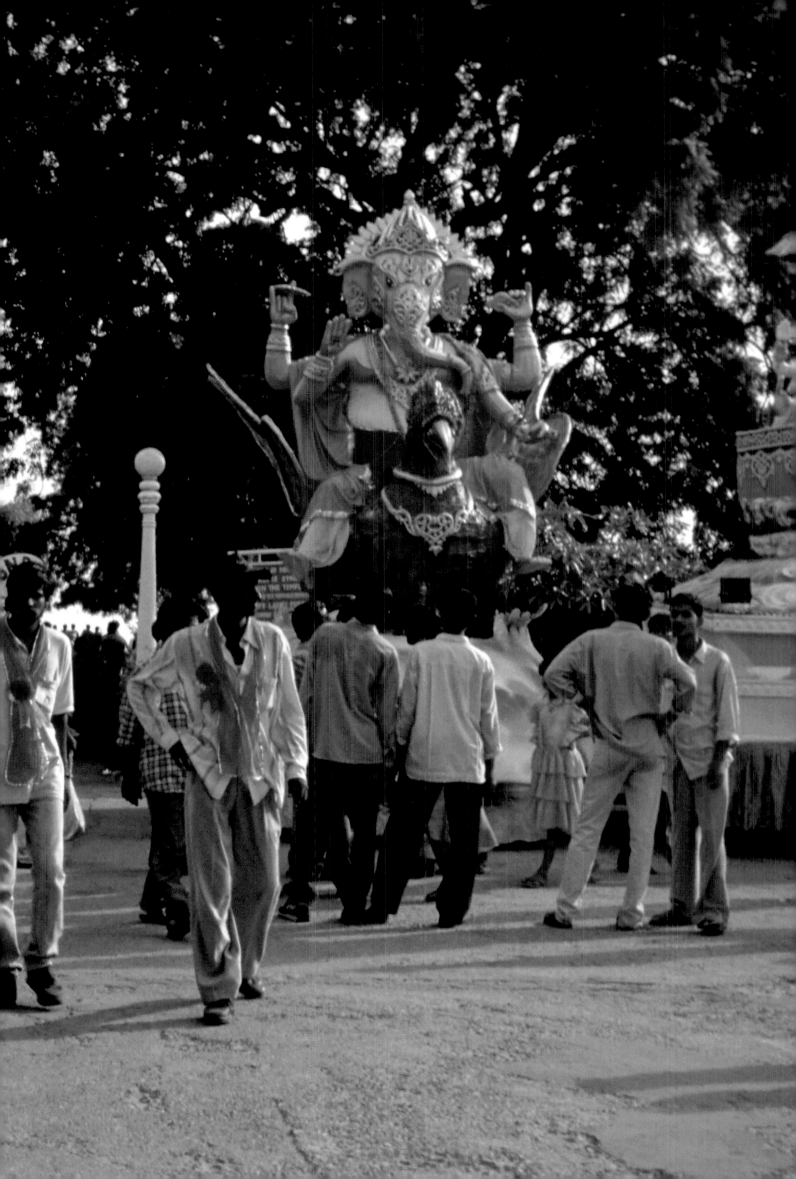

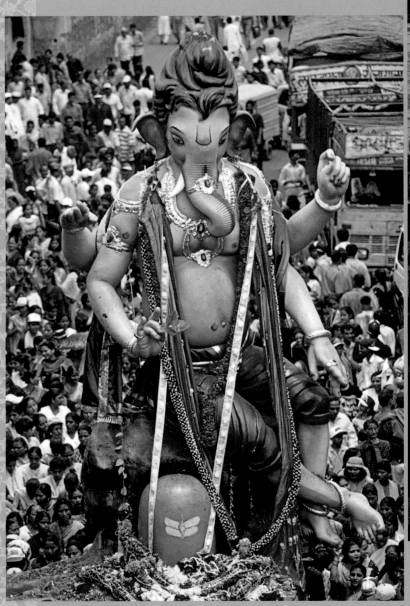

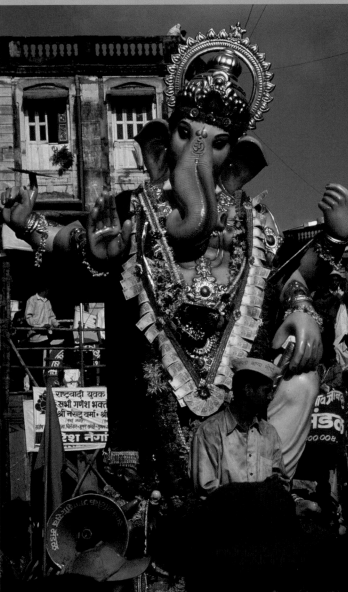

millions of devotees, attracting hordes of tourists to witness the mass immersions. Preparations begin months in advance of the immersion ceremony. Despite the political ideologues and the gangs of extortionists who annually try to co-opt the festival, thousands of statues are still voluntarily commissioned all over the city, paid for by people of many religions and made by craftsmen of differing faiths. Idols reach thirty or forty feet in height as trade unions, residential communities, sports clubs all compete to acquire the largest Ganeshas. Elaborate floats are constructed for carrying the idols to the sea. Equally elaborate shrines reflect the pervasive influence of Bollywood films with gilding, tinsel, sequins, and neon lights.

Above left and right: Ganesha Festival, Mumbai, Maharashtra

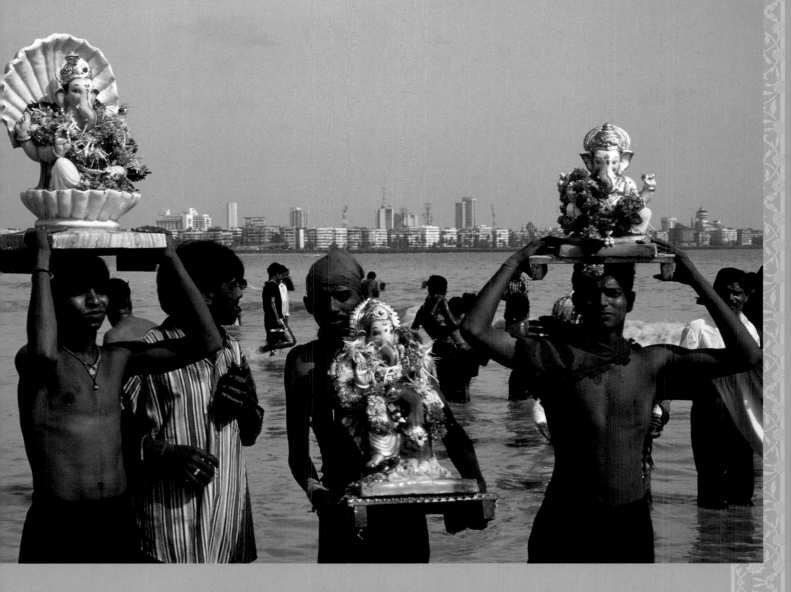

A week of festivities precedes the immersion, characterized by a great deal of eating as Ganesha images are installed in tiny shanty altars and corporation headquarters alike. Makeshift stages appear at street corners and bazaars. Religious plays are performed, still subverted as they were a century ago by political speeches and social commentaries. On immersion day the main routes leading to Chowpatty are cordoned off as police personnel and volunteers struggle to control the thousands of processions converging on the beach. There, accompanied by drumbeats, chants, and dancing, devotees surge forward to immerse their idols in the sea while hordes of irrepressible Indian children, mouths stuffed with sweets, plead for Ganesha's early return.

Above: Ganesha Festival, immersion procession, Mumbai, Maharashtra

It is no wonder that Indian children have special fondness for Ganesha. His festivals are happy occasions. His inordinate weakness for food means they can gorge themselves on the pyramids of sweets offered to the Pitcher of Prosperity. His comic form makes him a god to be loved not feared. And he encourages mischievousness.

A variety of local customs add to his popularity. For instance, as children we were told that it was unlucky to buy an image of Ganesha. If you wanted a Ganesha you either had to be given one or else—an irresistible option for children—you had to steal one. Fortunately, most Indian children are given a Ganesha before they actually have to steal, and by the time they are adults they have usually acquired several more as gifts.

I still have the first Ganesha I was given as a child. Small enough to fit into the palm of a child's hand, it is a miniature stone replica of the dancing Ganeshas which adorn the entrances to the great temples of Eastern India. Of all the Ganeshas I have since been given that tiny idol remains my favorite even if it so worn by time there is not much detail left. But then, my little Ganesha is mysterious. He appeared from a great mound of dirt when the foundations were being dug for my parents' house. There was great excitement among the construction workers when they found the image, mixed with relief that they had not damaged it with their equipment. As nothing else was excavated, as no other idols appeared to suggest that a long-forgotten temple lay crumbling under the ground, the little stone figure was deemed to be a sign of divine blessing. Everyone agreed the house would be lucky since the Lord of Beginnings had chosen to hide in the earth until the house was ready to be built.

Luckily, my worn stone idol still retains a fractional remnant of an elephant tusk, since Ganesha is adored by children as the Lord of Story-tellers who sacrificed his tusk to save India's greatest stories from being lost.

According to myth, after much cajoling from everyone in India, the great sage Vyasa finally agreed to recite the story of India.

Opposite: Lord Ganesha in ivory; overleaf: Rows of Ganesha idols, Dadar, Mumbai

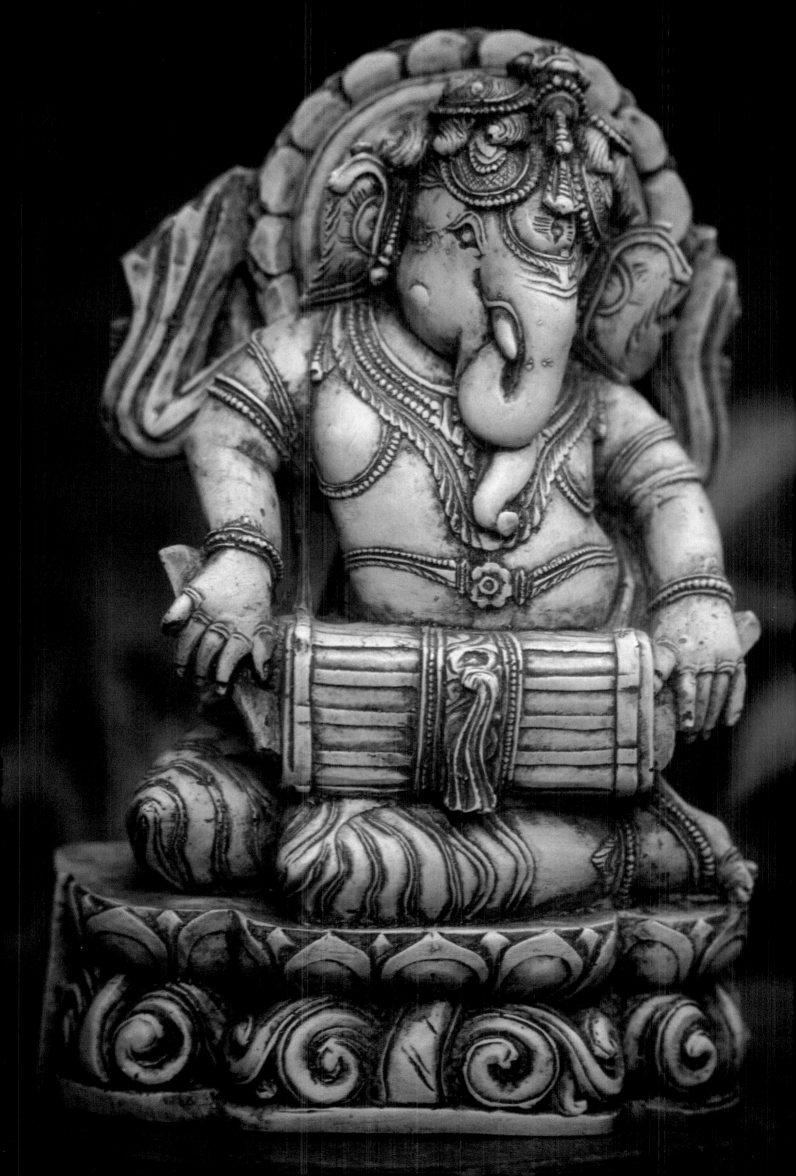

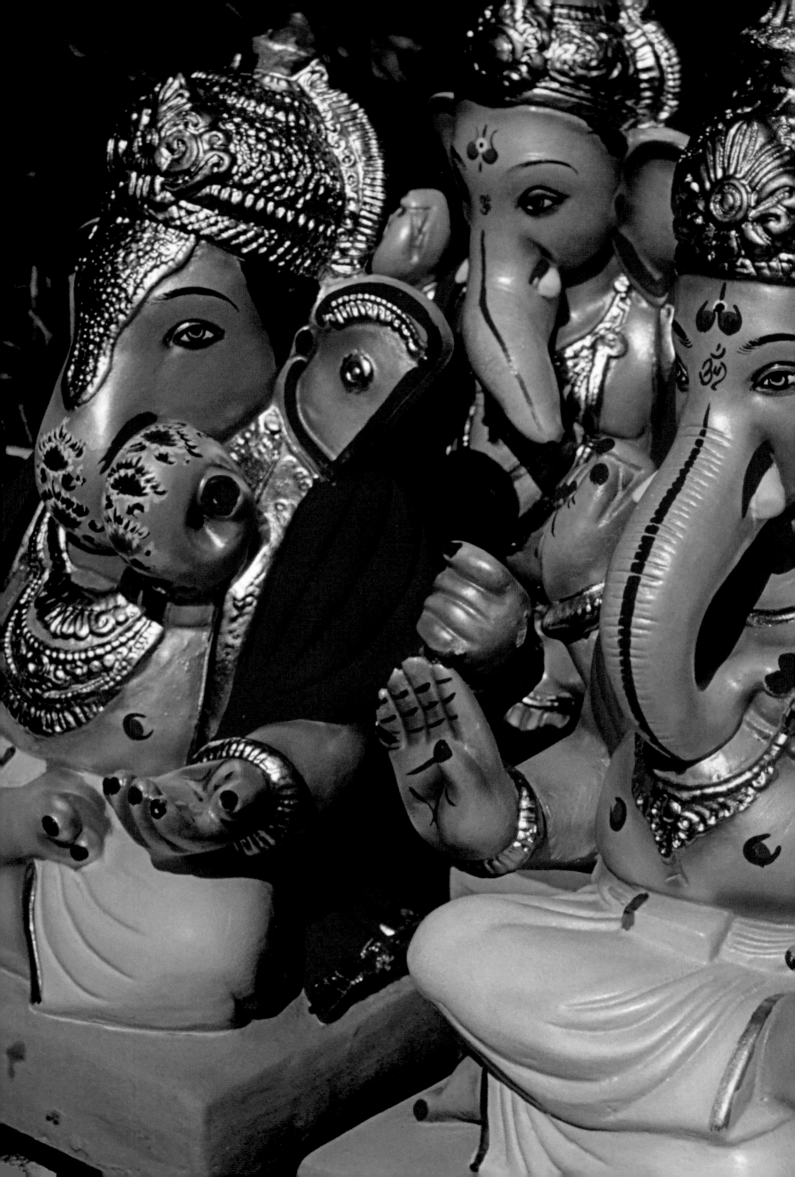

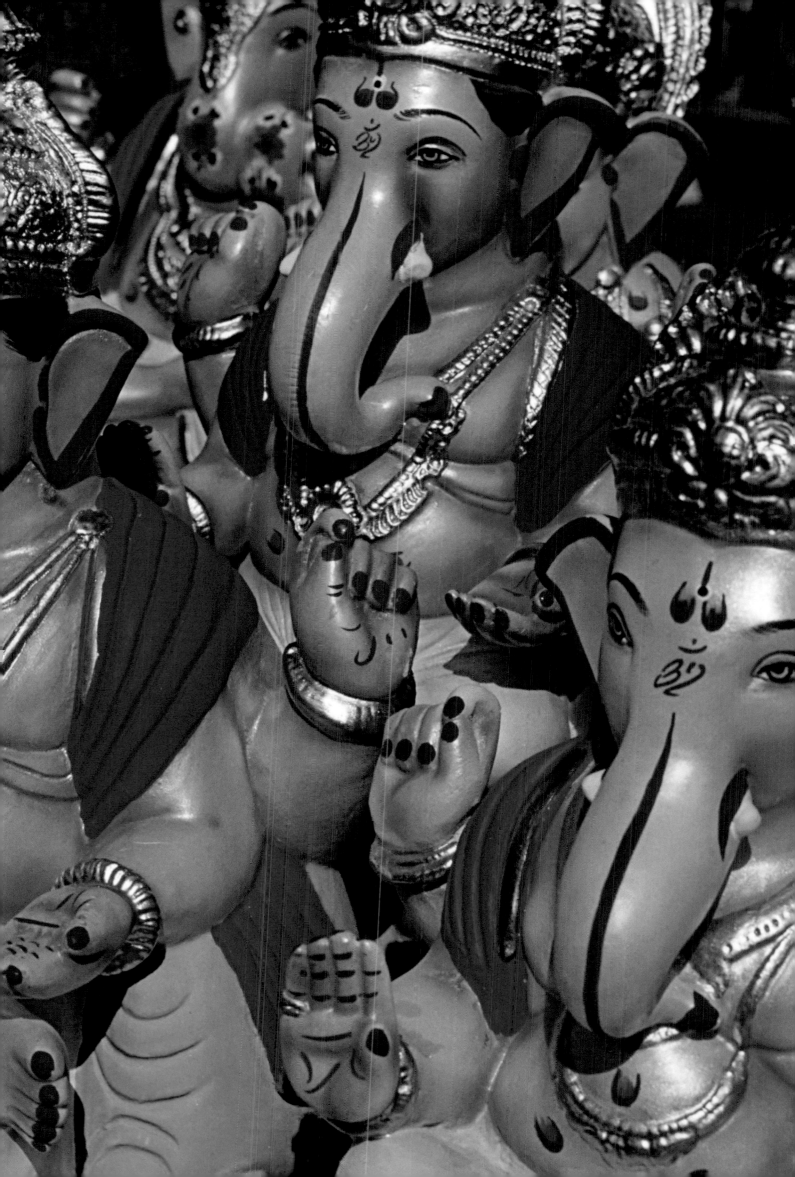

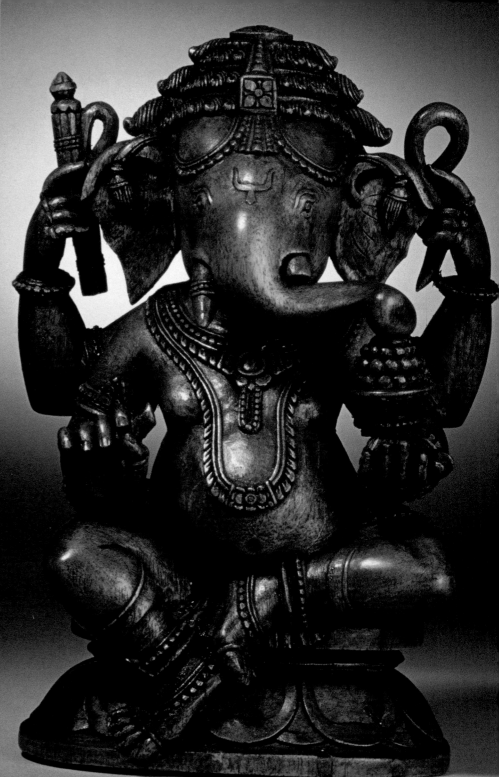

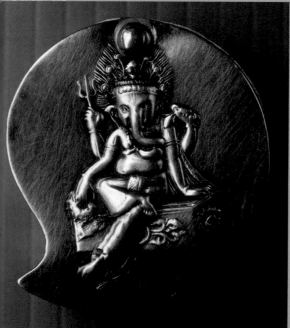

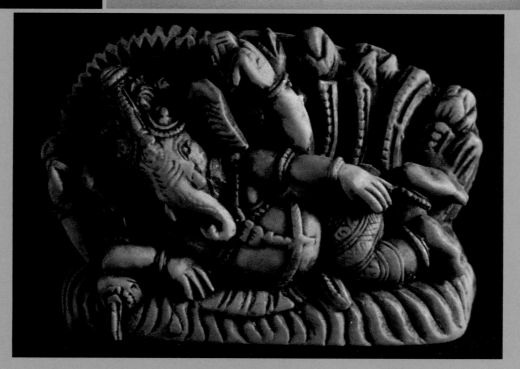

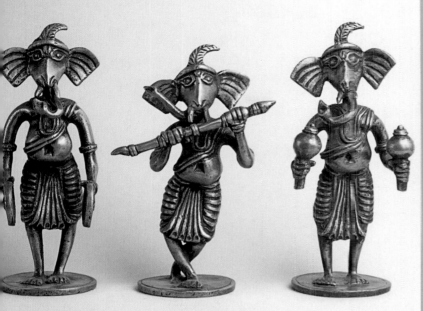

But Vyasa, who came from the lowest caste, announced that he would only recite the epic narrative containing India's mythologies, her histories her philosophies, if Ganesha could write it all down without halting. If for any reason Ganesha stopped writing, the story of India would remain untold. Ganesha accepted the challenge and over successive days and nights he proceeded to take down Vyasa's dictation of what remains the world's longest poem. Weeks passed, Ganesha's pens wore out and still the recitation went on. When his last pen was exhausted, fearing Vyasa might cease his revelations, a quick-thinking Ganesha broke off his tusk, dipped it in ink and continued writing. Thus, Ganesha succeeded in gifting the *Mahabharata* and the *Bhagavad Gita* to India. And thus, Ganesha is always depicted with a broken tusk.

This is only one of the many stories told about Ganesha. There are many others. In fact a whole Ganesha literature has been composed over the centuries, ranging from the philosophical ponderings of the *Ganesha Upanishad* and the *Ganesha Gita* to the mythological tales of the *Ganesha Purana*. Then there are the poems, hymns, and narratives created in every part of India, reflecting the religious and geographical preferences of their writers.

Of all these many narratives, one myth remains the favorite of Indian children. It tells the story of Ganesha's birth and how he came to have an elephant's head.

Opposite top left: Ganesha painting on marble plate; *opposite right:* A small carved Ganesha idol; *opposite middle left:* Lord Ganesha on Kukum Kuiri; *opposite bottom:* Ganesha amulet; *above left:* Ganesha musicians; *above right:* Lord Ganesha medallion; *overleaf:* Ganesha carried on a bullock cart in a ceremonial procession

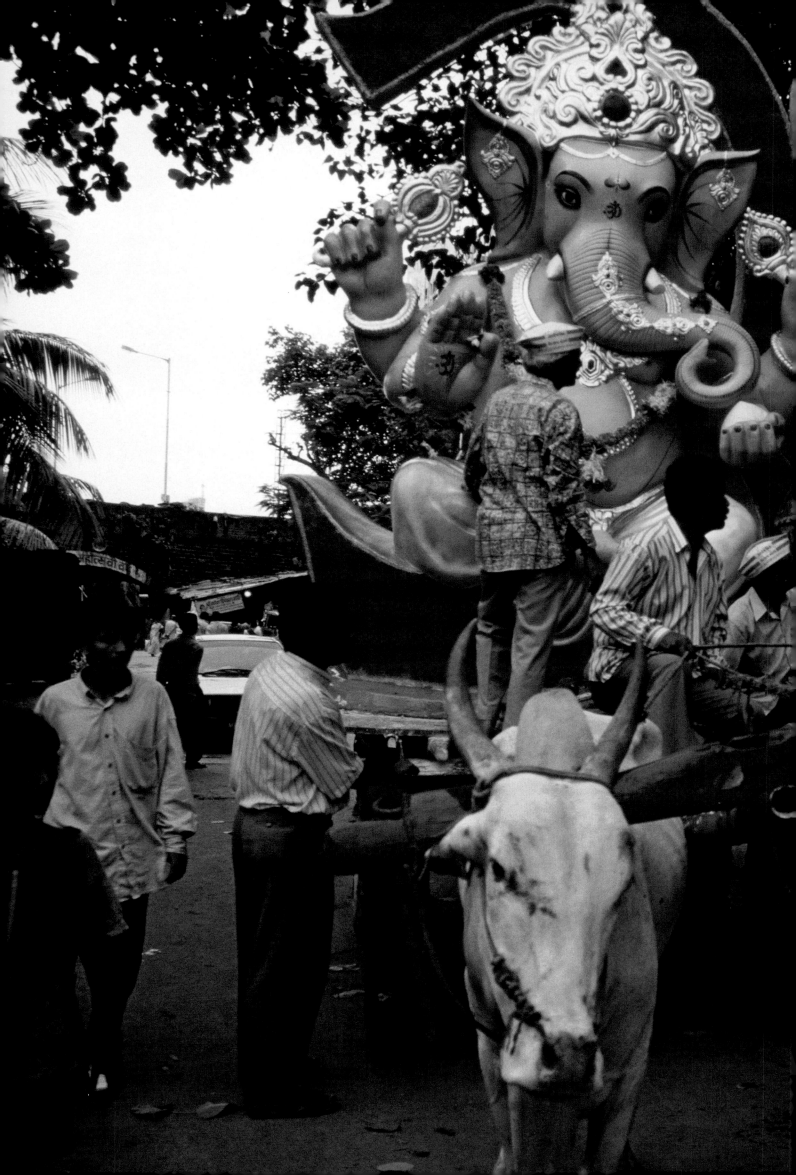

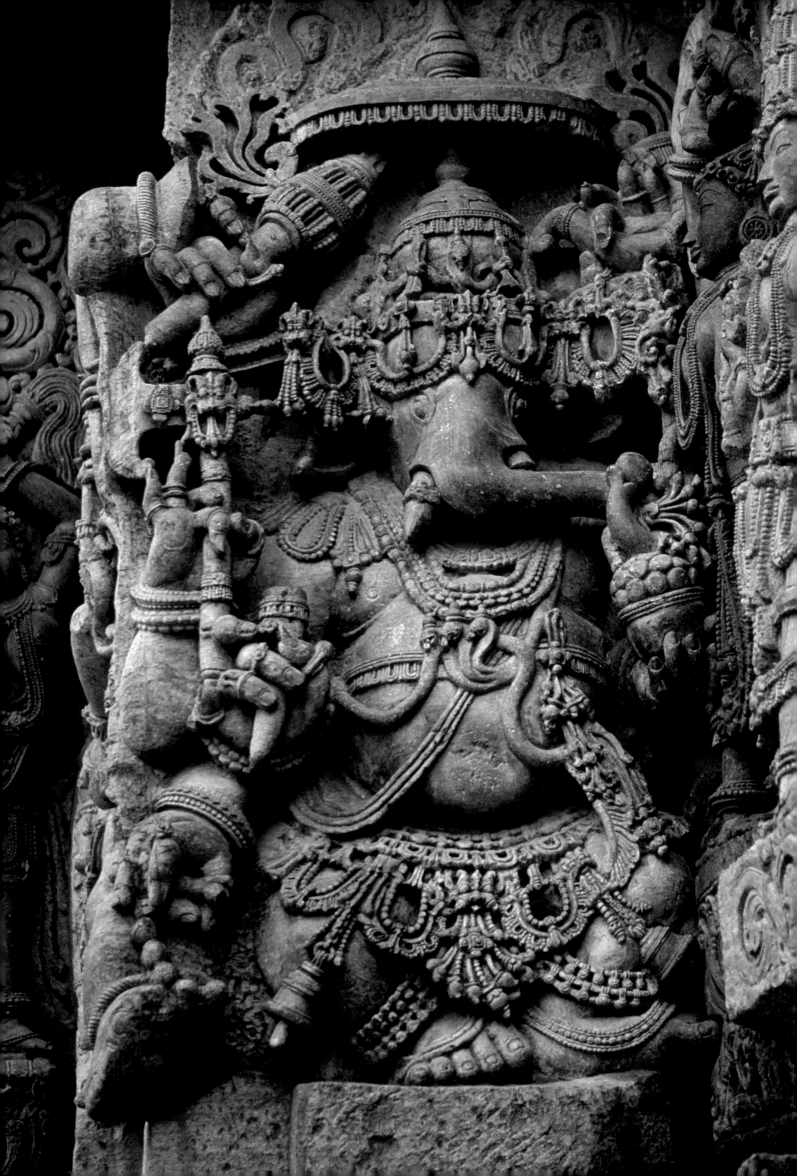

Ganesha's Origin

One day the goddess Parvati wished to bathe undisturbed. Casting about for a guardian who could ensure her privacy and finding none, she decided to make one. Scraping some sandalwood paste from her body the goddess mixed it with a handful of earth and molded a beautiful boy, a son. Delighted by her creation, the goddess instructed her beloved son to stand guard outside her chambers.

Unfortunately, while Parvati was bathing, her husband, the God Shiva, returned to find a small, unknown boy barring the door to his home. The child had no knowledge of Parvati's husband and refused to budge when told to move aside. Annoyed by the chubby infant's insistence that he could not enter his own house, Shiva instructed his attendants, the Ganas, to remove the child. The boy fought valiantly to protect his mother's privacy, laying waste to Shiva's cohort of Ganas, whereupon an enraged Shiva severed the child's head with his trident, sending it spinning into space.

When Shiva told Parvati what had happened, the goddess was overcome with grief. Shiva tried to make amends but the goddess was inconsolable, pleading with Shiva to somehow bring her son back to life. Shiva finally sent messengers to locate the child's head. Though they searched far and wide the child's head was irrevocably lost. Desperate to placate his wife, Shiva instructed his Ganas to bring back the head of the first living being they encountered. The wisest of beasts, an elephant, appeared and offered his head to their swords, which they carried back to their

Opposite: Lord Ganesha, Halebid Temple, Karnataka

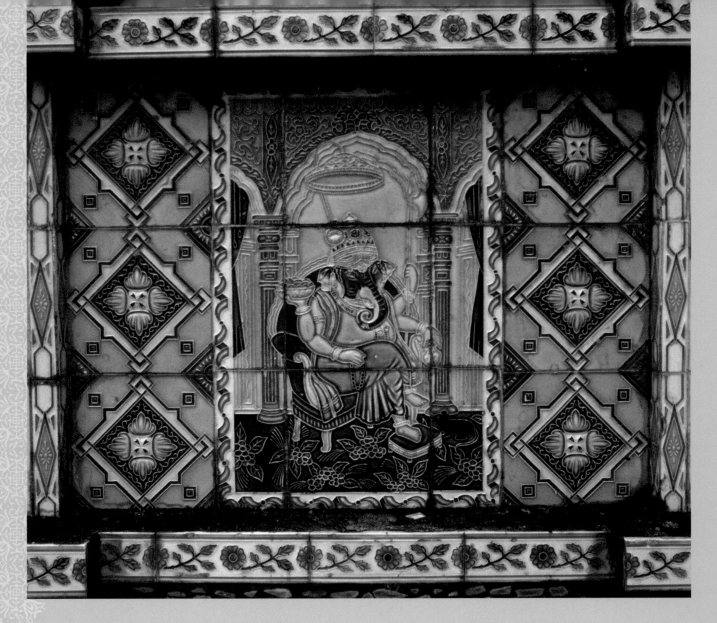

lord. Shiva placed the elephant's severed head on the boy's body, and in recognition of the child's valor in defending his mother, named the boy Gan-esha, Gana-pati, the Chief of Ganas.

Shiva triumphantly restored her beloved son to the goddess, and even acknowledged Ganesha as his own son. But the goddess refused to be placated. As reparation from Shiva, she demanded that Ganesha be known as the Remover of Obstacles. She further insisted that no god should be worshipped before prayers were first offered to her son, demanding that henceforth Ganesha be acknowledged as the Lord of Beginnings.

Proof that Shiva acceded to Parvati's demands is evidenced by the fact that no Hindu worship can commence without first reciting the Sanskrit invocation:

Om Ganapati namaya,
Om, I bow to Ganesha.

Above: Ganesha on Tulsi Vrindavan, Mangesh Temple, Goa; *opposite*: Ganesha Visharjan in well; *overleaf left*: Lord Ganesha in peepal trunk; *overleaf right*: Lord Ganesha carved in wood

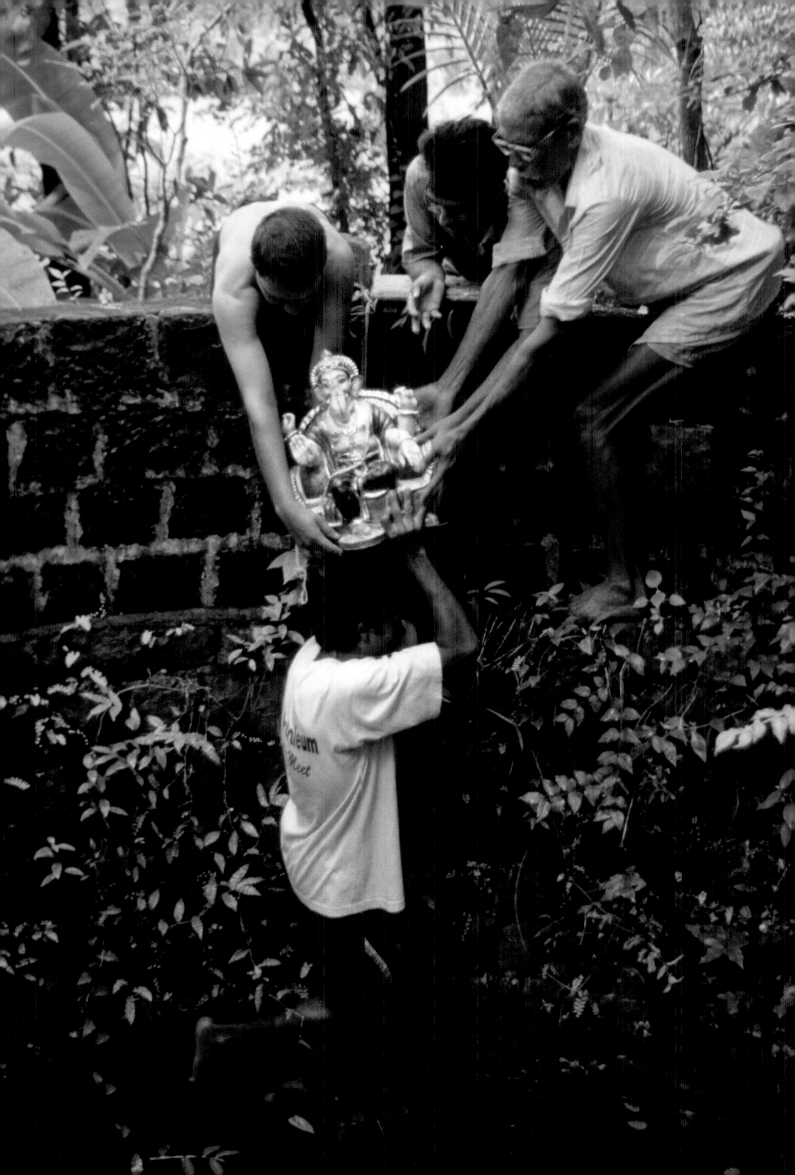

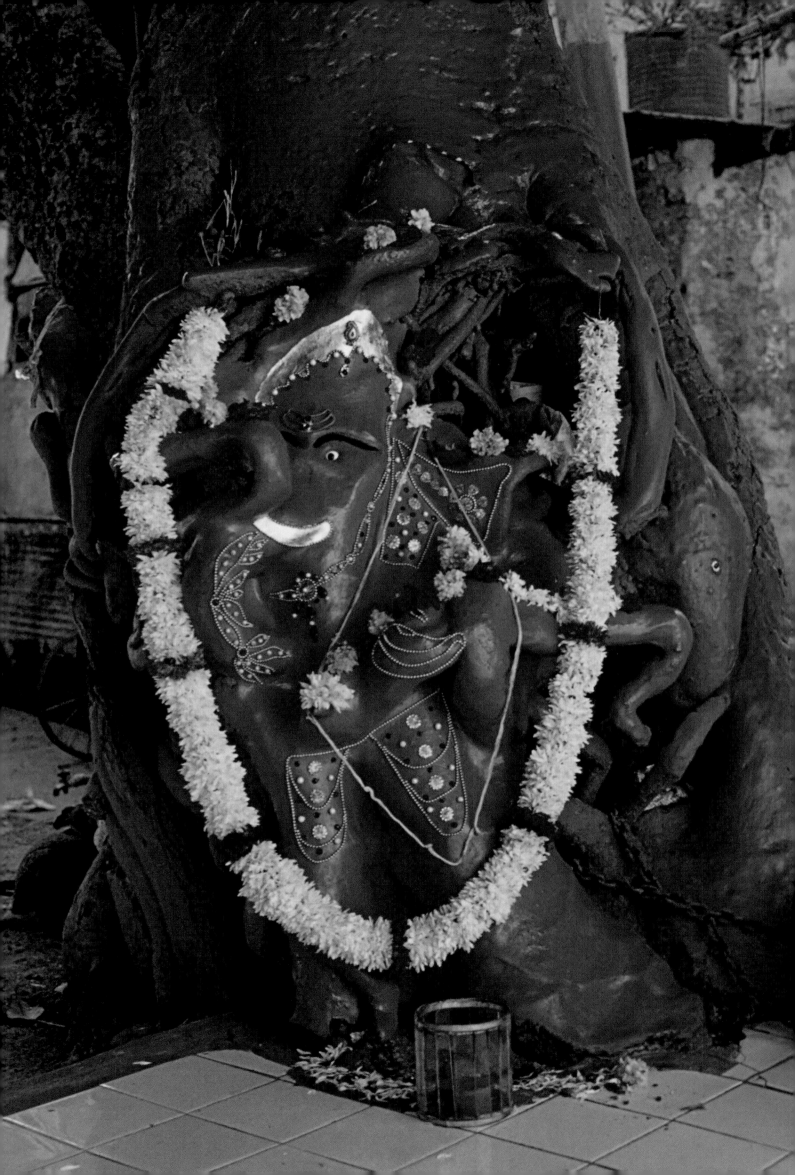

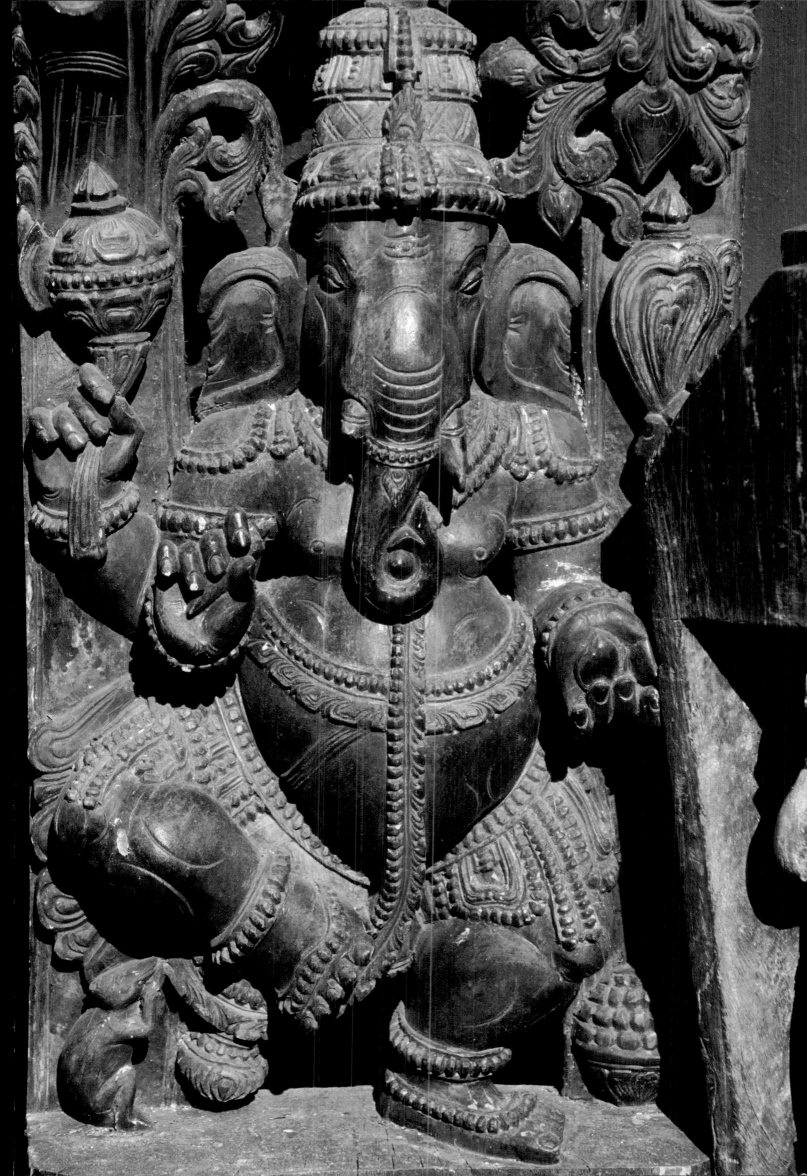

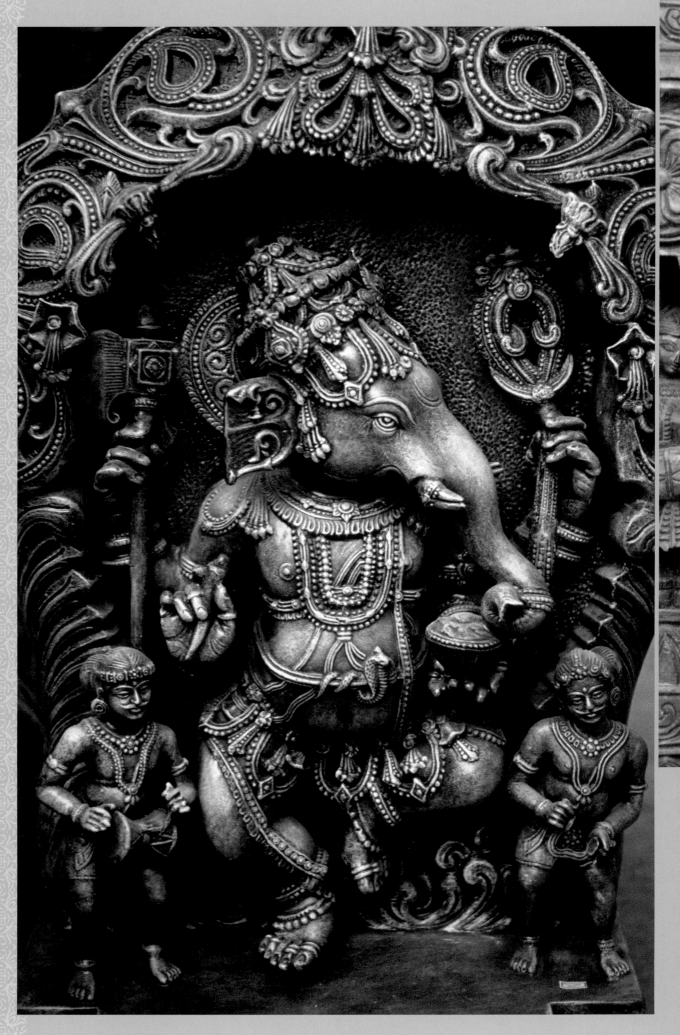

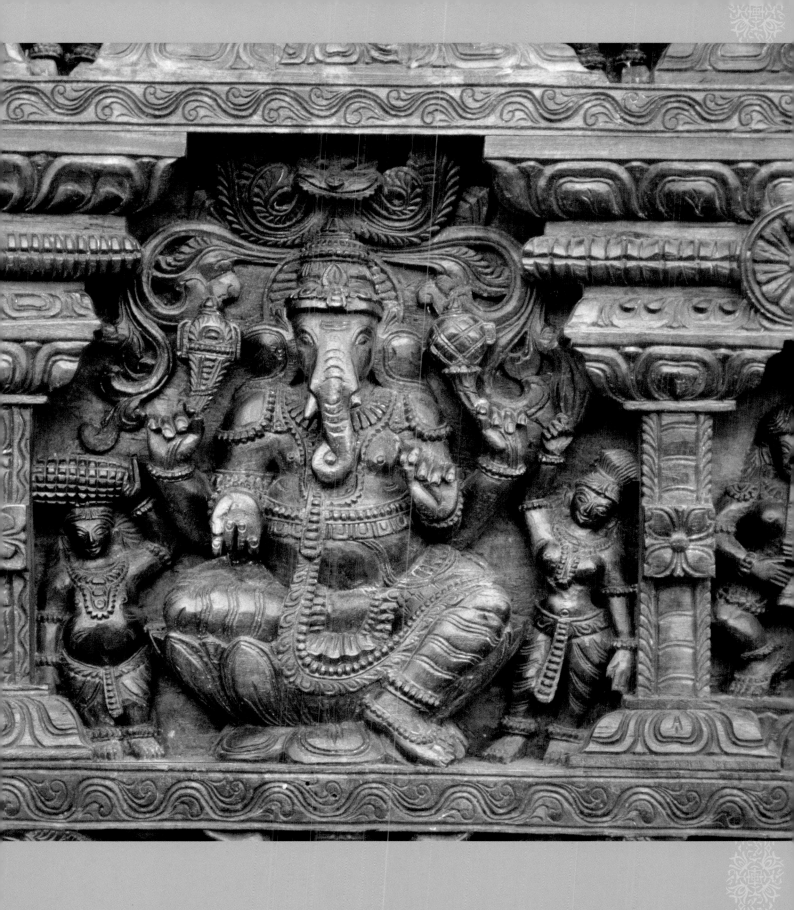

Opposite: Lord Ganesha in a dancing mood, *above:* Lord Ganesha wood carving, Kerala; *overleaf:* Pata Chita, handicraft

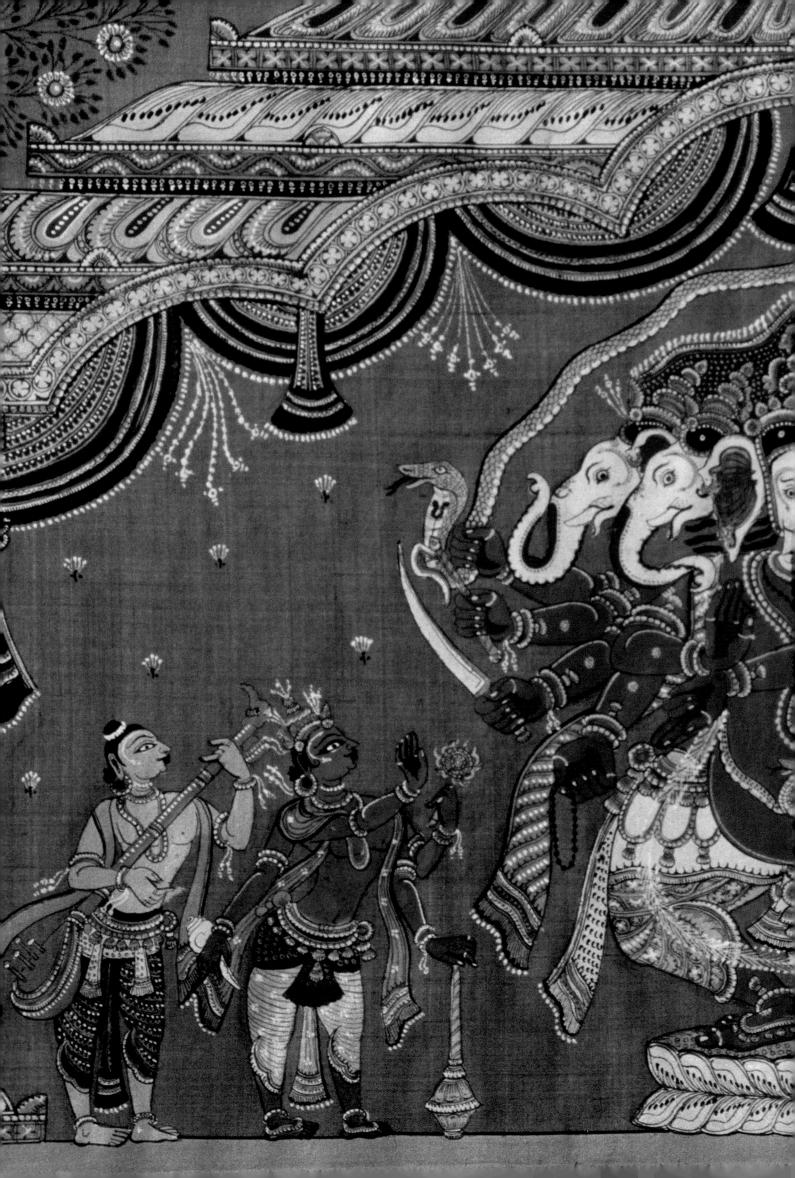

The Elephant-Headed God

Perhaps it is fitting that this much-invoked, much-loved Indian god should bear the head of an elephant. India has long been thought of as a land of elephants and tigers and snakes, a trio of beasts which appears again and again in the bestiary of Indian divinity. The hooded cobra is often depicted as guarding the sacred precisely because it inspires fear. Like the tiger, the elephant is self-evidently a symbol of power. But of the fearsome trio only the elephant has been of benefit to humanity.

The elephant cleared the jungle of wild animals and trees for agriculture, the original Remover of Obstacles. Later, as the mount of India's warriors, the elephant became the Protector, a living tank so awesome in battle that Alexander the Great in his campaign to conquer India was so terrified by his first sight of the massed elephants of the Indian king Porus, he sacrificed to his own gods for protection.

And unlike the tiger or the snake the elephant inspires love as well as awe, being possessed of that gentleness so eloquently described in *Progress of the Soul* by the metaphysical poet John Donne as:

> Nature's great masterpiece, an Elephant.
> The only harmless Great Thing, the Giant of Beasts.

Anthropologists have suggested that human beings find it easier to worship gods fashioned after what they find familiar. If this is true, then the Great Thing seems to exhibit characteristics

Opposite: Lord Ganesha

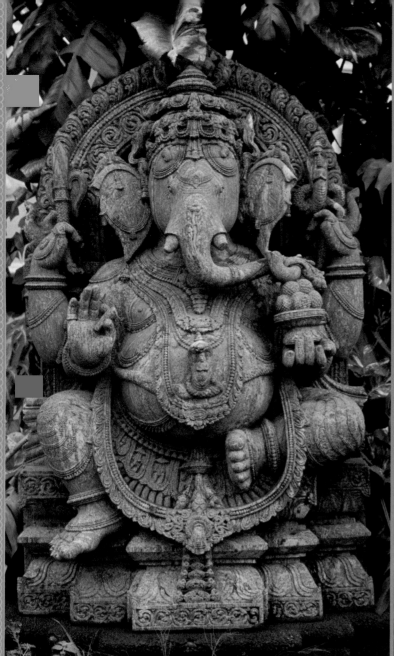

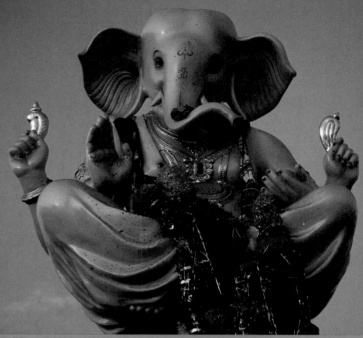

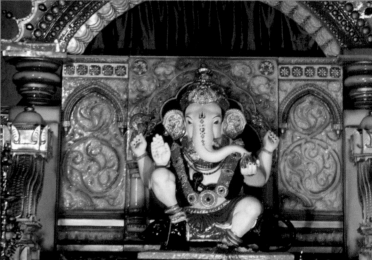

familiar to humanity. For instance, on first seeing elephants in the Roman Arena at a spectacle organized by the Roman general Pompey, Cicero writes in *Familiares* that even the bloodthirsty Roman mob experiences "a kind of feeling that the huge beast has a fellowship with the human race." And when twenty elephants are slaughtered for sport the Roman historian Pliny records, "the surviving elephants tried to gain the compassion of the crowd by indescribable gestures of entreaty, deploring their fate with a sort of wailing, so much to the distress of the public that … bursting into tears they rose in a body and invoked curses on the head of Pompey."

Above left: An ancient idol of Lord Ganesha; *top right:* Ganesha Festival, Immersion, Bombay, Maharashtra; *above right:* Ganesha Festival, Pune, Maharashtra; *opposite:* A tribal Ganesha, carved in wood and painted; *overleaf left:* Ganesha in tribal fabric; *overleaf right:* Lord Ganesha made of flowers, Mumbai, Maharashtra

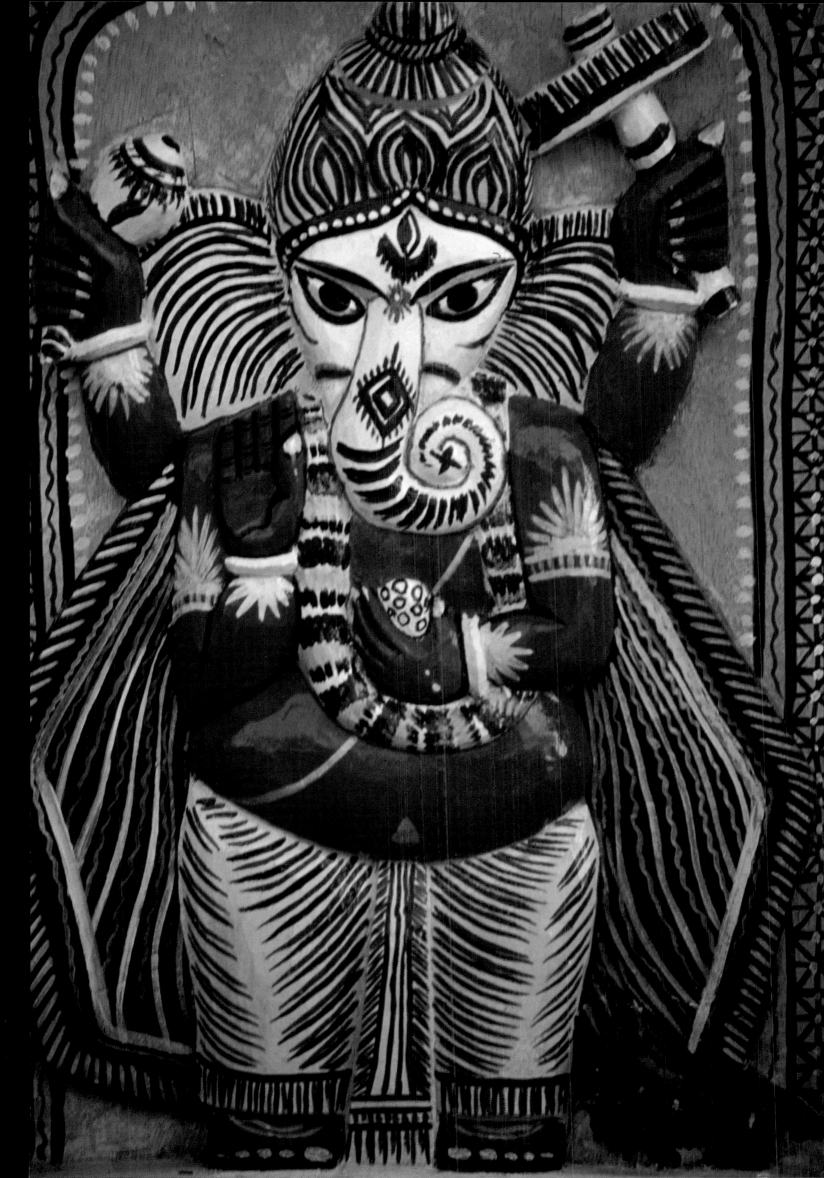

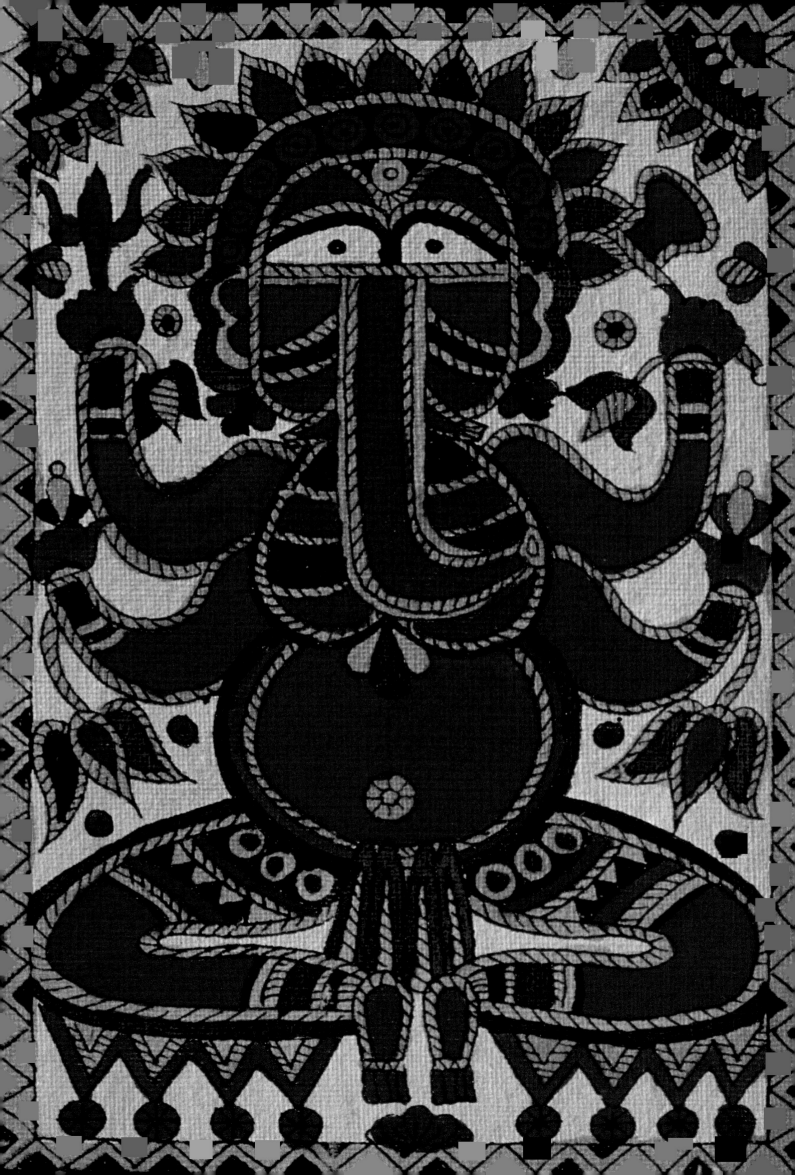

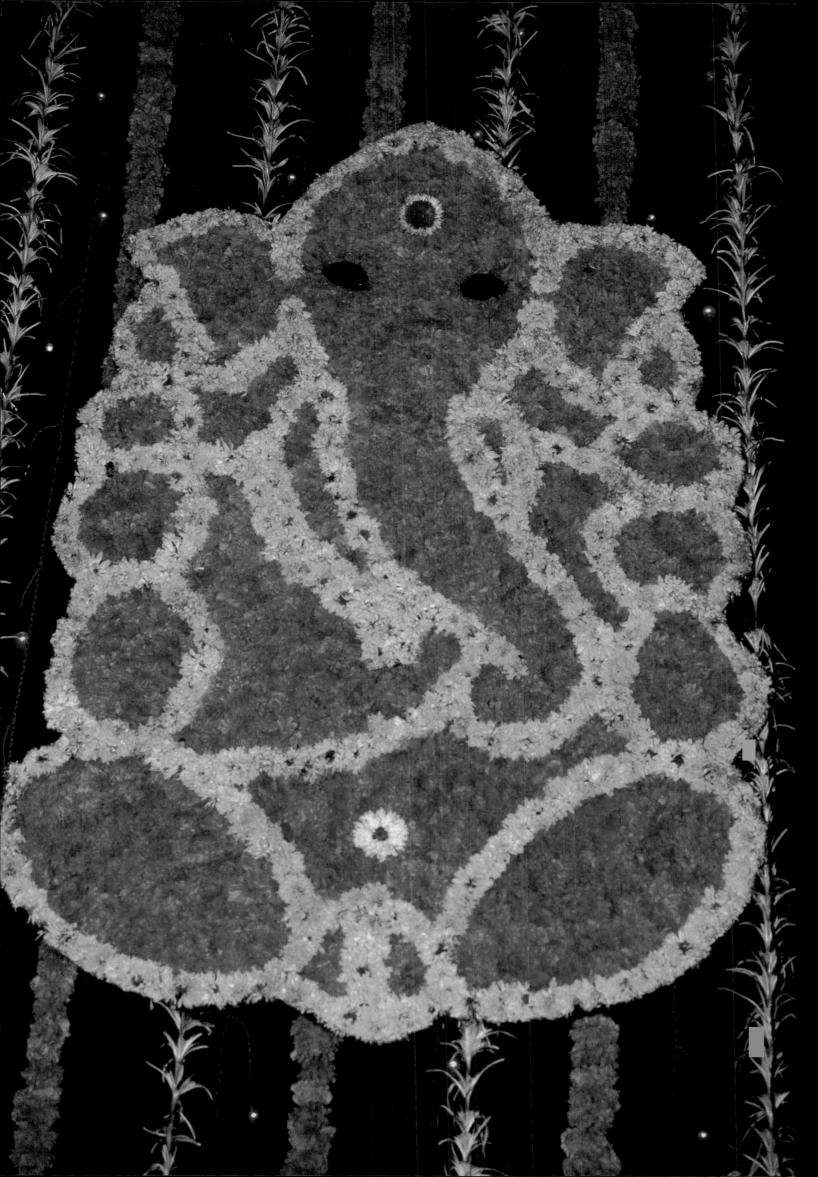

Can there really be something kindred in the natures of man and elephant to arouse such strong emotion in people who have never before seen an elephant? Pliny claims there is. In his *Natural History* Pliny writes, "of all animals the elephant in intelligence approaches the nearest to man ... and to a degree that is rare among men even, possesses notions of honesty, prudence, and equity. t has a religious respect also for the stars, and a veneration for the sun and the moon."

The elephant's veneration for nature may explain why Ganesha is loved by the descendants of India's original forest-dwelling inhabitants, her tribal populations who live so harmoniously with nature. The elephant occupies a totemic status in their worship. The tribals say the universe's primal Mother and Father descended to earth as two elephants, Matanga and Matangi. Surrounded by herds of wild elephants, Matanga and Matangi roamed the forests with their son Ganesha in a universe of innocent freedom. Some historians have even suggested that Shiva's beheading of Ganesha is a mythical version of the Aryan conquest of India's original tribal inhabitants, and that only after the tribals have been subjugated is their elephant god accepted into the Hindu pantheon as the subservient son of Aryan deities.

Whatever their humiliations at the hands of their conquerors, India's tribals would surely sympathize with the goddess Parvati's grief when her son is beheaded since they believe the elephant's maternal instinct closely mimics human behavior. Charles Darwin acknowledges that emotional similarity in *The Expression of Emotion in Man and Animals*, observing, "In the Zoological Gardens the keeper of the Indian elephants positively asserts that he has several times seen tears rolling down the face of the old female when distressed by the removal of the young one."

Going even further, Darwin asserts a biological similarity between humans and India's elephants. As proof he conducts an experiment that shows that unlike African elephants, "the Indian elephant contracts the same muscles as are used for the shedding of tears in man."

Opposite: Lord Ganesha in stained glass; *overleaf:* Lord Ganesha reading in the forest

51

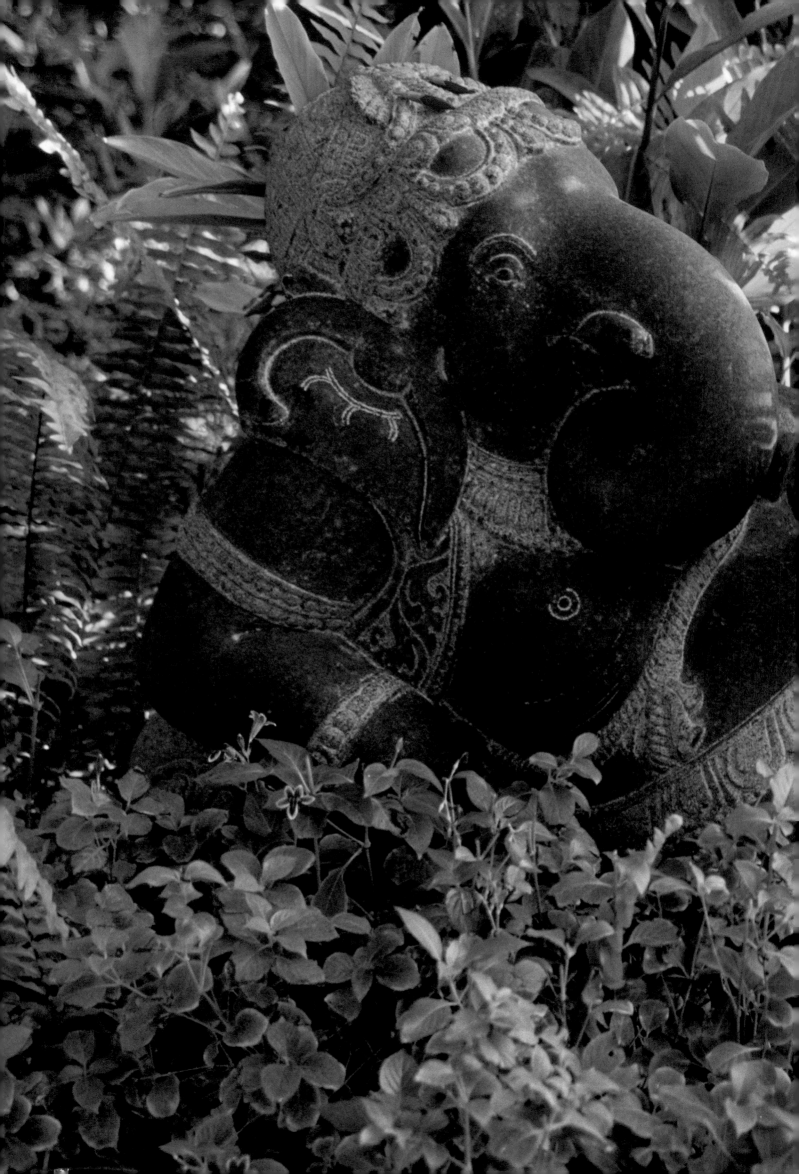

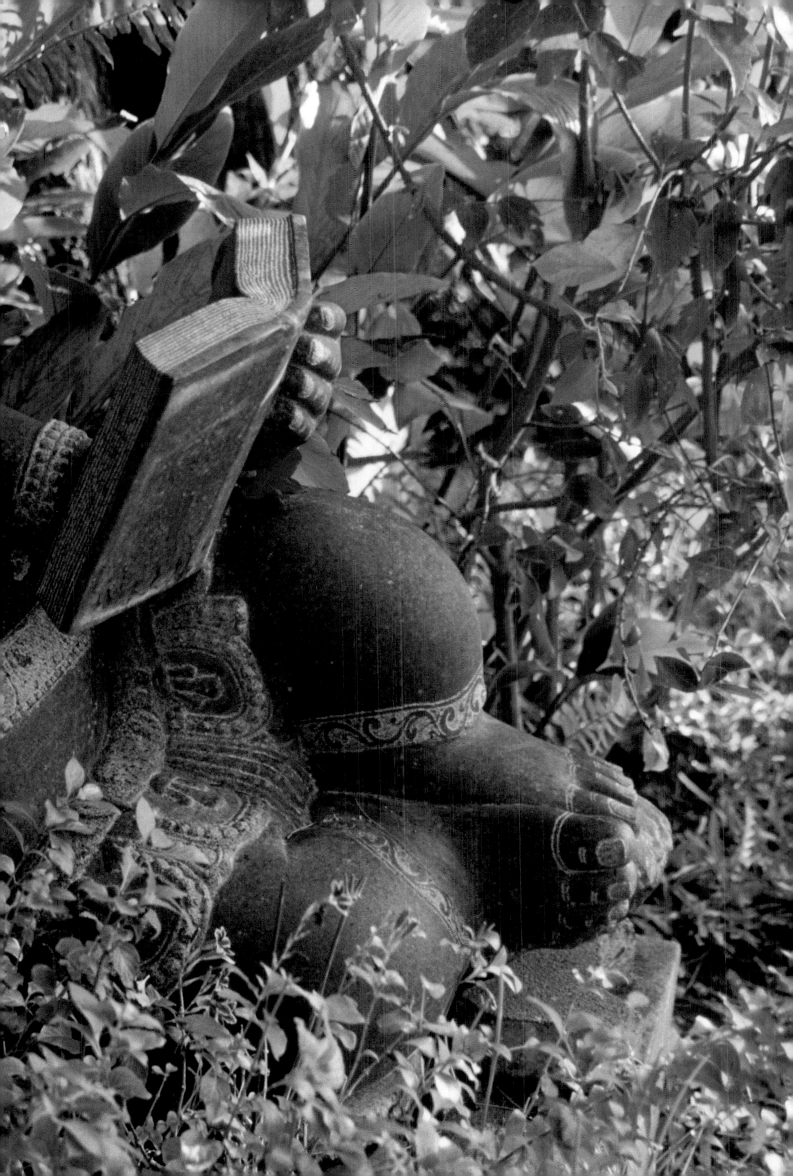

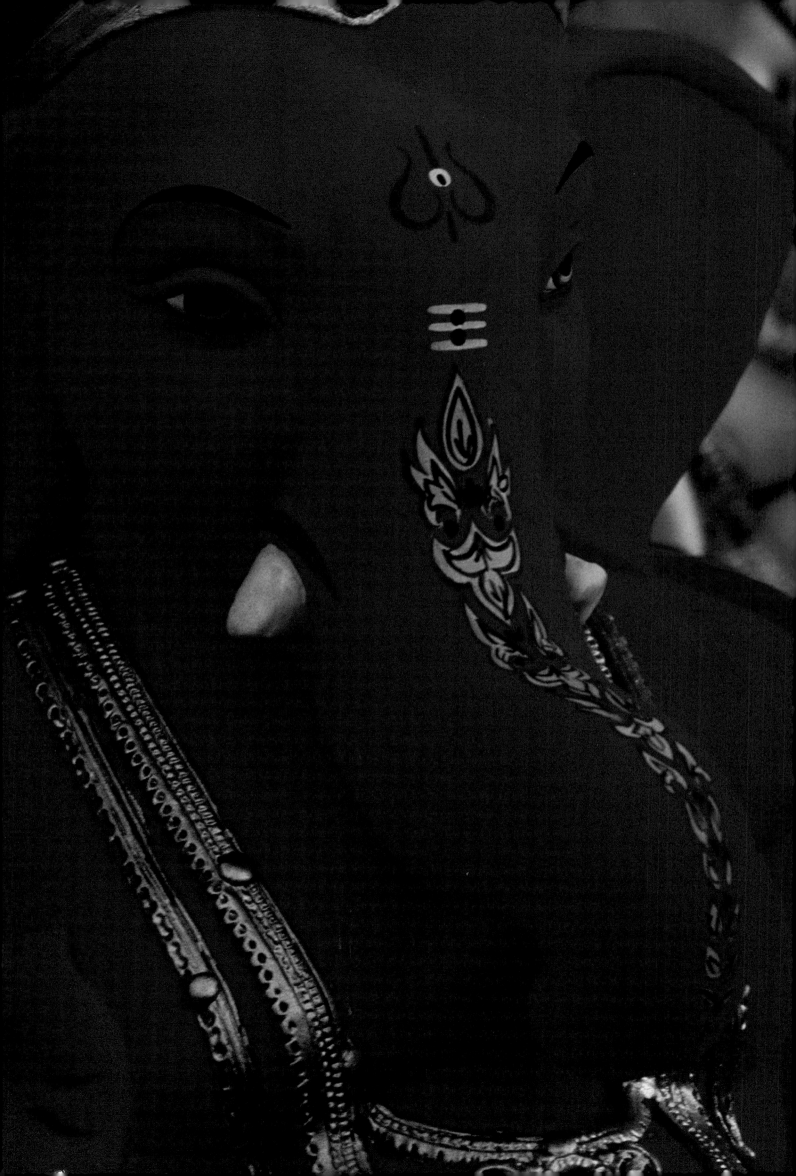

Ganesha's Sacred Trunk

The early Indian philosophers were not concerned with the parallels between human and elephant behavior, and not being sentimentalists they were unmoved by the notion that elephants weep. For them the significance of the elephant-headed god lay in the shape of his trunk.

Curling to the left Ganesha's trunk forms the shape of India's most profound concept, the syllable OM, symbolizing the origin of the cosmos.

According to the original Ganesha worshippers, the Ganapati cult, our cosmos was born with the sound of OM resounding through a primeval darkness. As energy escaped from darkness to become light, Ganesha appeared silhouetted against the light of the first dawn, blowing a conch shell. He came as Nritya Ganapati, the Dancing Ganesha, dancing the universe into existence with the abandon of energy escaping from dormancy. Sounding the conch shell until Om vibrated through the galaxies, Ganesha summoned the Trinity—Brahma, Vishnu, Shiva—to their triple tasks: Creation, Preservation, Destruction.

Hindus call their system of beliefs Sanatan Dharma, meaning the eternal search, the perennial philosophy. Its great thinkers maintain that creation has no beginning and no end. Rather, creation is an endless cycle of becoming in which one cosmos disappears into what modern physics would call a Black Hole, then out of that Black Hole energy escapes to form another universe, which in time collapses into darkness from which new energy eventually escapes to form yet another universe, ad infinitum.

Opposite: Lord Ganesha, Pune, Maharashtra

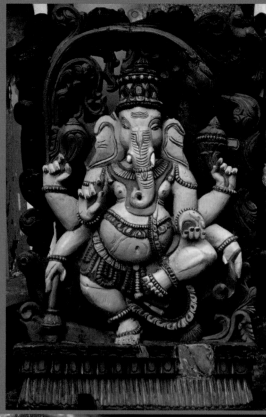

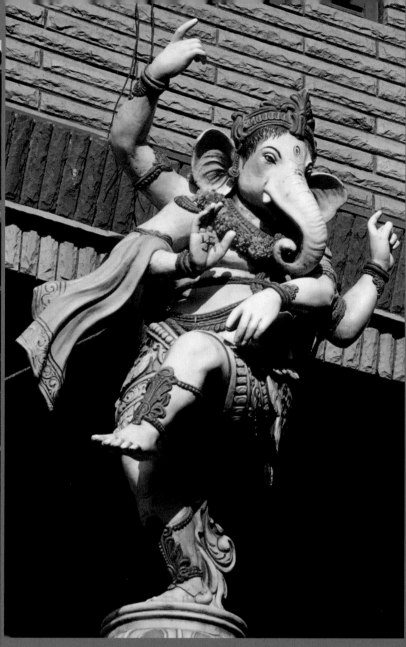

Each time, even before it becomes light, escaping energy reconstructs itself into matter through the vibrating of billions of particles which gradually merge into a vast humming that increases in volume until the birth of a new cosmos is heralded by sound, breaking in waves through time and space. The first syllable formed by that swelling wave of sound is OM, the Pranava Mantra, the creation mantra sometimes called the Sound of God.

Because Ganesha's trunk forms the sacred syllable, he is believed to embody OM in its material form. He is OM-kar, the origin of the universe. He is Vac, the first word. He is the First Cause.

Above top left: A dancing Ganesha; *above lower left:* the forefinger evoking Ganesha's trunk; *above right:* Haridwar, Uttar Pradesh; *opposite:* Close up of Ganesha idol, Pune, Maharashtra; *overleaf left:* Ganpati Festival, Mumbai, Maharashtra; *overleaf right:* Idol of Lord Ganesha dancing on drum, Girgaon, Mumbai, Maharashtra

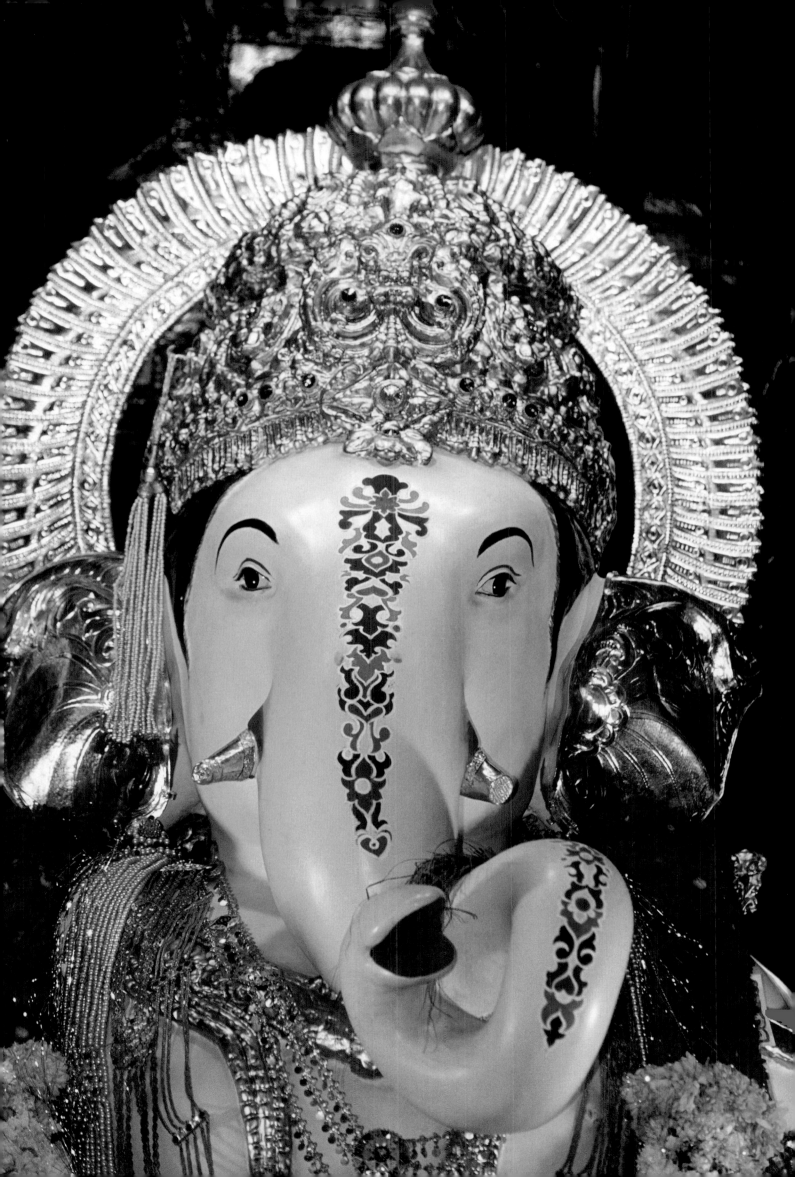

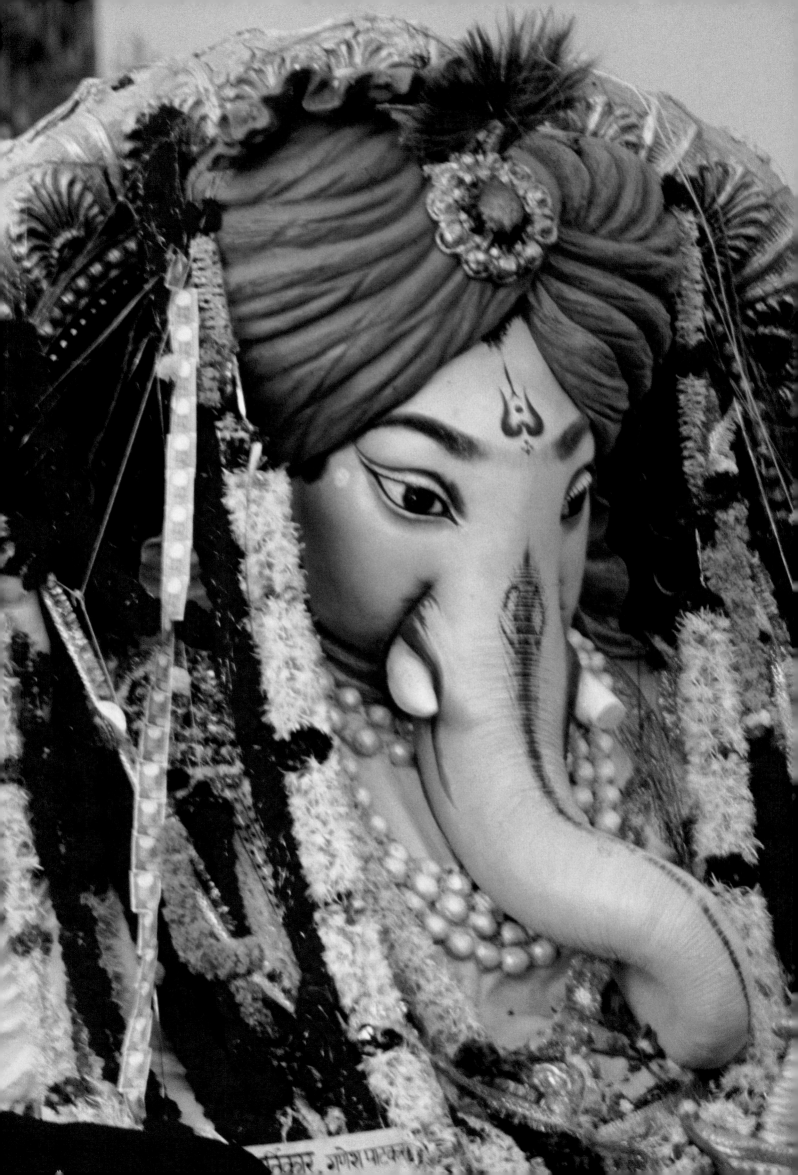

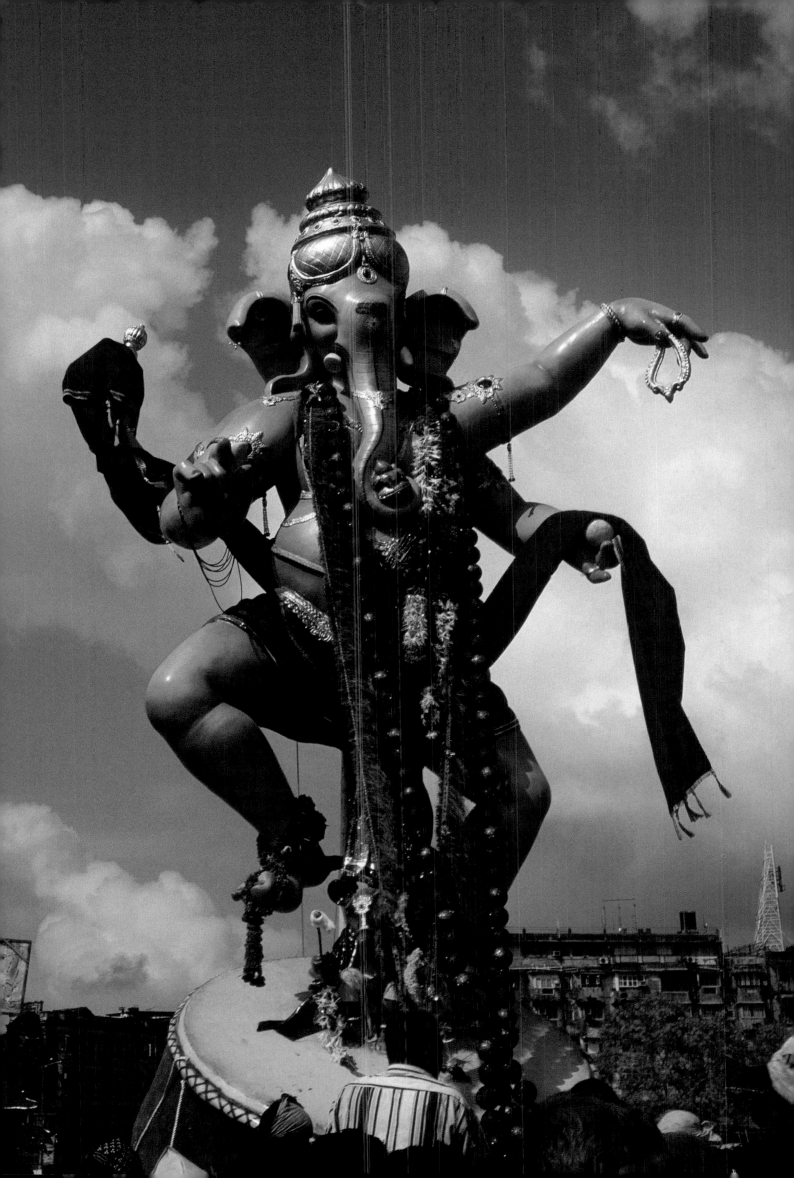

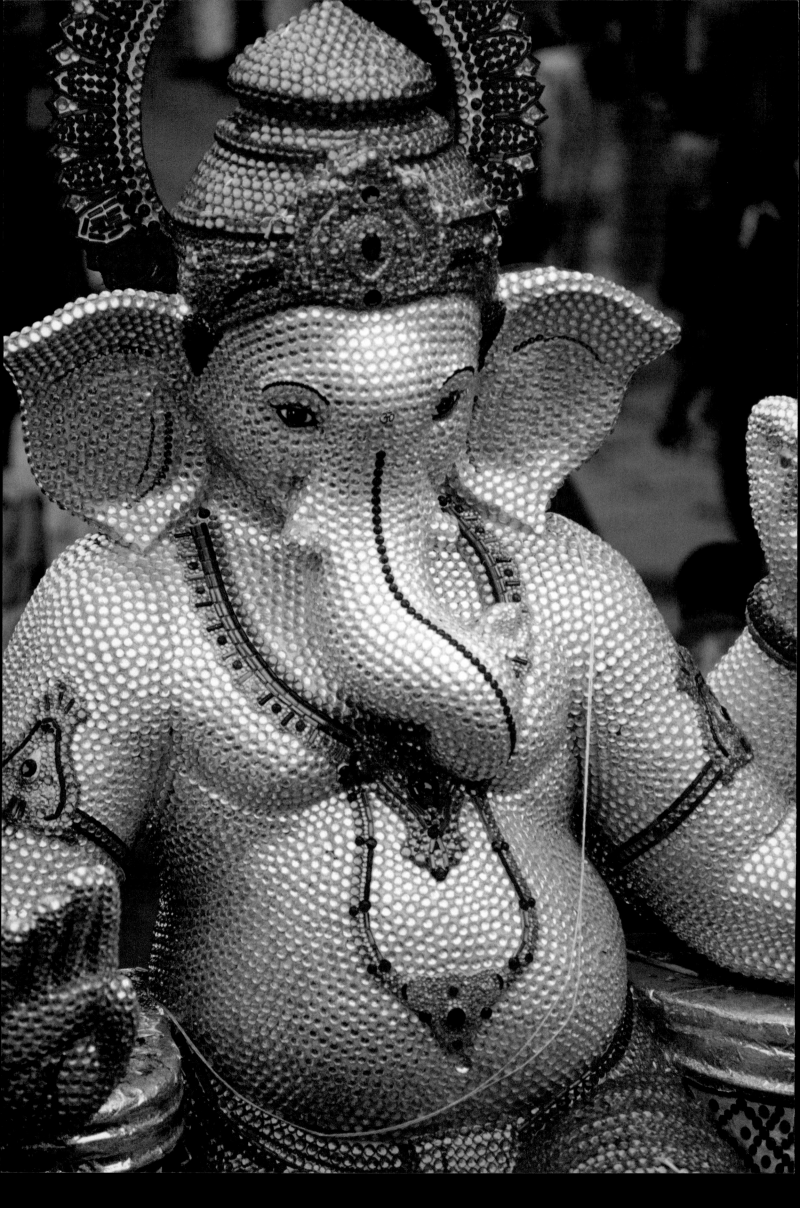

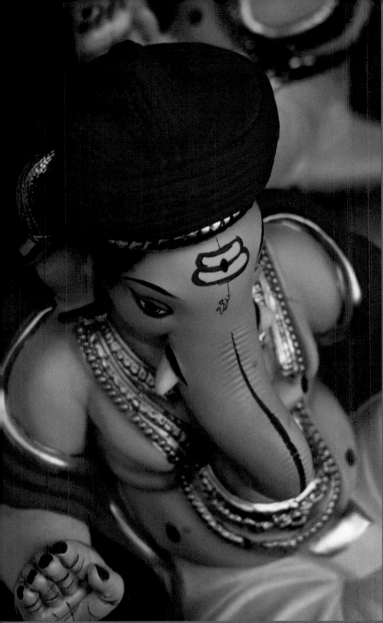
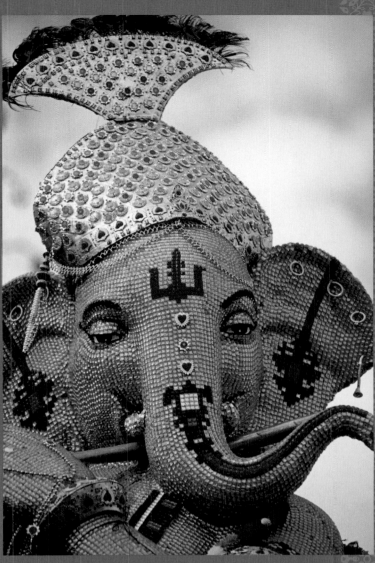

Ganesha is the only Indian god to physically incarnate creation. He is the sole physical manifestation of Brahman, the Unifying Principle which informs all life. That singularity is praised in the sage Shankaracharya's hymn:

To You
Whom the wise recognize
As the single syllable
Of Supreme Sound
Stainless and peerless
Formless and unconditioned
Dwelling in the core of
Sacred tradition,
To You
Primal One
I bow in wonder.

*Opposite :*Ganesha Festival Immersion, Mumbai, Maharashtra; *above left:* Lord Ganesha, Pune, Maharashtra; *above right:* Ganesha Festival Immersion, Mumbai, Maharashtra *overleaf:* Ganesha Idol, Mumbai, Maharashtra

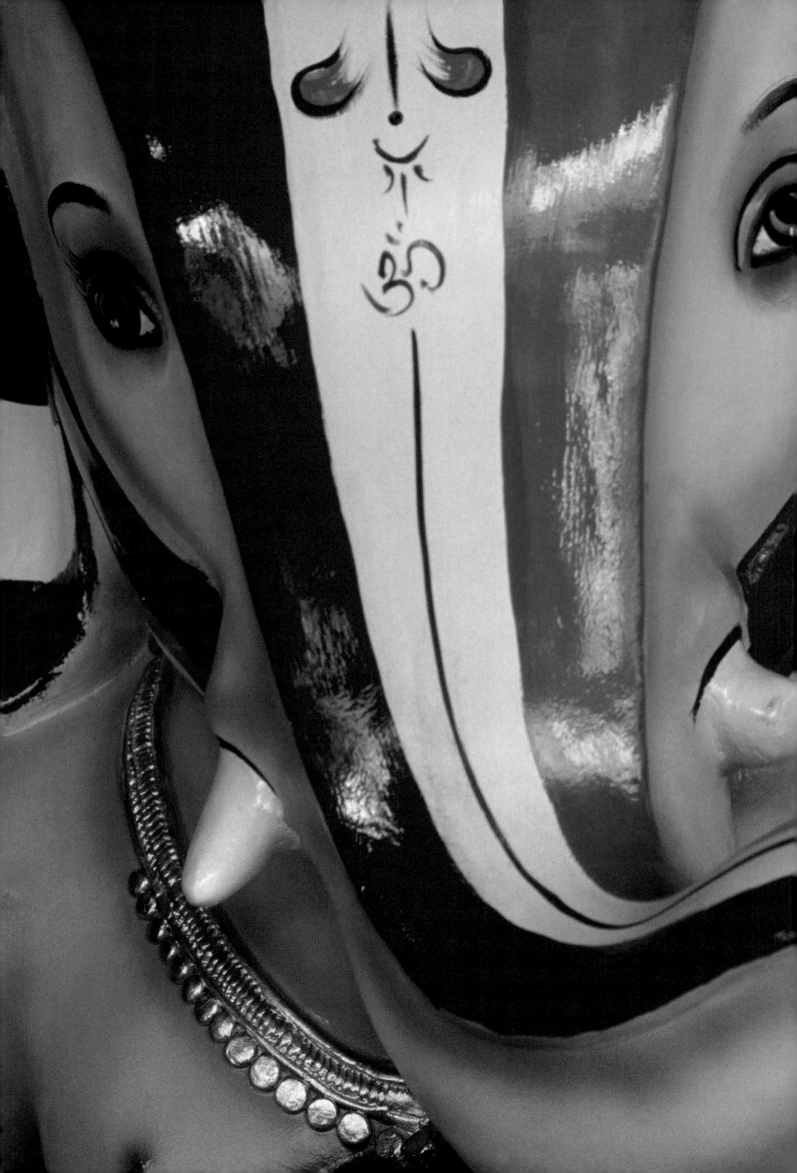

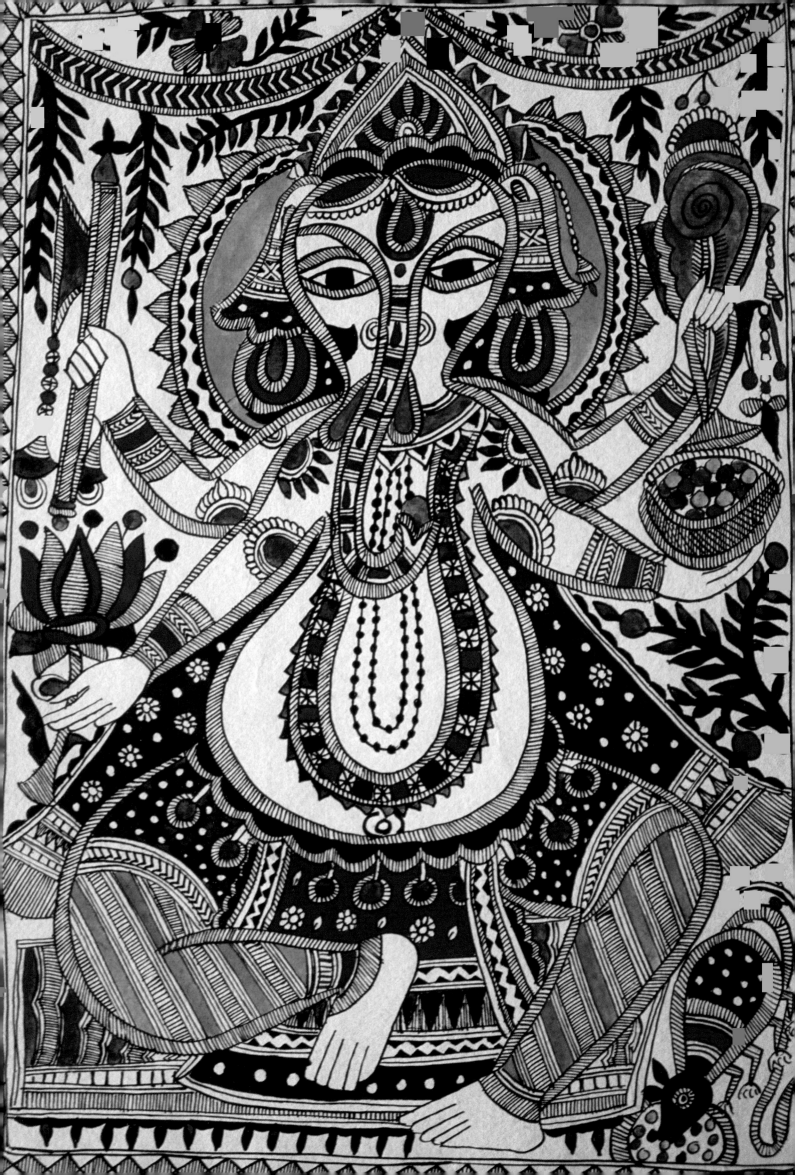

Ganesha's Body

If Ganesha's elephant head symbolizes the supreme reality of existence, his body signifies Maya or the illusion of existence.

The comically corpulent belly indicates that physical appearance is an illusion which must be overcome to reach truth. It is also symbolic of a divinity vast enough to contain the entire universe and all the contradictions that exist within it.

Then there are his limbs. Ganesha is always shown with at least one foot touching the ground, indicating his closeness to reality, while his many arms are left free to illustrate philosophical abstractions.

Some Ganesha scholars meditate on a six-armed Ganesha as representing six separate schools of Indian philosophy. Other scholars meditate on his four arms as depicting the four categories of life forms—that which lives on land, aquatic life, amphibious life, and avian life—an ancient allegory that bears a startling resemblance to the conclusions of contemporary zoology. Still others view his four arms as representing the four stages of language and therefore learning.

Although four arms are usually thought sufficient to delineate Ganesha's attributes he is sometimes shown with six or eight arms, sometimes twelve, sometimes thirty-two. But then Indian gods are notorious for the number of their arms as if only an excess of limbs can satisfy the Indian temperament so accurately described by the Indian economist Amartya Sen as the Argumentative Indian.

Opposite: Lord Ganesha, Madhubani painting

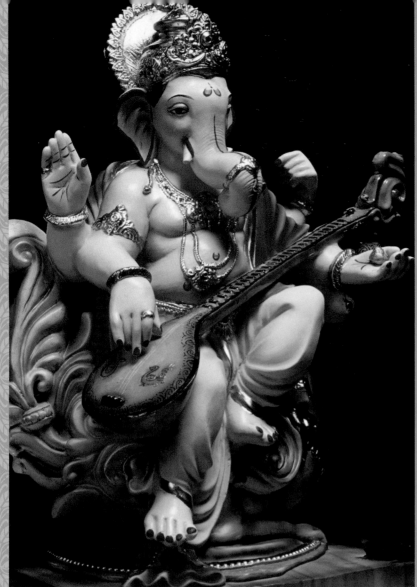

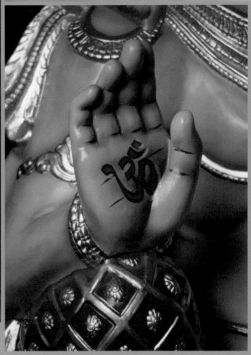

Indians have always loved philosophical discussion, loved debating that on the one hand there is this, on the other hand there is that. The Indian historian Irfan Habib even quotes an ancient Persian definition of Hindus as "those who have been debating with each other within a common framework for centuries. If they recognize another as somebody whom they can either support or oppose intelligibly, then both are Hindus."

Ironically, the word Hindu comes not from India but from ancient Persia to describe people living by the river Indus. Only in the nineteenth century does the term "Hinduism" enter common parlance to describe the myriad forms of worship originating geographically within India, a definition now embraced by the constitution of the Indian Republic. The Indian constitution then distinguishes Hinduism from other faiths of Indian origin such as Jainism,

Above left: Lord Ganesha, Pune, Maharashtra; *above top right:* Ganpati; *above below right:* the hand of a Ganesha idol marked with the sign of OM, Mumbai, Maharashtra; *opposite:* Lord Ganesha, Pune, Maharashtra; *overleaf:* Lord Ganesha idol enthroned, Ganesha Festival, Pune, Maharashtra

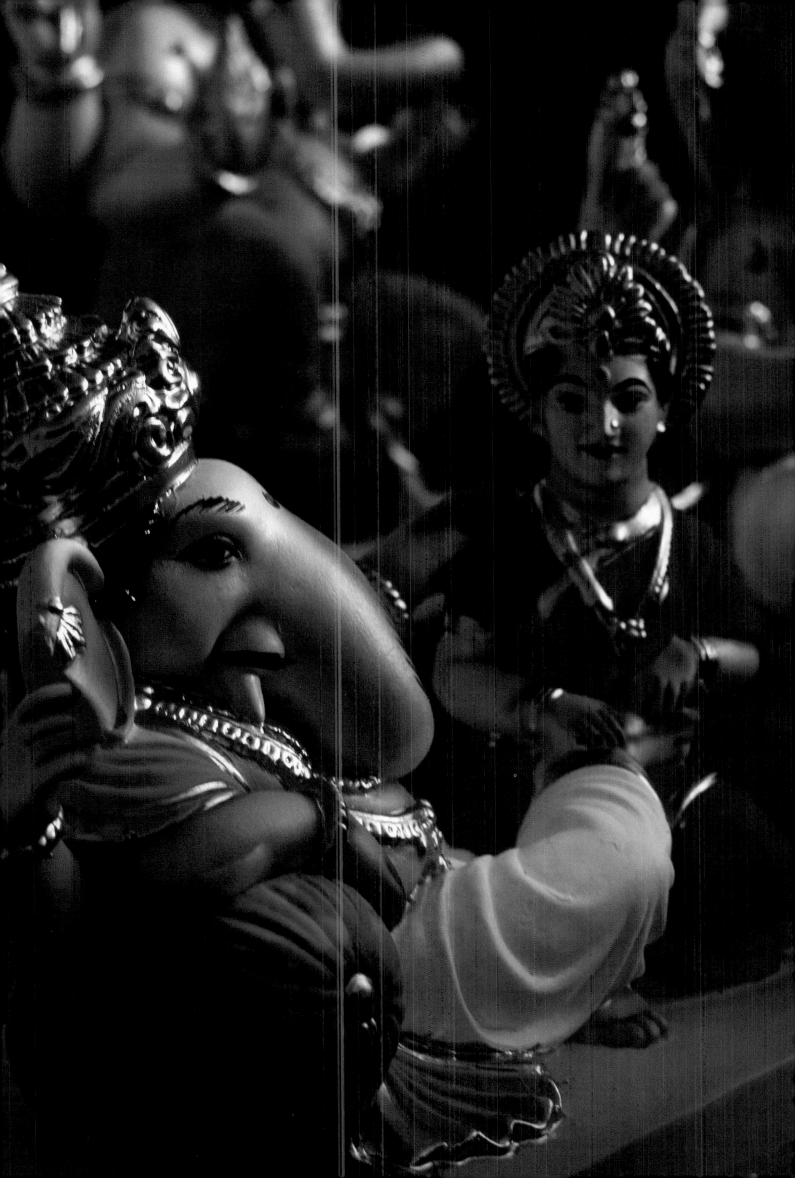

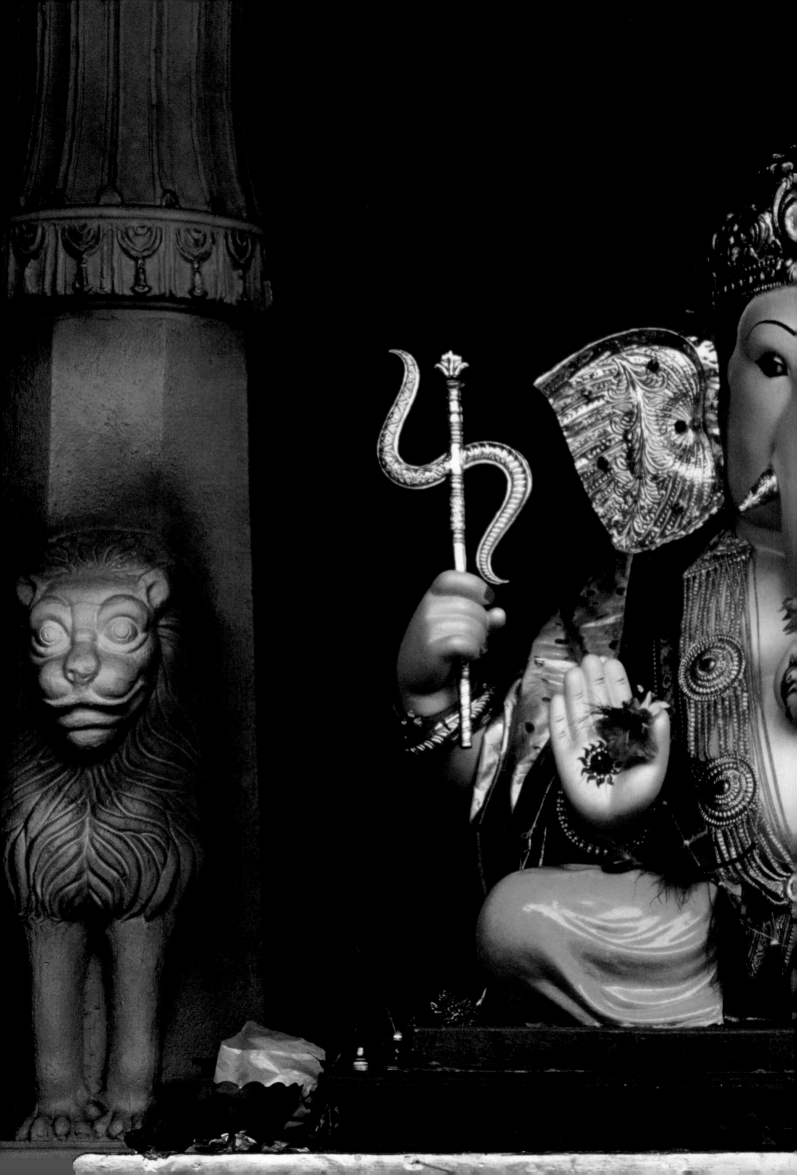

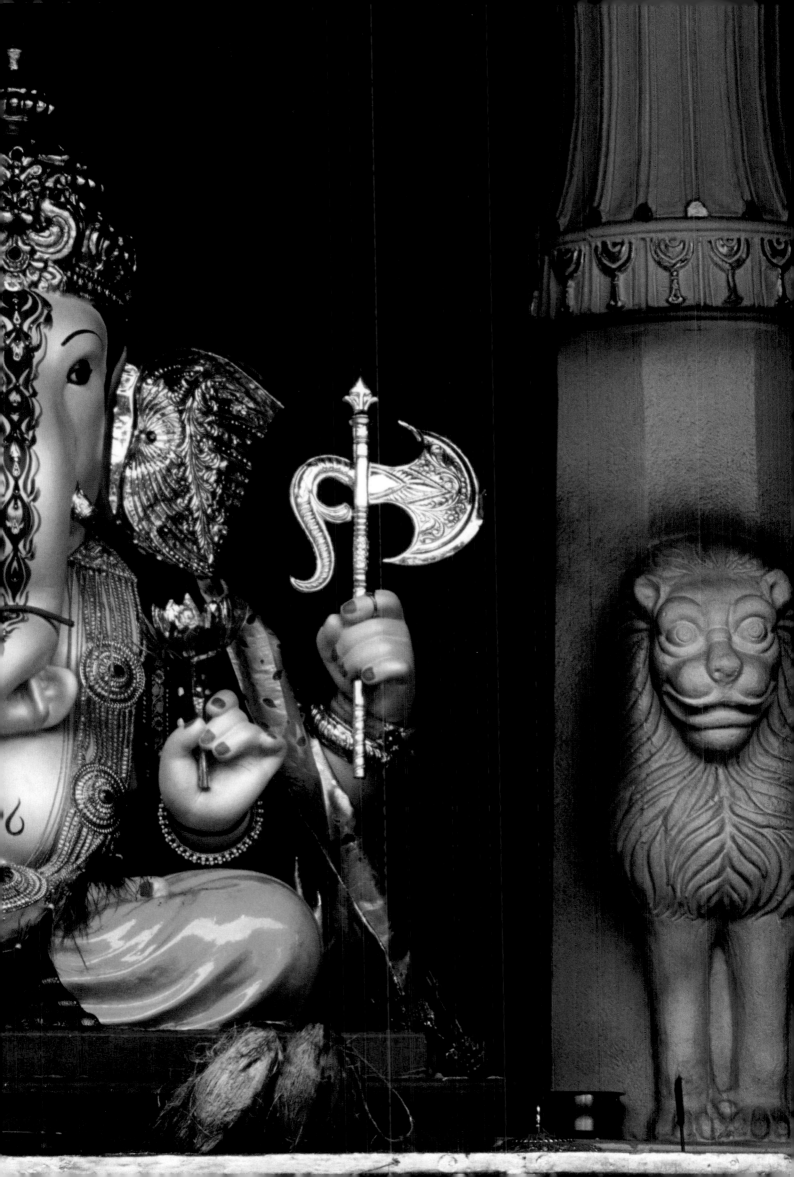

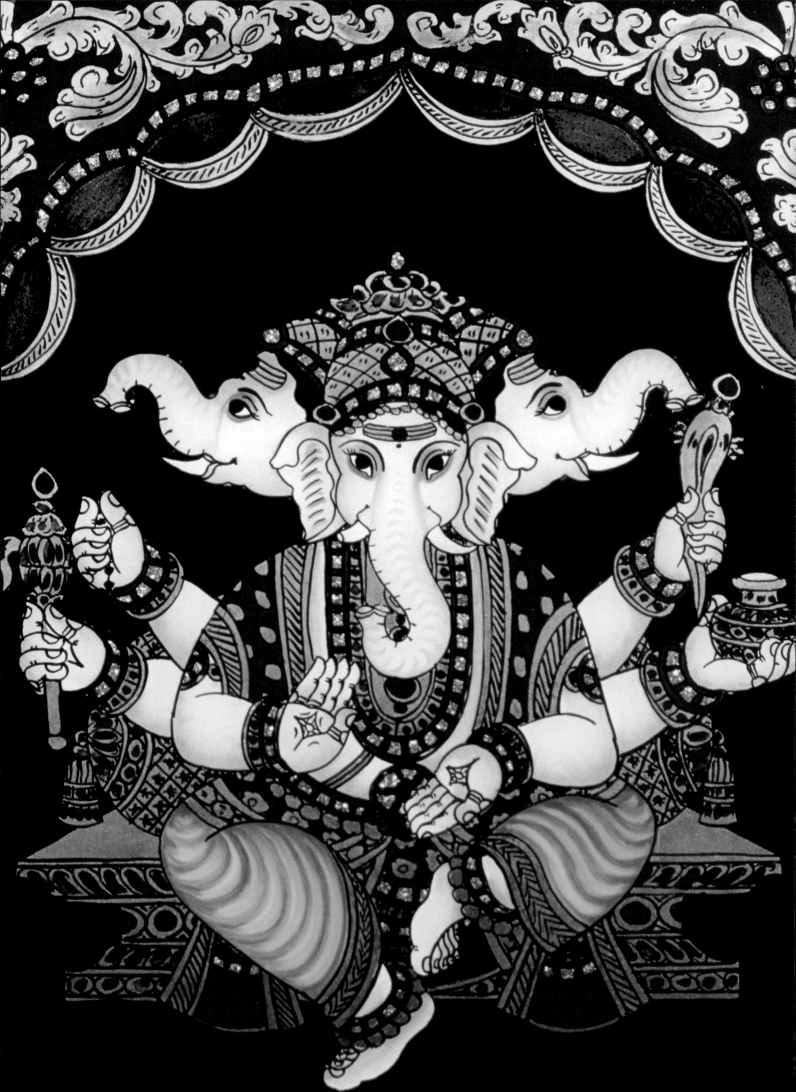

Buddhism, Sikhism. Unfortunately, of all India's many faiths only Hinduism is routinely described as the religion of a million gods.

Although Hindu philosophy is obsessed by defining a single Unifying Principle which it terms Brahman, its attempts to arrive at this formless reality through the use of a million forms have often been dismissed as simple-minded polytheism. In fact, Hinduism's pantheons of gods are an attempt to represent aspects of a single truth sternly defined in the *Atharva Veda* as:

> The One, the one Alone,
> In him all deities become One Alone.

One could legitimately ask why quite so many gods with quite so many arms are required to pursue a single truth. Hindu metaphysics has considered that question for several thousand years. Its answer is still a work in progress.

Hindu philosophers are still trying to define truth, still trying to produce a sole image to illustrate truth's infinite attributes. But the human mind cannot encompass infinity. As the ancient Hindu text, the *Vishnu Samhita*, says, "Without a form how can God be meditated upon? Where will the mind fix itself? Therefore the wise will meditate on some form, remembering, however, that the form is a superimposition and not a reality."

Indians appear to have taken the advice to heart. It has been calculated that currently Hindus meditate on 330 million different forms of god. One explanation offered for this phenomenon is that gods are to the Hindu what diagrams are to the mathematician. If so, what diagram of truth does Ganesha provide?

As the sum of his many arms and hands, Ganesha does indeed appear to offer a useful diagram for meditation. For instance, Ganesha's hands can be viewed as a philosophical template. In one hand he holds a noose symbolizing the bondage of desire. In another he holds an axe to break the ties that bind men to materialism. The sweets held in a third hand indicate the pleasures of knowledge and spiritual wisdom. His fourth hand is raised in the symbol of enlightenment which comes with liberation from all desire.

Opposite: Trimukhi Ganpati, Tanjore glass painting

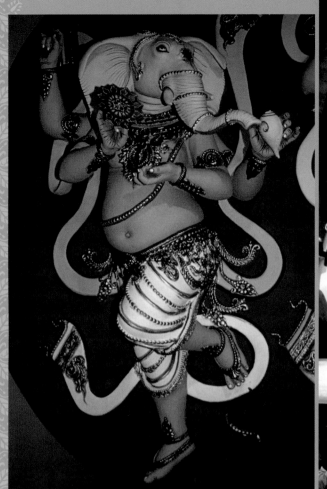

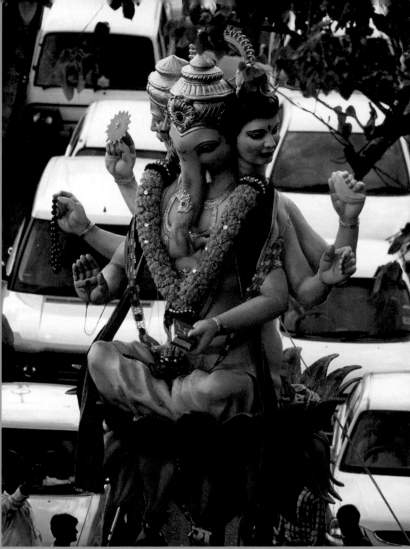

Then there is his unique shape. Ganesha is a composite of four separate animals. He has the head of an elephant, the body of a man, a snake binds his belly, and he rides on a mouse. These contradictory animals—elephant and mouse, serpent and man—are contained within a single image, pointing to the supreme goal of Hindu metaphysics: finding an over-arching unity in which all apparent contradictions can be contained.

They also point to a moral imperative—that opposites can and must live in peaceful co-existence. Non-violence and humanism derive from that imperative. The elephant does not kill living creatures to survive; it is a symbol of *ahimsa* or non-violence. A human body circled by a snake connects the elephant to a mouse, the union of the small with the great, the microcosm with the macrocosm. Illustrating the intimate connection between all life forms, as a meditational diagram Ganesha incarnates Hindu philosophy's fundamental law, the unity in diversity that it is humanity's primary duty to maintain.

Above left: Lord Ganesha, West Bengal; *above right*: Ganesha Festival procession, Mumbai, Maharashtra; *opposite*: Spray painting Ganesha idols; *overleaf*: Ganesha Festival Immersion, Mumbai, Maharashtra

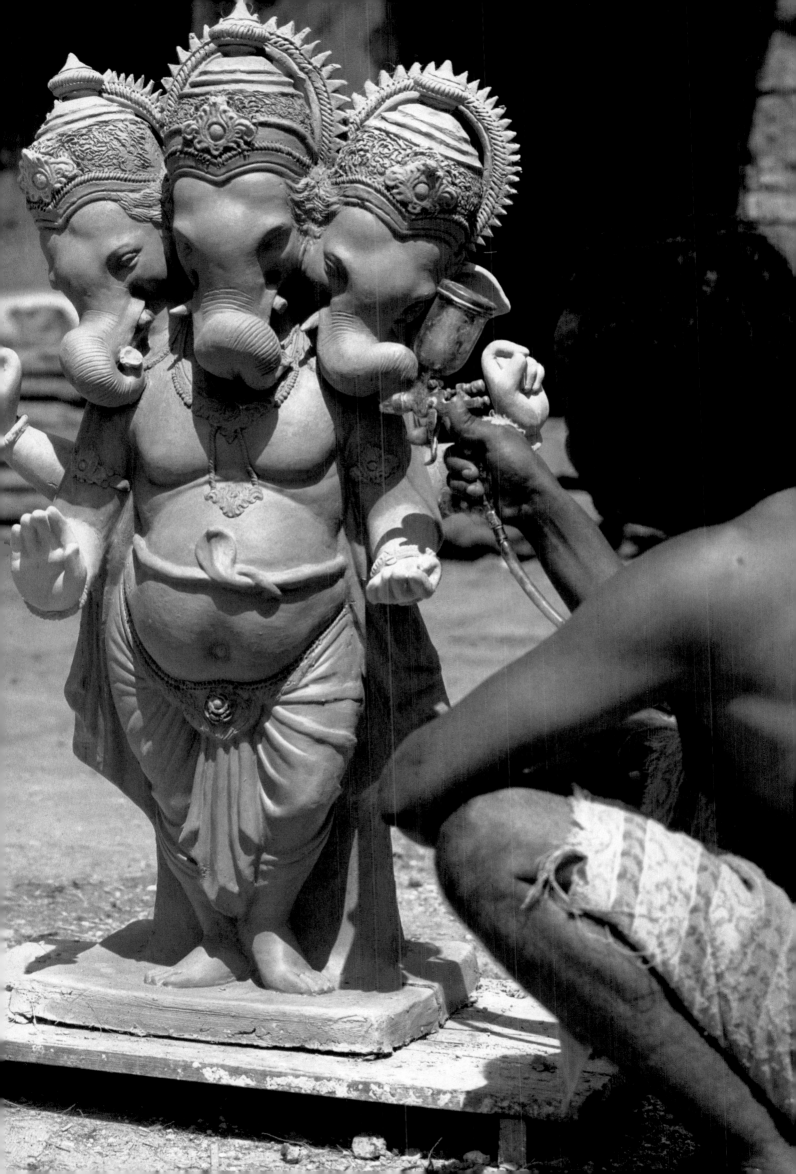

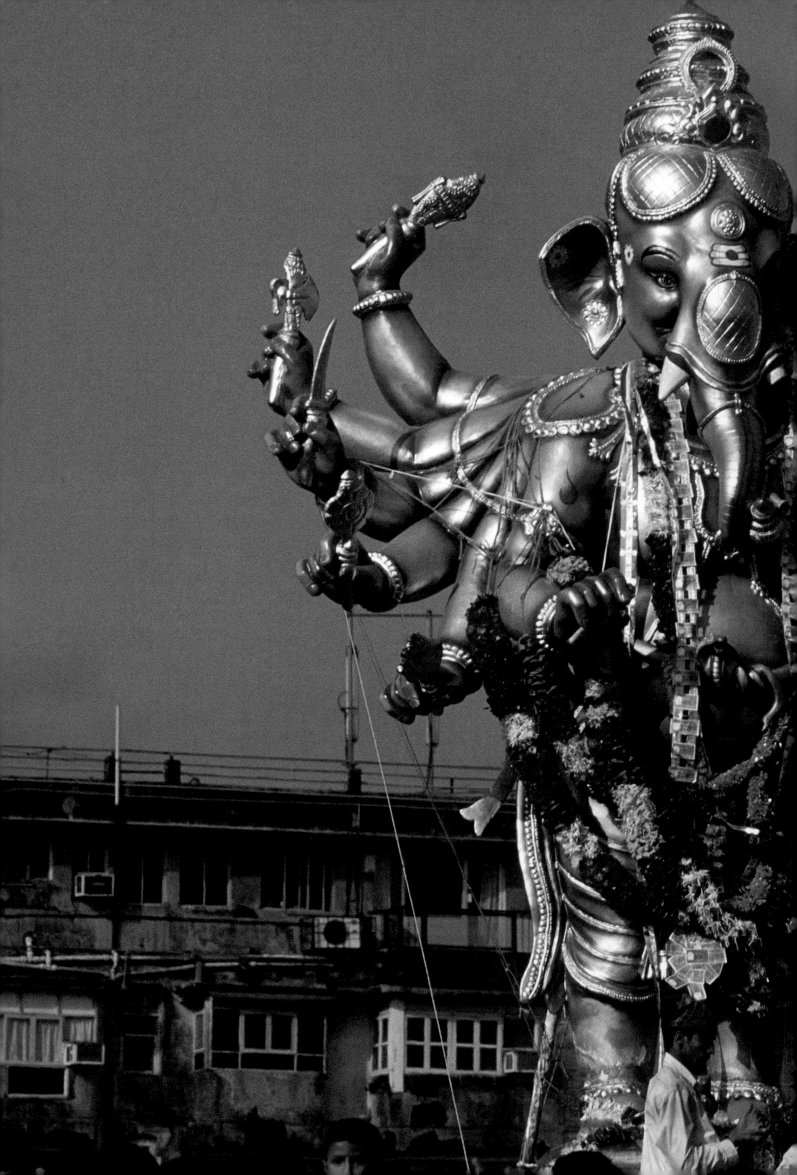

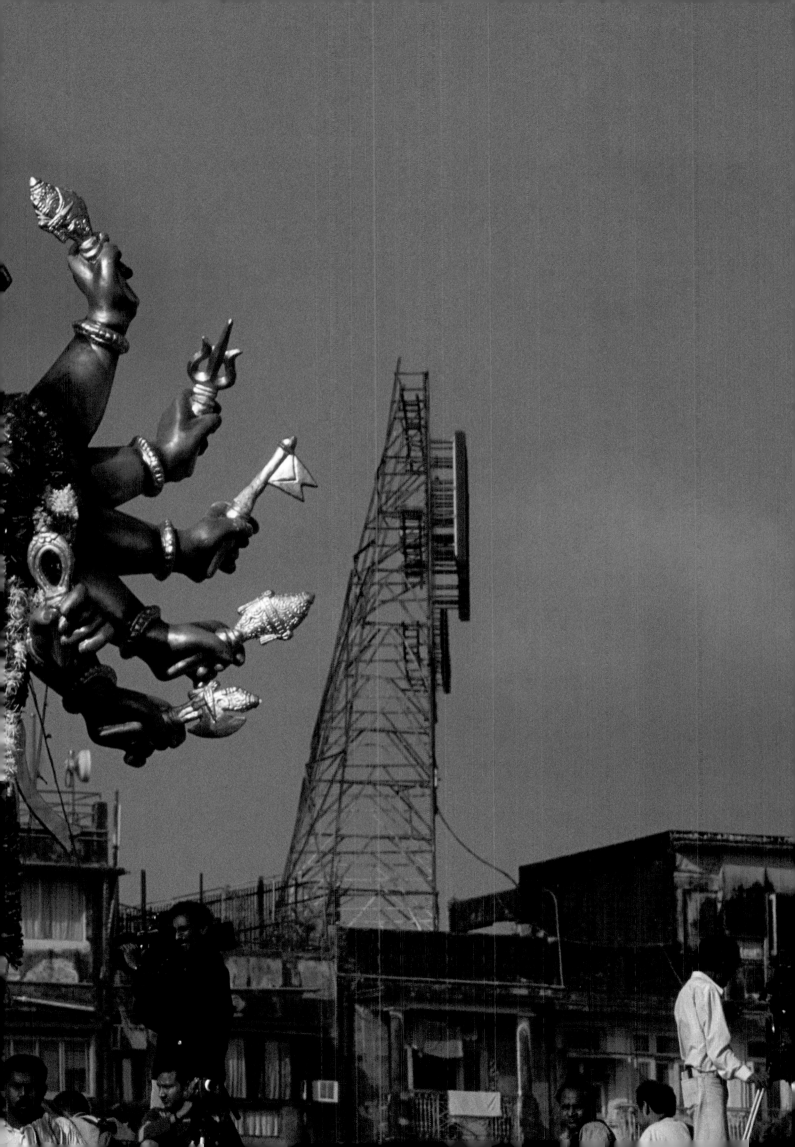

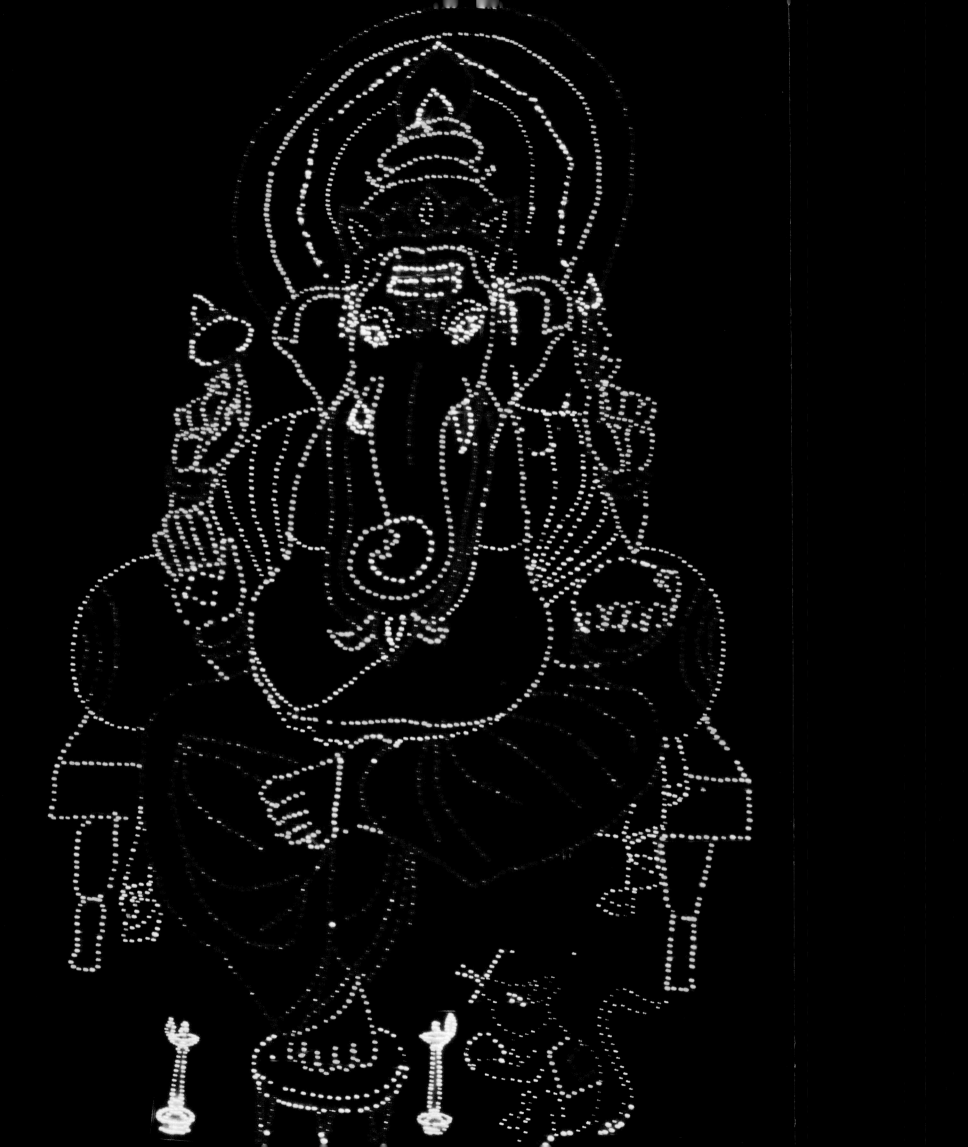

Ganesha's Mouse

The four animals that constitute Ganesha are often used as a guide to spiritual development. Ganesha's trunk may curl into OM, the highest symbol of consciousness, yet he rides on a mouse which to many Hindus represents the lowest form of consciousness, the ego. Some devotees believe Ganesha's mouse represents a thief who roams the darkness of the subconscious desires, gnawing at the tranquility of the inner self, and Ganesha's supremacy over his mouse symbolizes the conquest of egoism and the self-annihilating power of desire.

Other interpretations give Ganesha's mouse a more exalted role. Some Ganesha worshippers believe that Agni, the sacrificial fire of Hindus, once disguised himself as a mouse. Because fire is kindled inside the earth, burns on the ground, and rises to heaven as smoke, Agni is considered the mediator between the three worlds of ignorance, materialism, and enlightenment. Disguised as a mouse Agni becomes Ganesha's steed, enabling consciousness to evolve from its lowest point to its highest.

Another myth holds that when all the gods offered Ganesha presents, the Earth herself gave him a mouse to carry him into the heart of the Earth's innermost secrets. Here, Ganesha's mouse represents the restless intellect within human beings, the scurrying vehicle they ride to penetrate the dark mystery of things. It is a myth peculiarly suited to modern India where Ganesha's mouse is fast becoming a popular vehicle for accessing knowledge and entering secret worlds.

Opposite: Lord Ganesha in lights

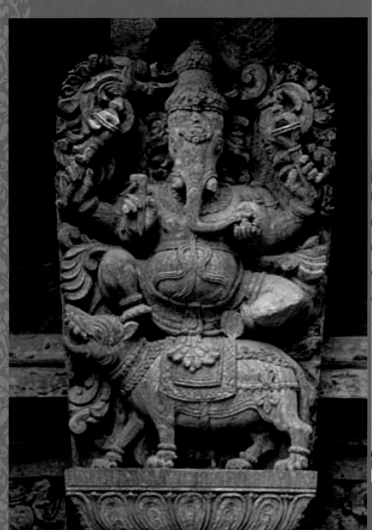
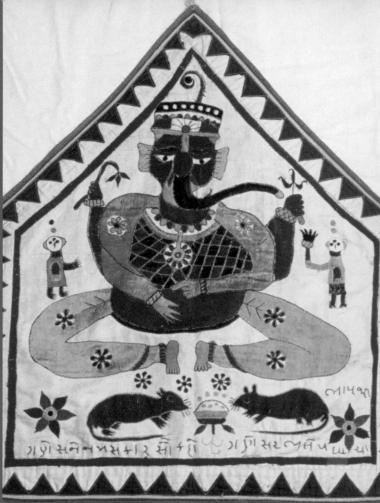

For instance, at a handicrafts fair in Chennai the world's first Techno Ganesha was unveiled with the boast, "Ganesha comes in many forms, but we bet you have never seen this one! This 28-inch-high bronze 'Computer Ganesha' is probably the first ever created. Elegantly crafted, He sits on a pedestal while typing 'best wishes' on His screen with one hand. With His left hand—he moves the mouse, which is not your ordinary computer rodent, but mushika, or Ganesha's mouse... price $2,900."

Appropriately, Techno Ganesha was launched in the year 2000, a sign of things to come. The Lord of New Beginnings has become a new icon for a new millennium when India threatens to achieve super power status through her rapid progress in electronic communication and information systems. If Indians do indeed achieve a gigantic leap forward they will be riding, as Techno Ganesha claims, not on some ordinary rodent but astride Ganesha's mouse.

Above left: Lord Ganesha carved in wood, 17th century, Sree Meenakshi Temple, Madurai, Tamilnadu; *above right:* Lord Ganesha, wall hanging; *opposite:* Lord Ganesha, Chidambaram

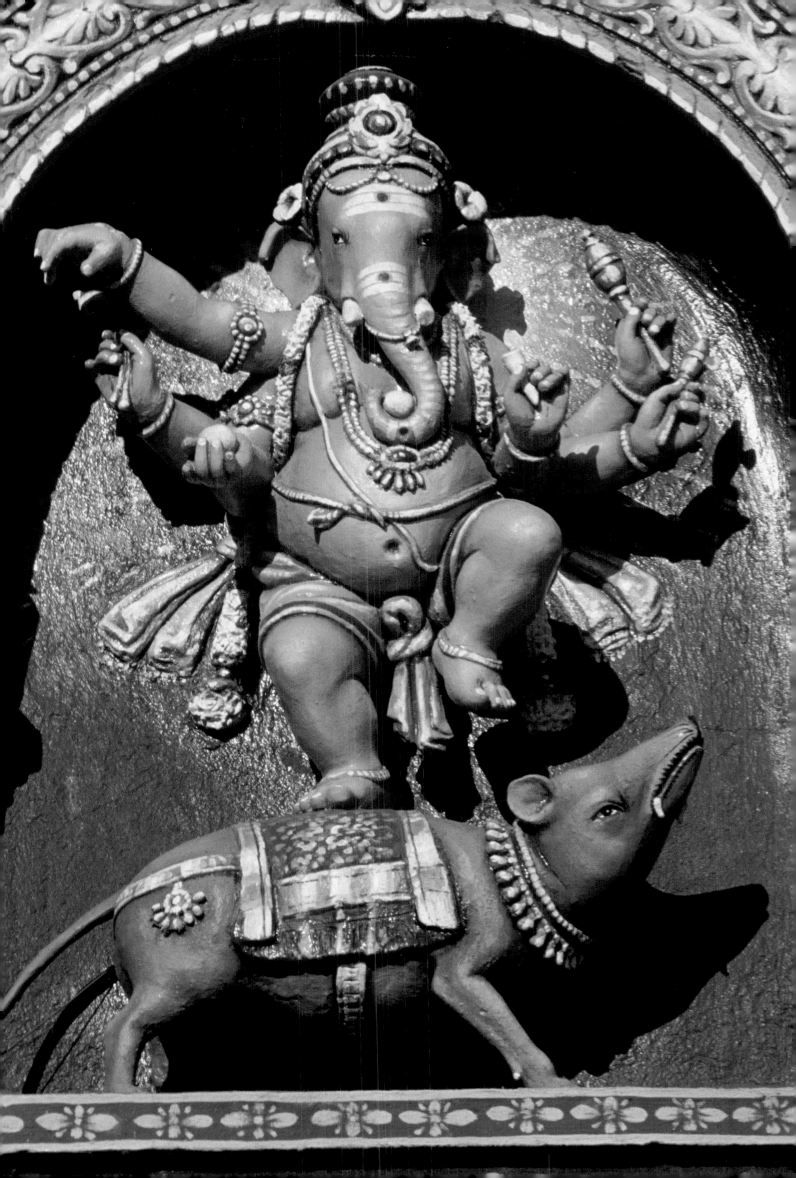

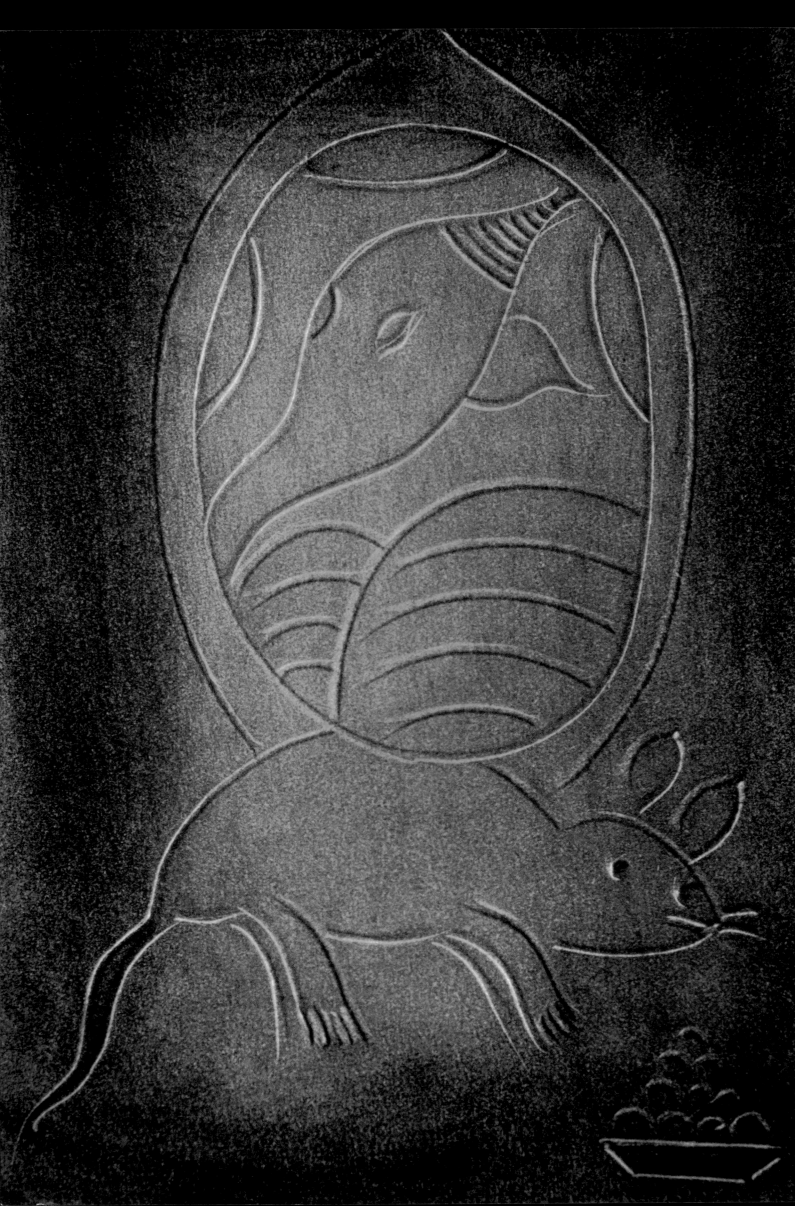

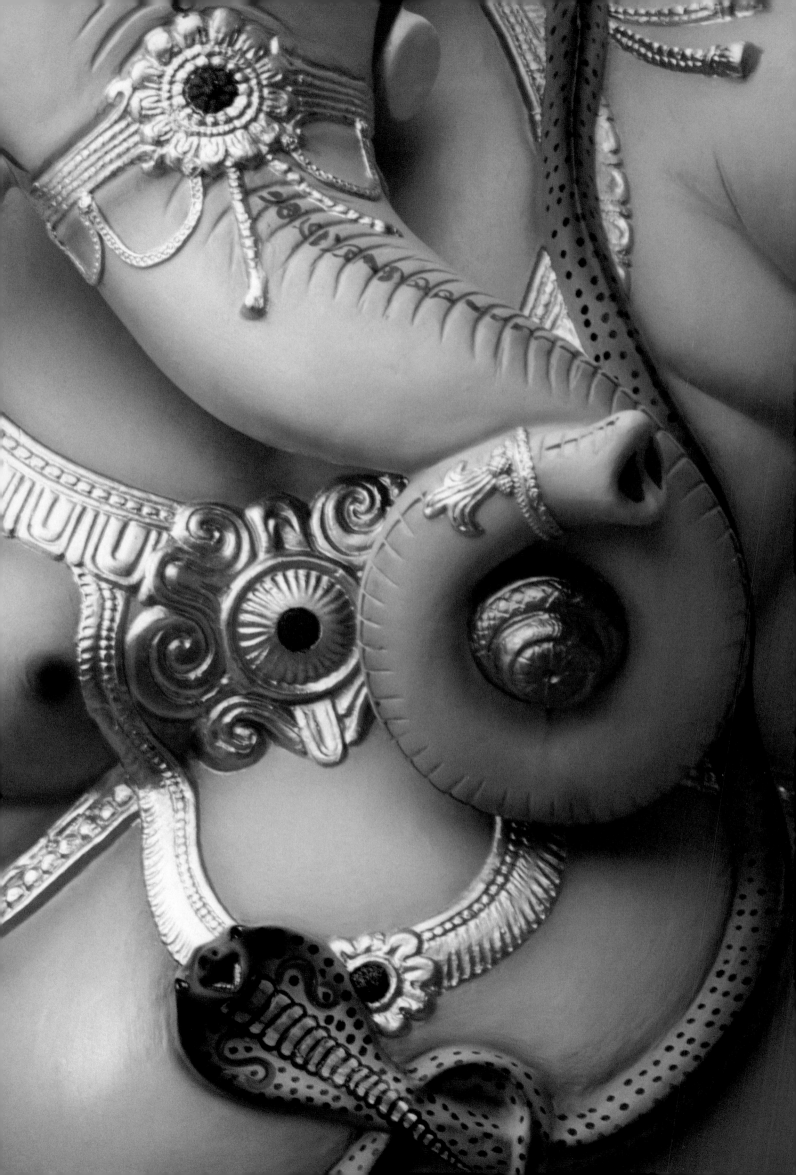

Ganesha's Serpent

If Ganesha's mouse connects Indians to the virtual world, the serpent binding Ganesha's belly offers entrance to an even greater world, the vast energy field of the universe accessed through Kundalini Shakti, the power of the Kundalini.

Kundalini means coiling and Ganesha's serpent represents the coiled and latent psychic energy within each individual that seeks union with undifferentiated universal energy. To activate this inner energy every illusion of individual separateness must be dissolved through arduous mental and physical disciplines. Only then can pure energy, pure consciousness be experienced.

When the Kundalini is dormant, an individual's psychic energy lies coiled at the base of the spine, the central axis of the human body. Thus, Kundalini has been called the serpent power. As Carl Jung observed, "In India the serpent is at the basis of a whole philosophical system...the Kundalini serpent...known only to a few specialists."

Awakening the serpent is the supreme goal of those who practise Kundalini Yoga. Their teachers devised the techniques necessary to release the force described in their ancient text, the *Yoga Kundalini Upanishad* as:

> The divine power,
> Resting half asleep
> Like a snake coiled round upon herself
> At the base of the body.

Opposite: Ganesha's serpent, Ganesha Festival, Mumbai, Maharashtra

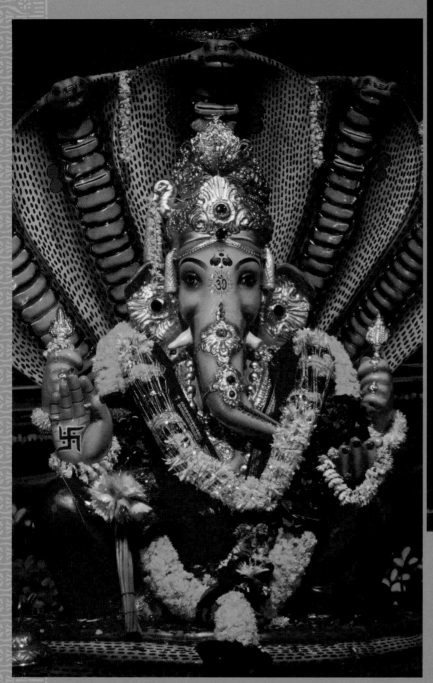

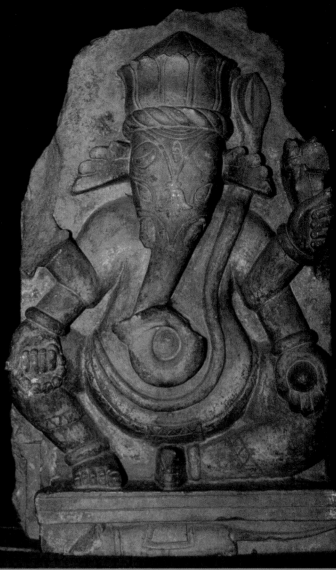

For centuries in the monasteries of India and Tibet, teachers of Tantra and Kundalini Yoga practiced the rigorous meditations and yoga controls required to activate a dormant Kundalini. They kept their knowledge secret for fear it could be abused, believing Kundalini energy granted its adepts supernatural powers able to transcend the natural laws of time and space. They also feared great damage could be done to those inadequately initiated in withstanding Kundalini's force, warning that great practice and preparation are necessary before the Kundalini can be successfully roused, and that physical strength, breath controls, and meditatioal

Above left: Lord Ganesha Sitting on Kaliya Nag (snake), Mumbai, Maharashtra; *above right:* Lord Ganesha, Orchha, Madhya Pradesh; *opposite:* Lord Ganesha, miniature painting on paper; *overleaf:* Ganesha Festival Immersion, Mumbai, Maharashtra

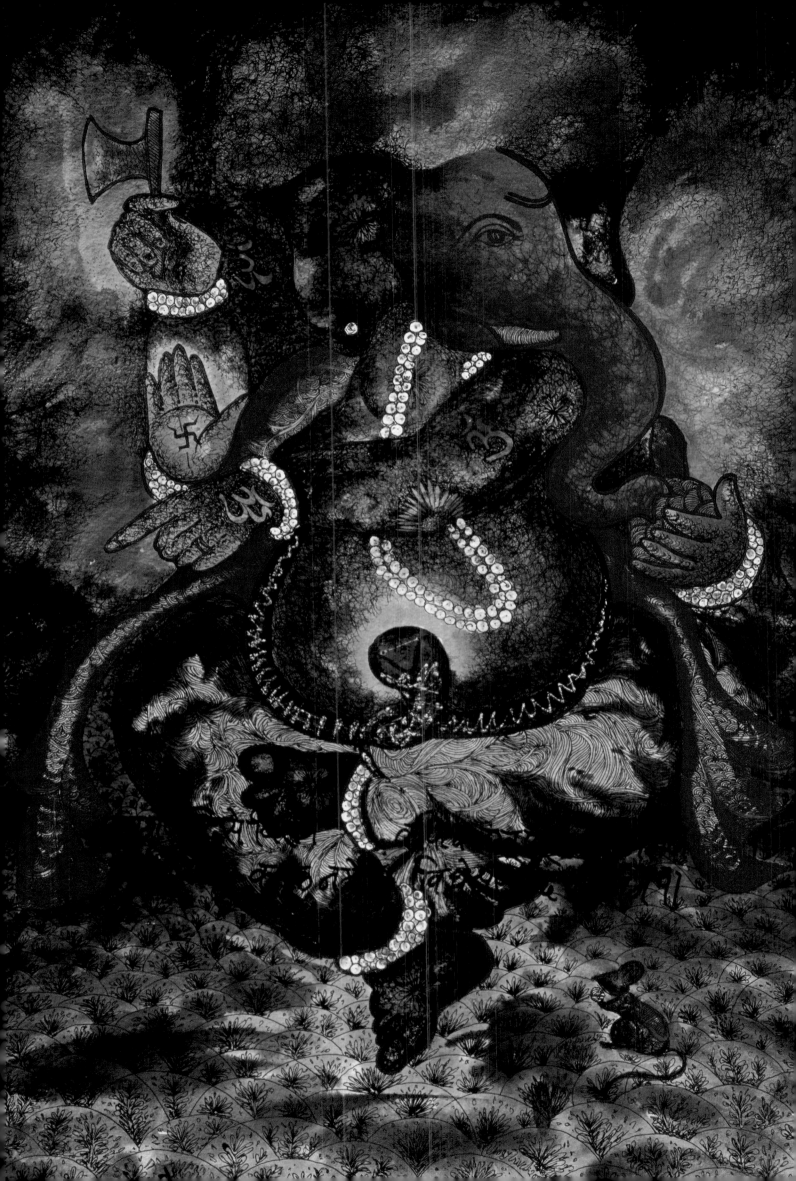

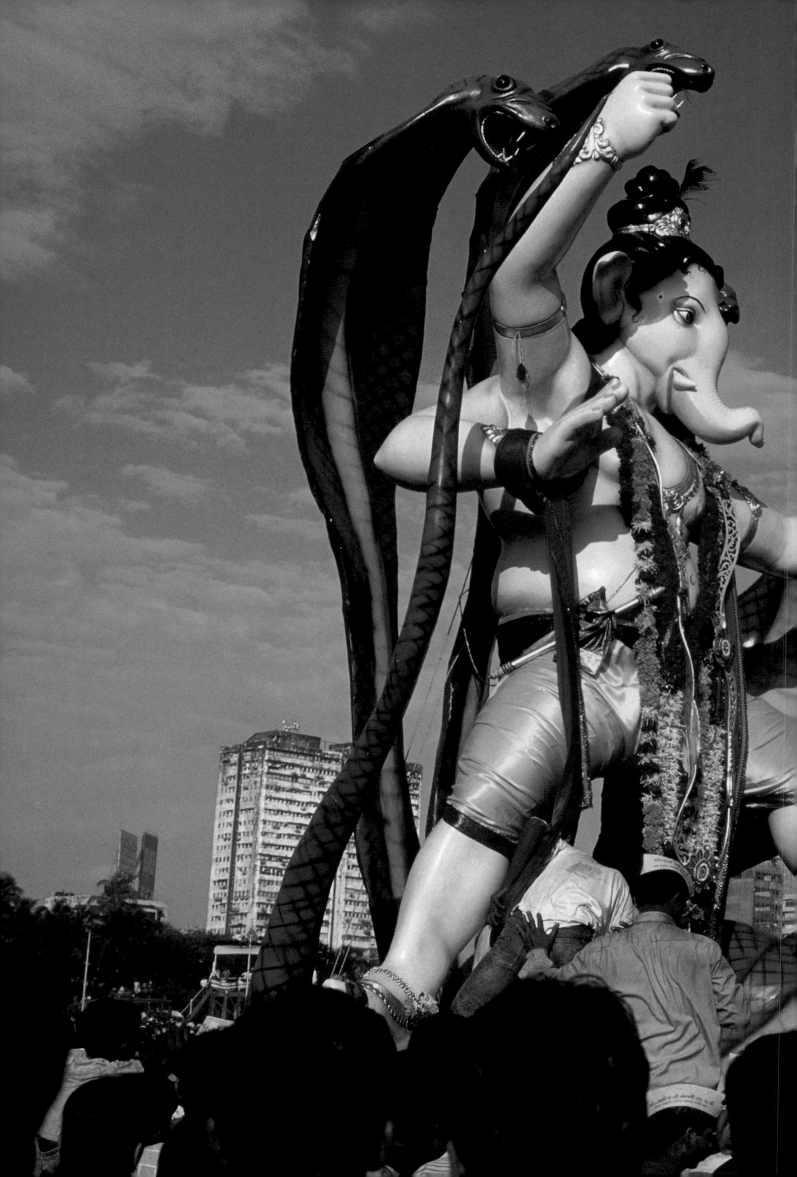

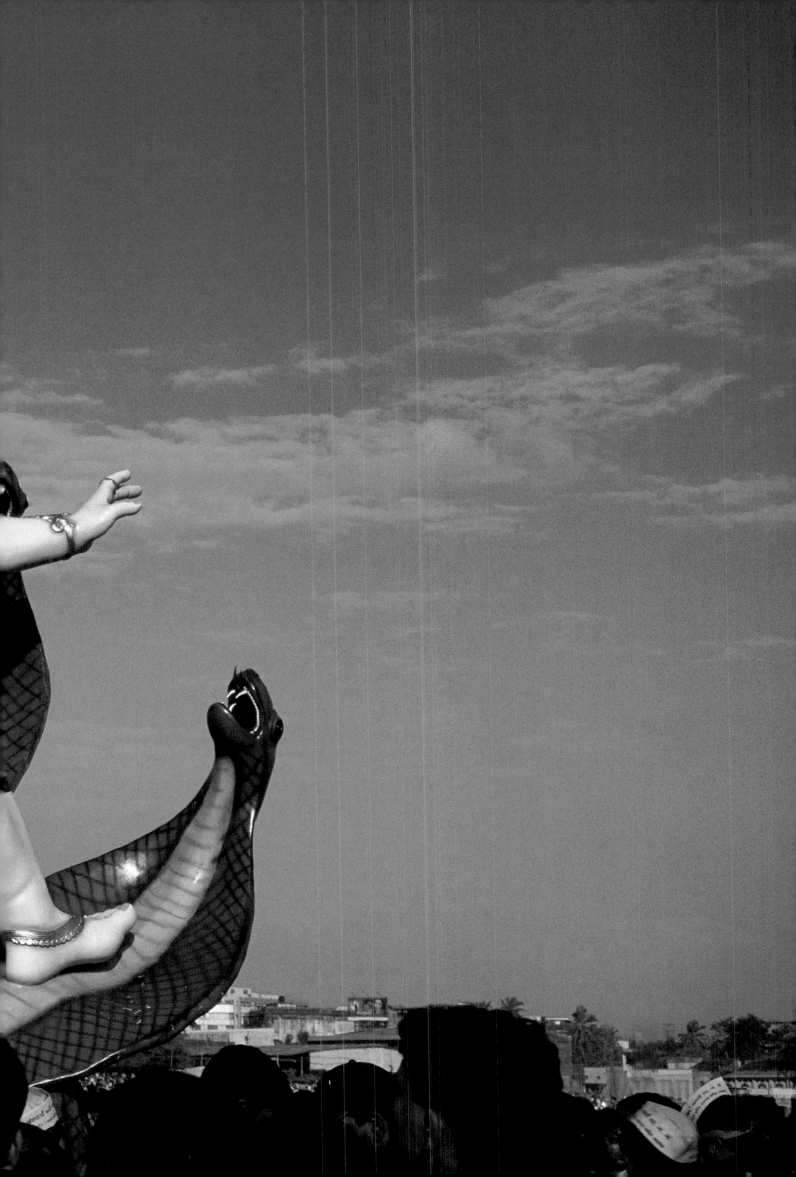

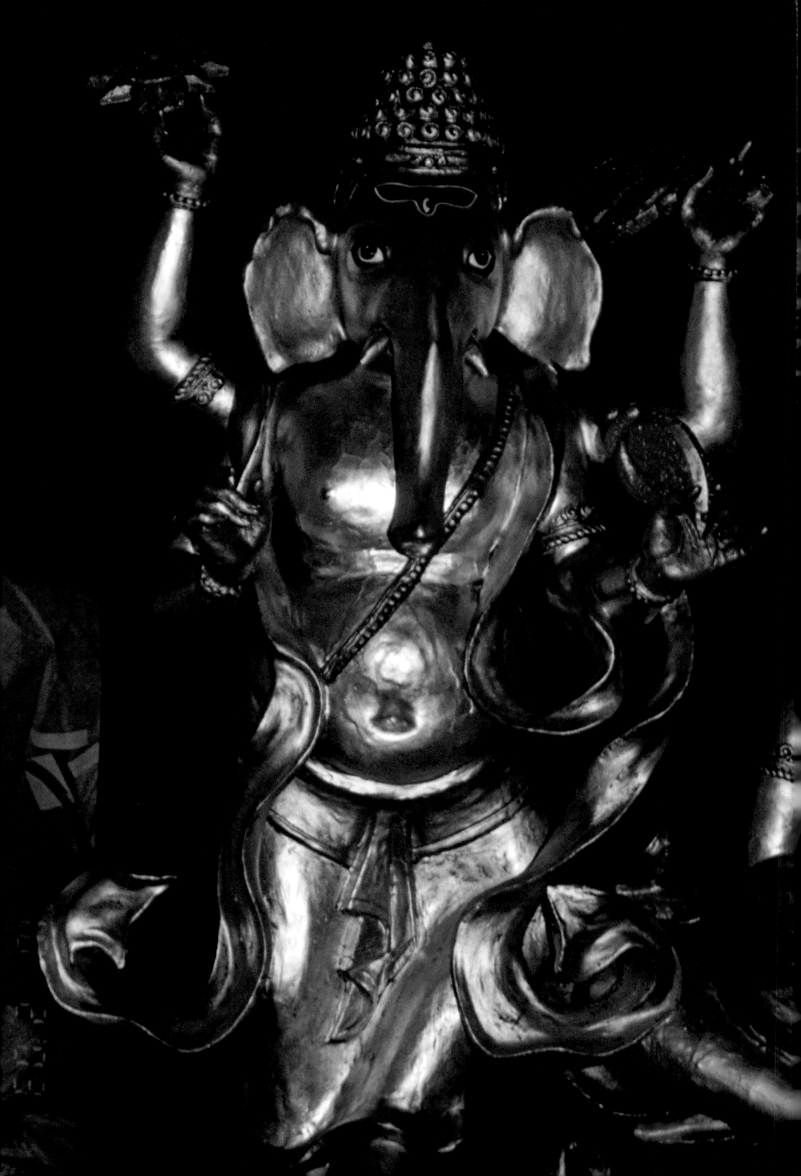

command are all required to enable the human physique and mind to contain the surging impact of its uncoiled power.

Yoga texts identify seven chakras or centers of energy in the human body, rising from the sacrum, the base of the body, to the skull. The famous lotus position of Yoga, cross-legged and seated on the ground, is the primary position of meditation because in this position the spine is closest to the earth, grounding energy in physical reality. This first energy center at the base of the spine is the Muladhara Chakra meaning the root chakra, and its power is controlled by Ganesha.

Only when the first chakra is activated will the serpentine energy of Kundalini uncoil from the base of the body and begin its ascent. Once the power of Kundalini energy is awakened it spirals upwards through the spine, activating each energy center until it explodes into the core of the pineal gland which Tantric mystics call the Third Eye.

The Third Eye releases the concentrated column of energy through the crown of the skull, an experience described by Yoga and Tantra practitioners as feeling the self dissolve into a thousand-petalled lotus of light In this state individual consciousness merges with universal consciousness where the *Yoga Kundalini* says, "all illusions of separateness dissolve and That alone remains which is soundless, formless, and deathless, which has neither beginning nor end, which is without decay."

As the presiding deity of the Muladhara Chakra, the seat and foundation of Kundalini power and the resting place of the coiled serpent, Ganesha is invoked as the prime force able to awake the Kundalini. Without Ganesha's blessing the serpent power cannot be roused.

Those with pure intentions who succeed in awakening the Kundalini in our own times are considered twice blessed by Ganesha. They have managed to gain enlightenment in Kalyug, defined by Indian philosophy as the Age of Evil.

Alas, for the human race, we are now living in Kalyug, in the Age of Evil.

Opposite: Lord Ganesha, West Bengal; *overleaf:* Ganesha Festival Immersion, Mumbai, Maharashtra

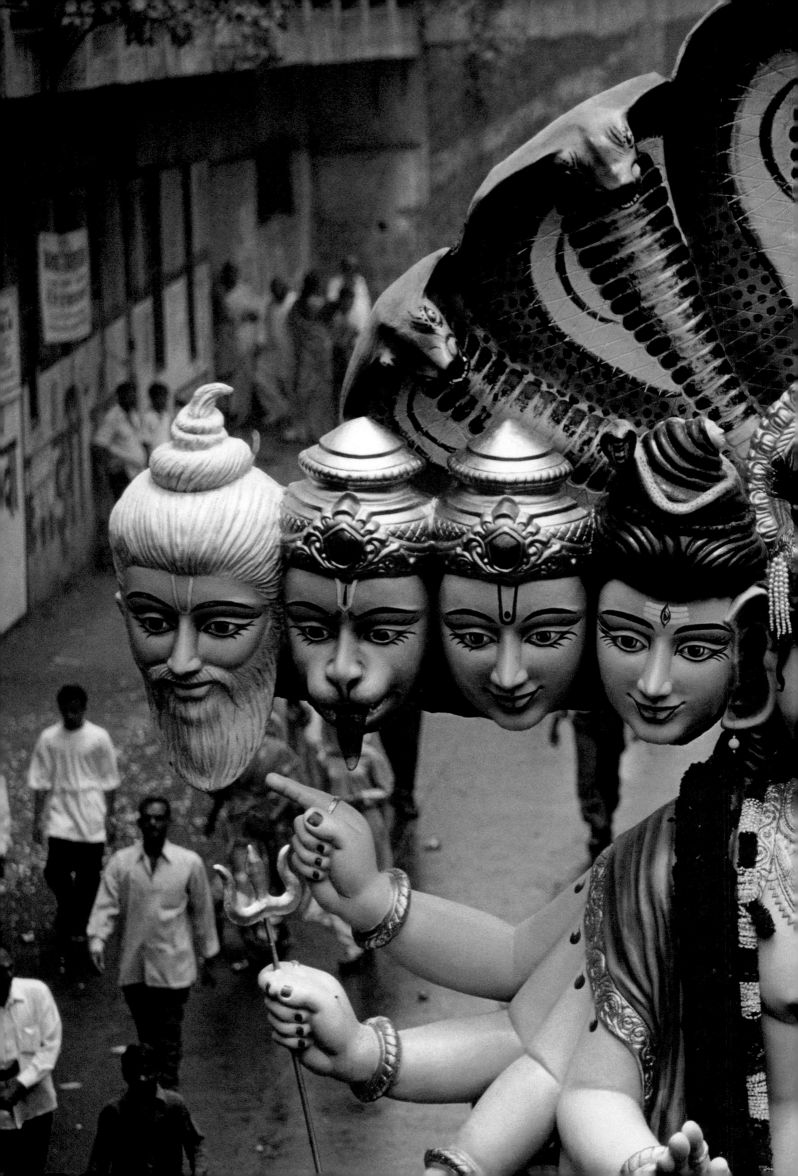

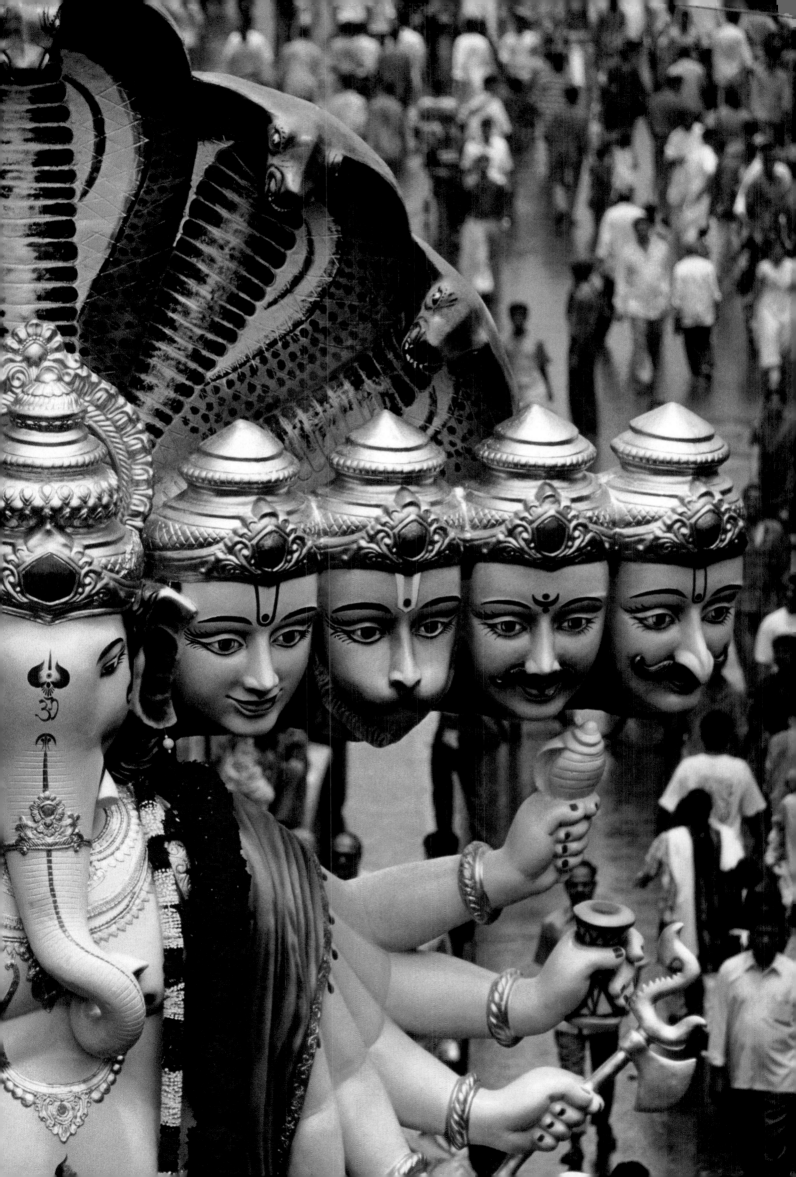

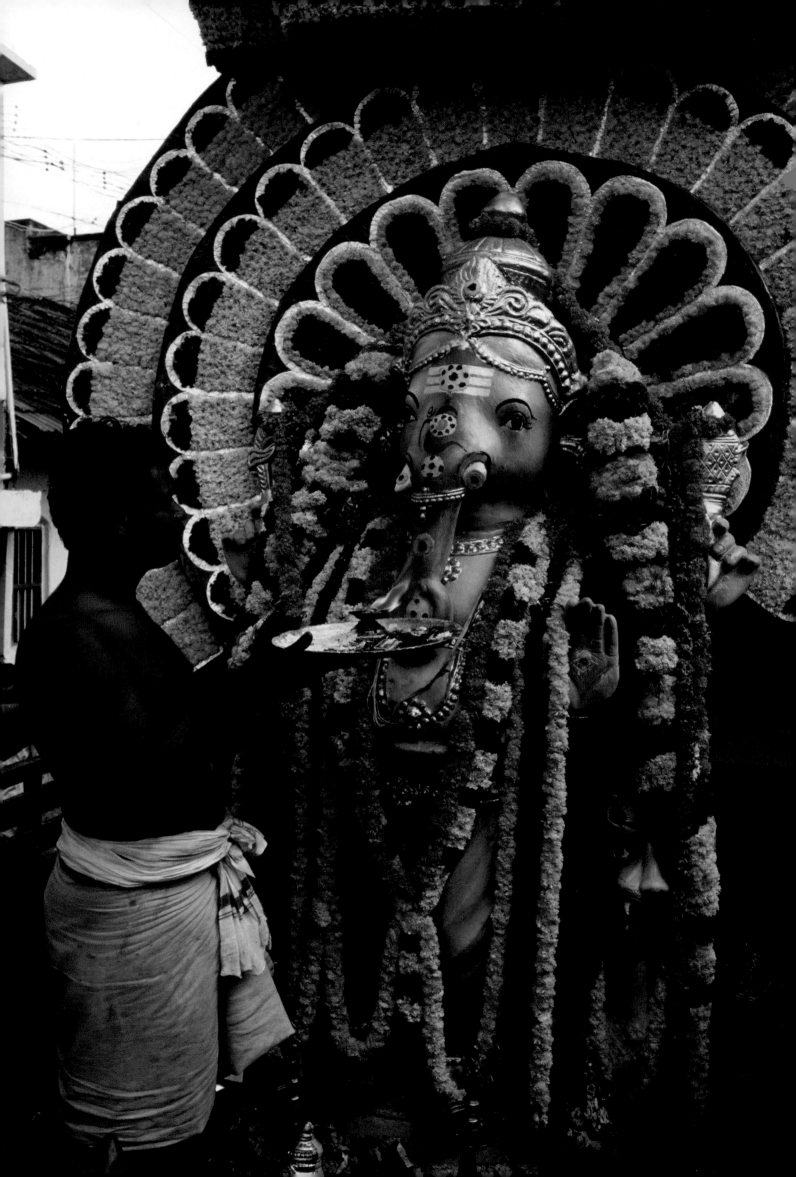

Ganesha's Miracle

Enlightenment is not easily come by in the Age of Evil. The world is thought to have reached such a nadir of wickedness, many Hindus believe the time is ripe for Ganesha to reappear. Some Hindus are even convinced Ganesha has already returned to cleanse the world of evil. They say Ganesha reached earth in 1995.

Skeptics may smile at such naive faith, but on September 21, 1995, the British newspaper, the *Manchester Guardian*, reported an extraordinary occurrence:

"*It all began at dawn in a temple on the outskirts of Delhi, India, when milk offered to a statue of Ganesh just disappeared into thin air. Word spread so quickly throughout India that soon thousands were offering milk to the gods and watching in amazement as it disappeared. Life in India was brought to a virtual standstill as people rushed to temples.... At one of Delhi's largest temples, the Birla Mandir, Pandit Sunderlal was just coming on duty at 5:30 A.M. when he got a call telling him of the miracle in the suburbs. 'I went and took a spoon of milk and put it to Ganesh's mouth. He drank it and it became empty. Then I gave Shiva a drink too.'*

"*Traffic in Delhi was halted as police struggled to control crowds who gathered outside hundreds of temples with jugs and saucepans of milk for the marble statues of Ganesh.... Across Delhi, society ladies with silver jugs and tumblers full of milk were standing alongside uneducated laboring women in mile-long queues, awaiting their turn. At one Delhi temple a priest said more than 5,000 people had visited his temple: 'We are having a hard time managing the crowds.'*

Opposite: Ganesha Festival

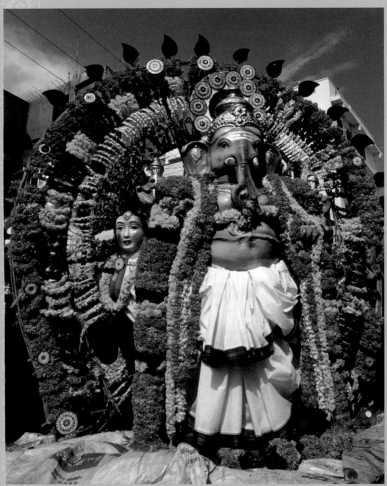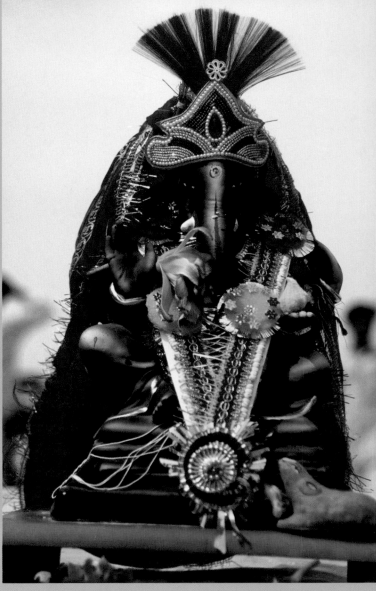

"A Delhi housewife who had waited two hours to feed the white marble statue of Ganesh said: 'The evil world is coming to an end and maybe the Gods are here to help us.'"

As eyewitnesses throughout the country reported accounts of Hindu statues drinking milk, the Indian stock market and then the federal government closed down. People were deserting their desks to feed their idols. Milk was in short supply. The Indian Rationalist Society heaped scorn on the general gullibility accusing Indians of lacking scientific temperaments, warning India would remain a backward nation if superstitious Indians persisted in such foolishness. Their warnings were ignored as even cynics joined the queues.

"'It's unbelievable. My friends told me about it and I just thought it was rubbish,' said a Delhi businesswoman, Mabati Kasori. 'But then I did it myself. I swear that the spoon was drained.'

Above left: Ganesha Festival; *above right:* Ganesha Festival Immersion, Mumbai, Maharashtra; *opposite:* Ganesha Festival, Mumbai, Maharashtra; *overleaf:* Making an offering to Lord Ganesha, Meenakshi Temple, Madurai

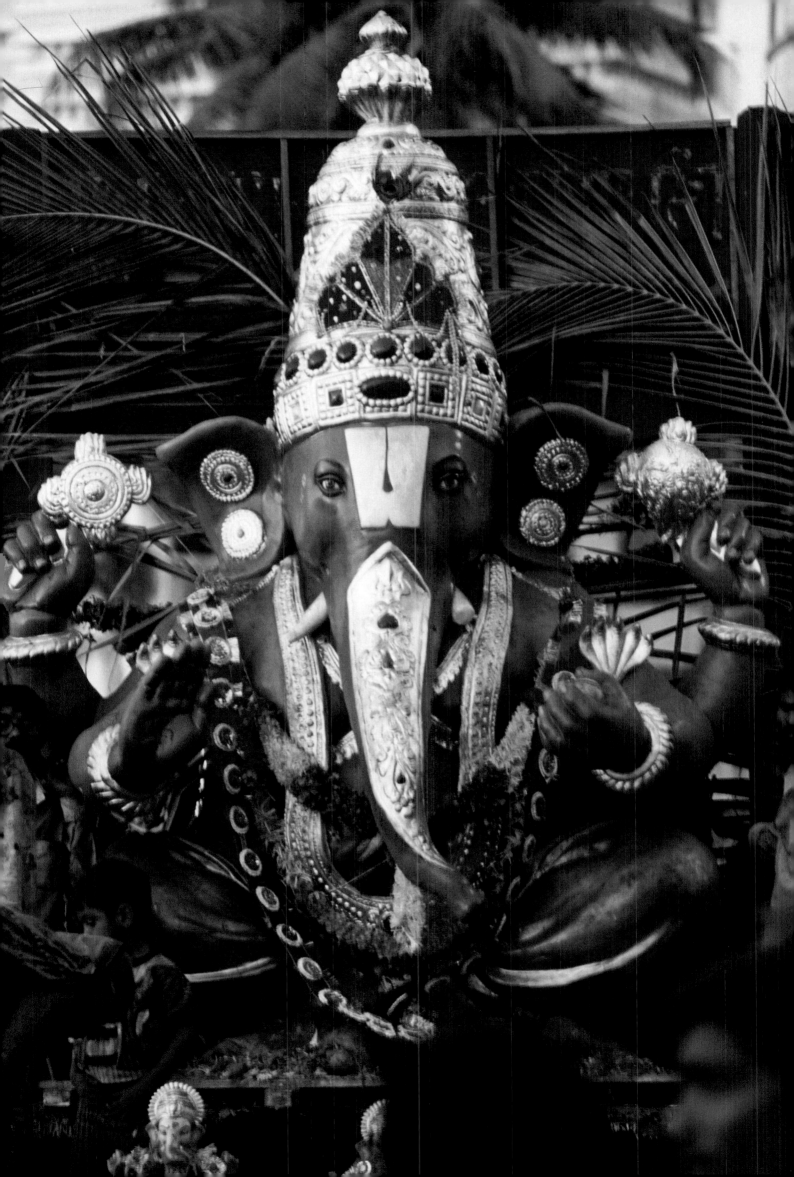

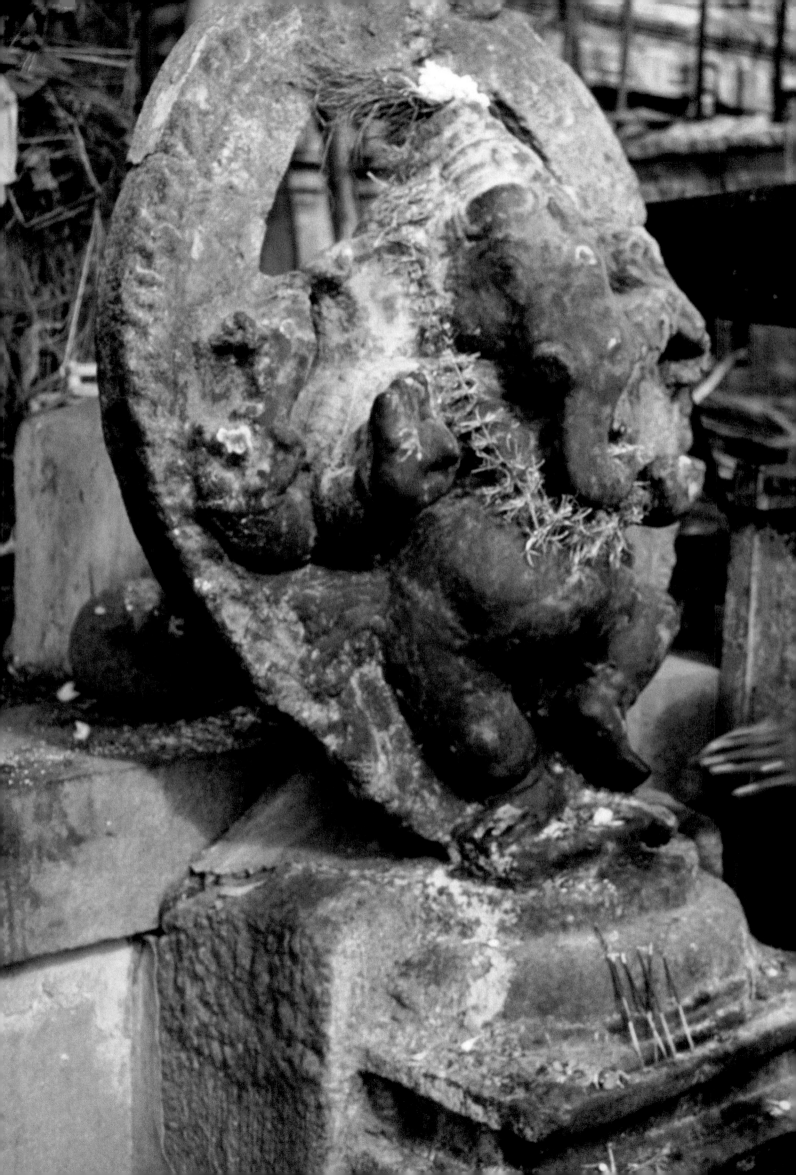

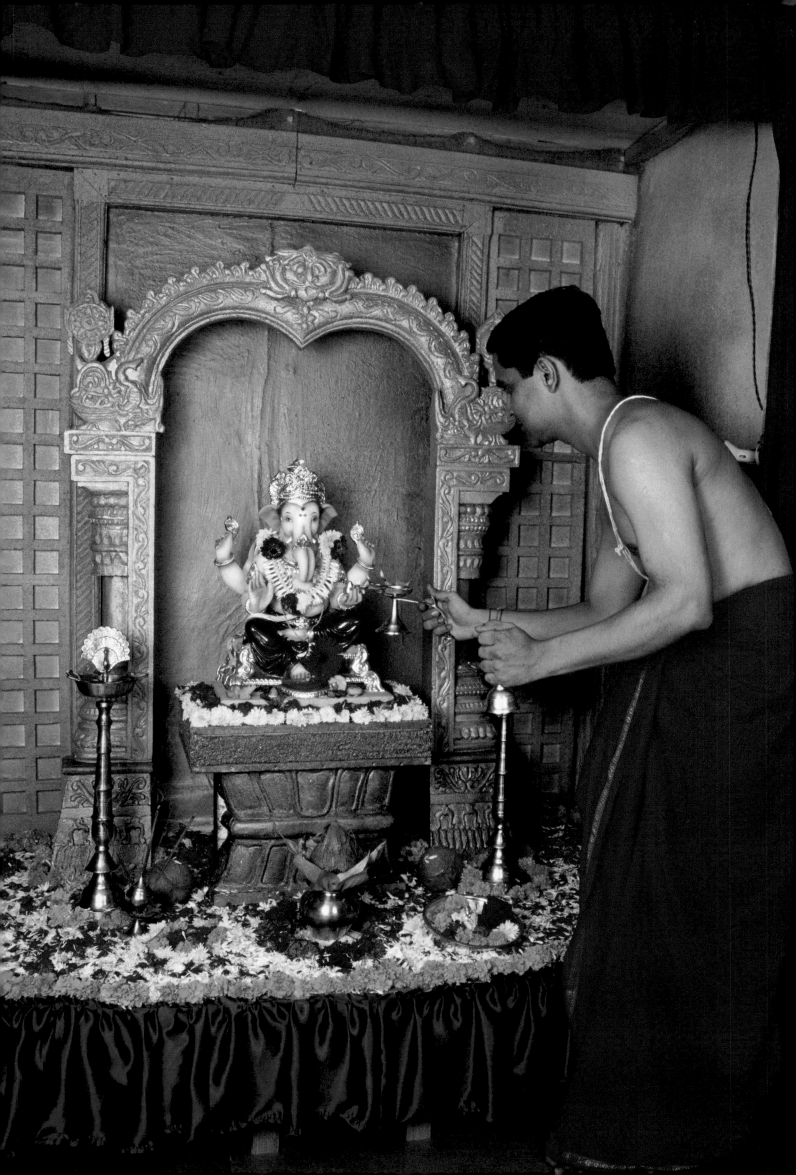

"Parmeesh Soti, a company executive, was convinced it was a miracle. 'It cannot be a hoax. Where would all that milk go to? It just disappeared in front of my eyes.'"

To the horror of the Indian Rationalist Society, within seventy-two hours the international press began reporting an even more astounding development. The miracle had jumped national boundaries. Now Hindu idols around the world were consuming milk by the gallon. Television crews mobbed temples to record the phenomenon. Skeptical newspaper reporters joined the faithful in raising spoons of milk to the lips of the gods—only to watch, humbled, as the milk disappeared. Scientific explanations fell on deaf ears as reports of further miracles poured in from different countries. In Hong Kong more than 800 people converged on the Hindu temple in Happy Valley where priests claimed a small silver statue of Ganesha had "already drunk 20 liters of milk."

In the United Kingdom, idols were even drinking milk in family shrines. At the Southall home of Asha Ruparelia, a clay statue of Ganesha consumed milk in her living room. She told reporters, "It has drunk 20 pints of milk since last night. Nearly 600 people have come round to see it." Rikee Verma, a reporter from the London *Times* newspaper, wrote: "I placed a spoonful of milk underneath the trunk and within seconds the spoon was empty."

Inspired by the news coverage, believers and non-believers alike flooded into Britain's temples to personally witness the miracle. Over the course of a single day at London's Vishwa Temple in Southall, ten thousand people saw idols drinking milk from cups and spoons. In Manchester, at the Geeta Bhavan Temple, crowds watched amazed as a three-inch silver Ganesh consumed pint after pint of milk.

A *Daily Express* journalist described the reaction of a photographer from a British tabloid newspaper standing right in front of the statue at a London temple. "He was convinced it was drinking the milk. He said he could see no mechanism to explain the phenomenon after scrutinizing it at length. He said, "As a lapsed Catholic I don't believe in stories of the Virgin Mary shedding

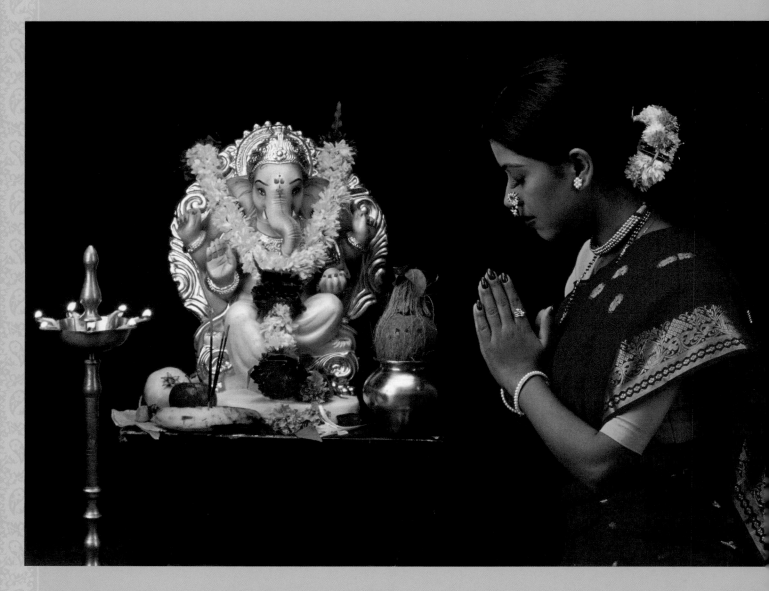

tears. Indeed, I would say I was as skeptical as anyone—but it's difficult to dismiss something you have seen for yourself."

The *Manchester Guardian* noted, *"The media coverage was extensive, and although scientists and 'experts' created theories of 'capillary absorption' and 'mass hysteria,' the overwhelming evidence and conclusion was that an unexplainable miracle had occurred… While the media and scientists still struggle to find an explanation for these events, many Hindus believe they are a sign that a great teacher has been born."*

Perhaps Rebecca Mae of the *Daily Express* best described the prevailing sentiment: "Most of the worshippers said they only went to the temple occasionally and were certainly not religious fanatics. But they were adamant that a new god had been born to save the world from evil."

Above: Lord Ganesha Puja; *opposite:* Lord Ganesha Idol, Ganapati Festival, Mumbai, Maharashtra; *overleaf:* Ganesha Puja

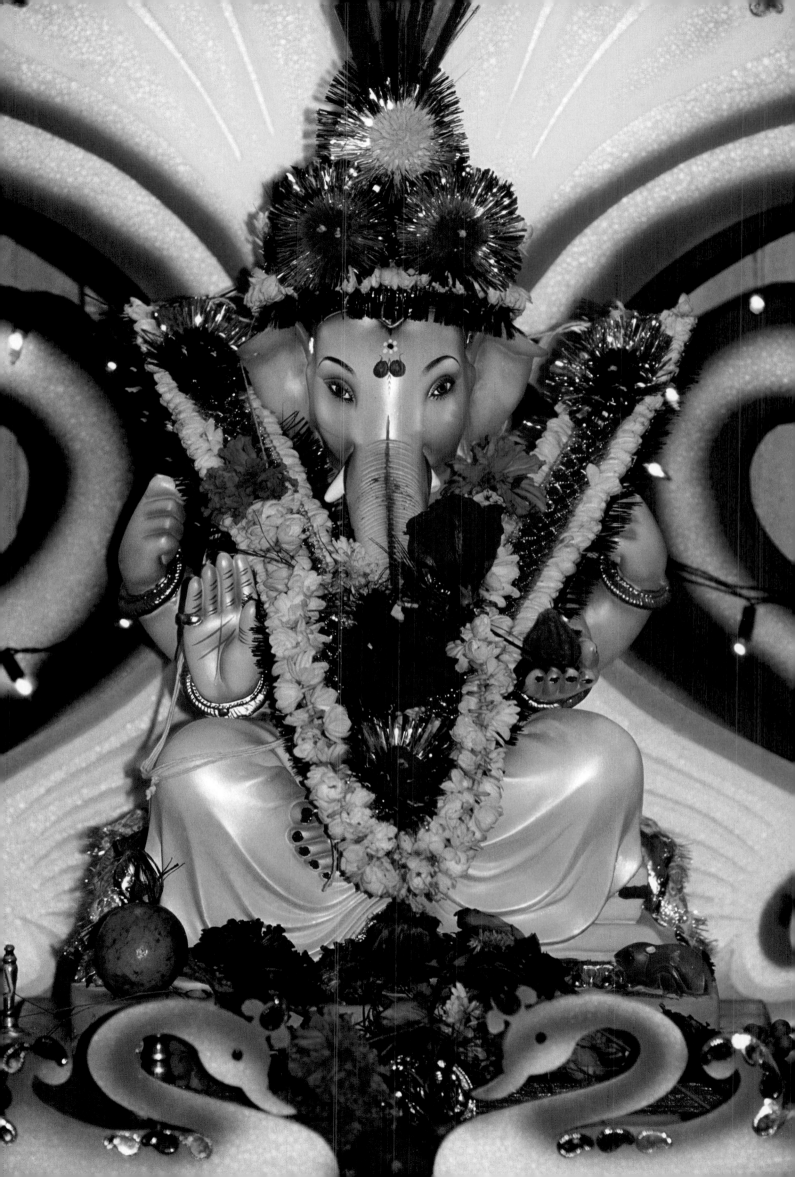

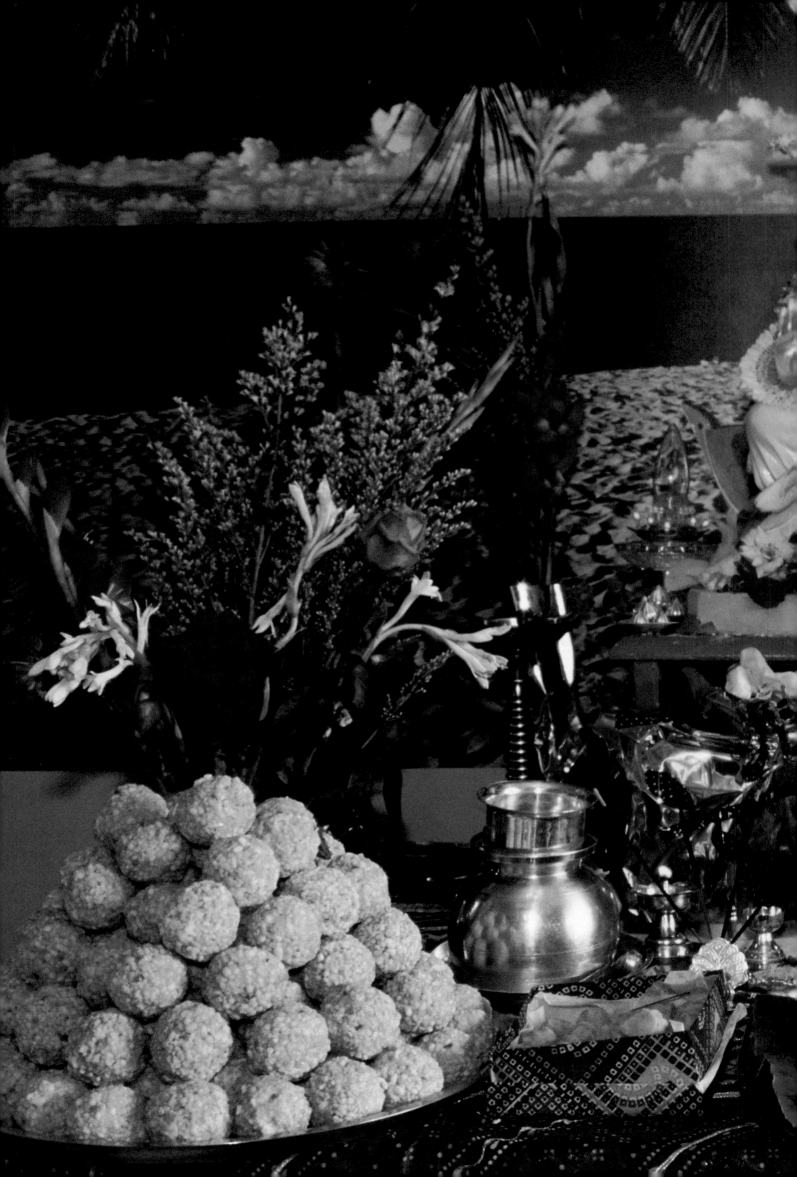

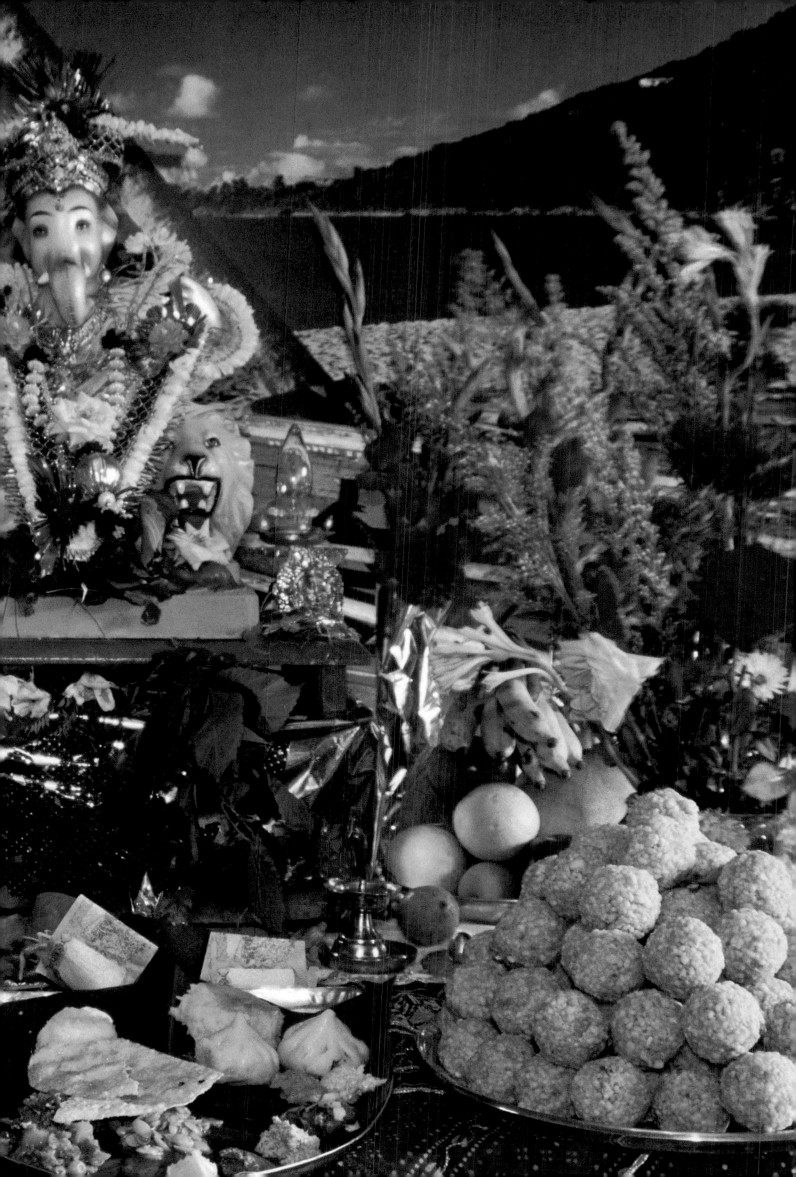

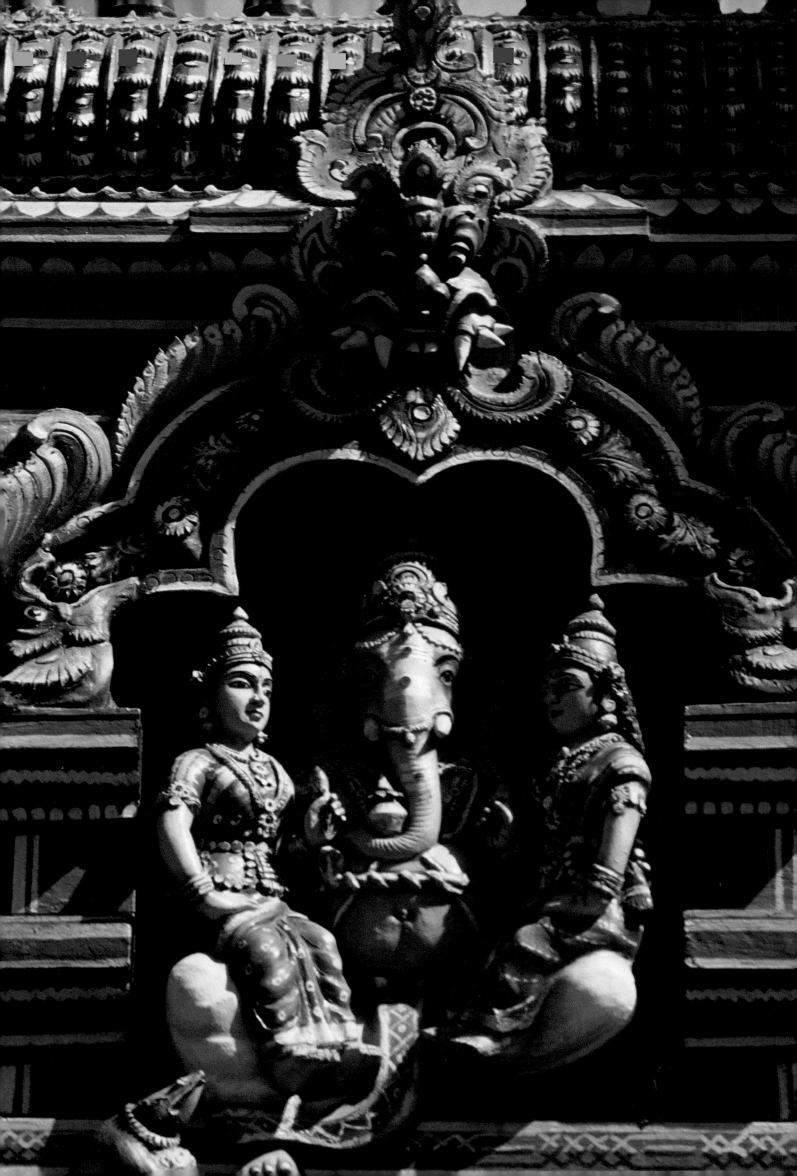

Ganesha's Revelation

There is little evidence to suggest the world has become less evil since September, 1995. Even less evidence exists to prove a reincarnated Ganesha walks among us. It would appear that Ganesha's followers must find new miracles. Or they could consult Ganesha's two wives for advice.

In some parts of India Ganesha is worshipped as a bachelor. In other parts he has two wives, Riddhi and Siddhi, Prudence and Discrimination. Instead of dismissing Indians as gullible fools for believing in idols drinking milk, perhaps the Indian Rationalist Society should have urged Indians to use a little Prudence and Discrimination when faced with paranormal disturbance.

At the very least, India's rationalists could have pleaded for more Prudence and Discrimination in controlling the vivid excesses of modern versions of Ganesha. Already miracles of kitsch, each successive Ganesha festival produces ever more bizarre Ganeshas, breaching new boundaries of bad taste in the bid to gain prosperity. Mr. Srinivas, the proprietor of Sri Vinayaka and Company that provides many idols of the elephant-headed god for southern India, says, "The festival has now become a commercial venture. There is great competition over the design of the Ganesha. We have to deliver fancy-looking models."

These "fancy-looking models" are no longer made of humble mud and vegetable colors which dissolve harmlessly when immersed into rivers or lakes. They are made of plaster of Paris and painted with industrial colorants, sporting nylon eyelashes

Opposite: Lord Ganesha with his wives Riddhi and Sidhhi

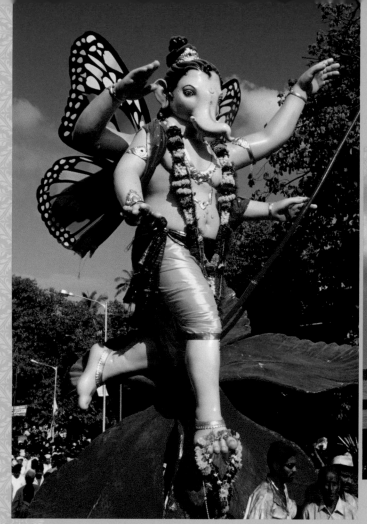

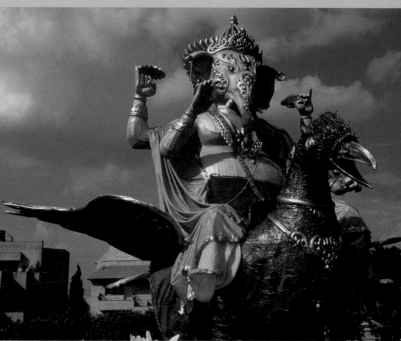

and elephant trunks coated in enamel, and ears which flap open to reveal shocking chemical pinks. They wear ornate plastic crowns studded with brightly colored glass to resemble gems. Wire serpents circle their bodies, weaving between papier maché peacocks fanning feathers of day-glo hues. Ganesha's wives, poor Prudence and Discrimination whom some devotees call Wealth and Power, are clad in inflammable saris and weighted down with garish metal jewelry, their features sculpted to resemble film stars or beauty queens.

Even this display is not considered sufficiently lavish to extract goodwill from the Remover of Obstacles. Contemporary Ganeshas also require retinues as proof of contemporary piety, so festival floats must now be crowded with figures, enclosing Ganesha and his wives in a claustrophobia of devotion. Such modern demands put intolerable pressure on idol makers like Sri Vinayaka and Company. As the divine images and their expanding entourages multiply Mr. Srinivas has to wrestle with problems of space and storage, exacerbated by growing export orders. "Even

Above left and right: Ganesha Festival Immersion, Mumbai, Maharashtra; *opposite:* Fabricating a Ganesha idol for the festival; *overleaf:* Illumination of Lord Ganesha, Deccan Gymkhana, Pune, Maharashtra

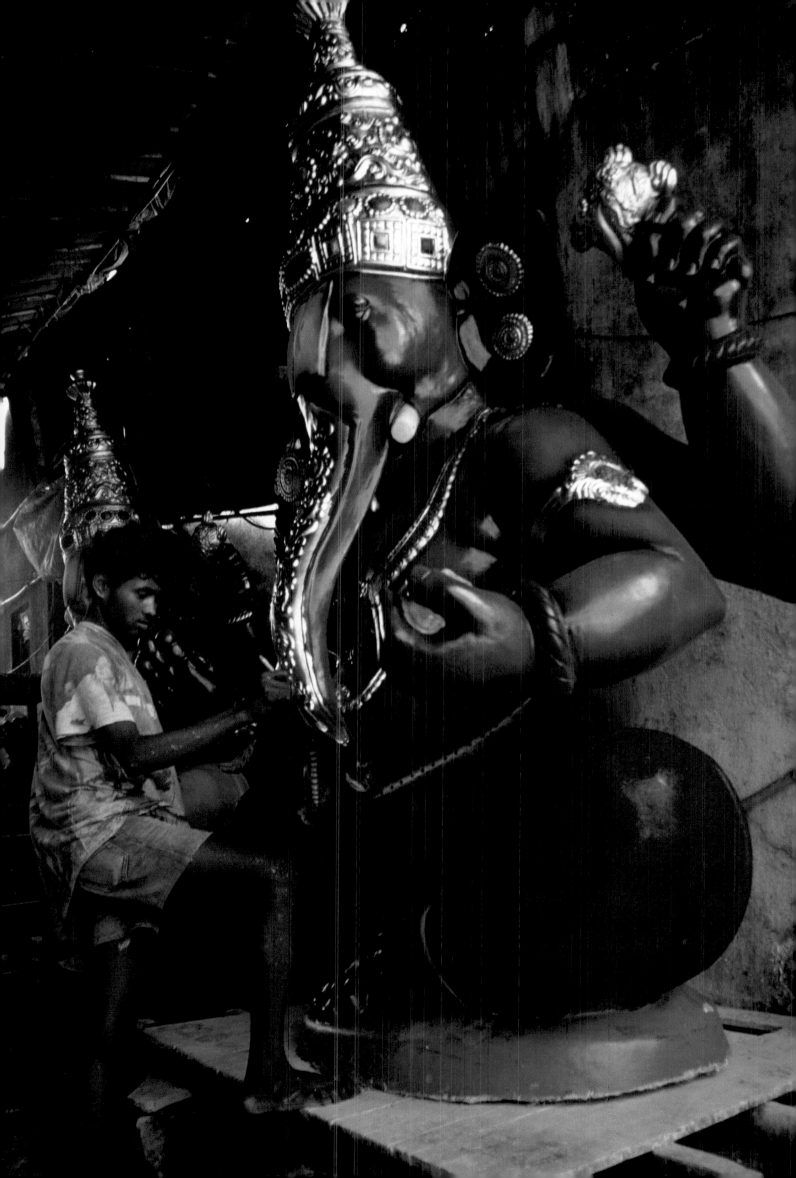

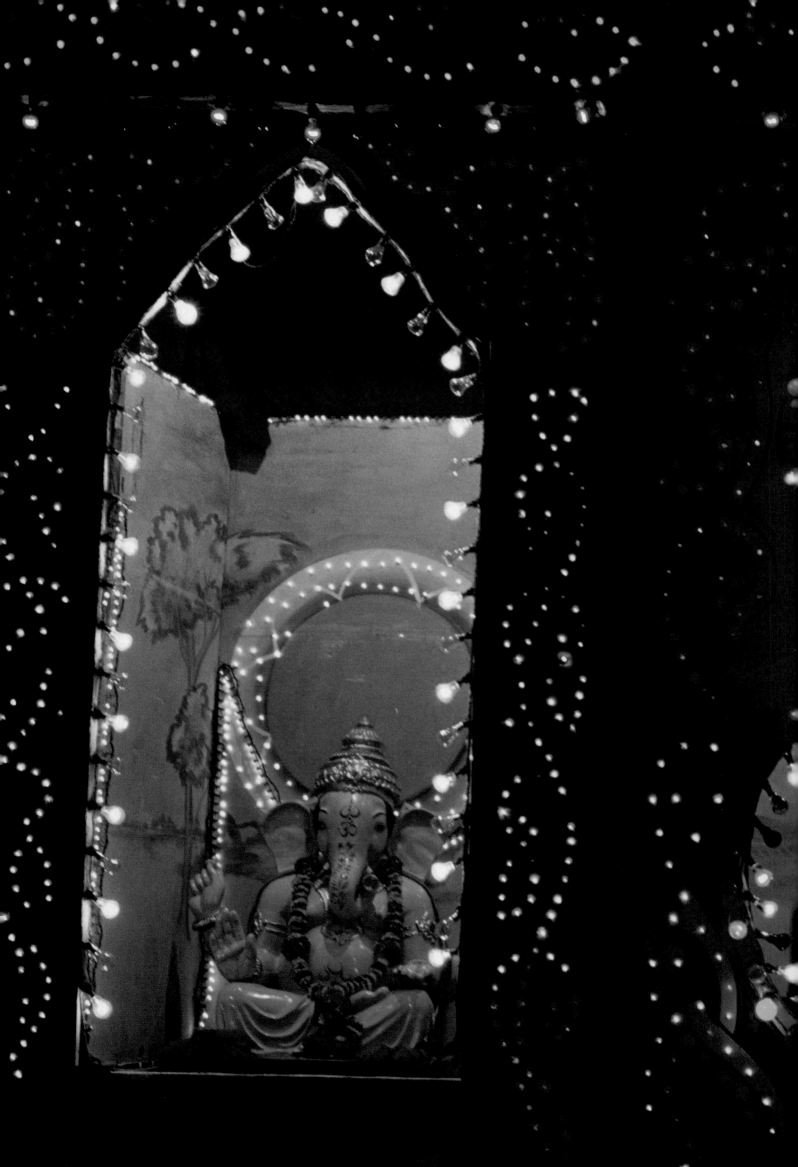

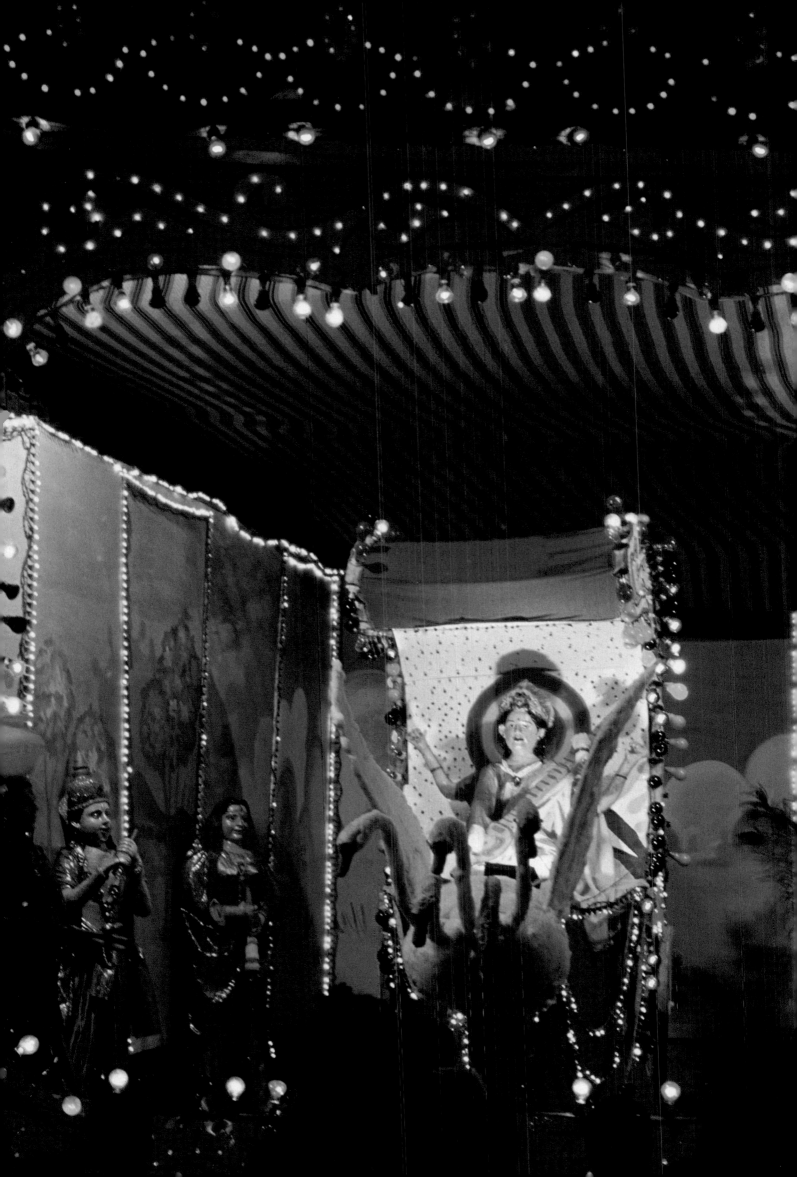

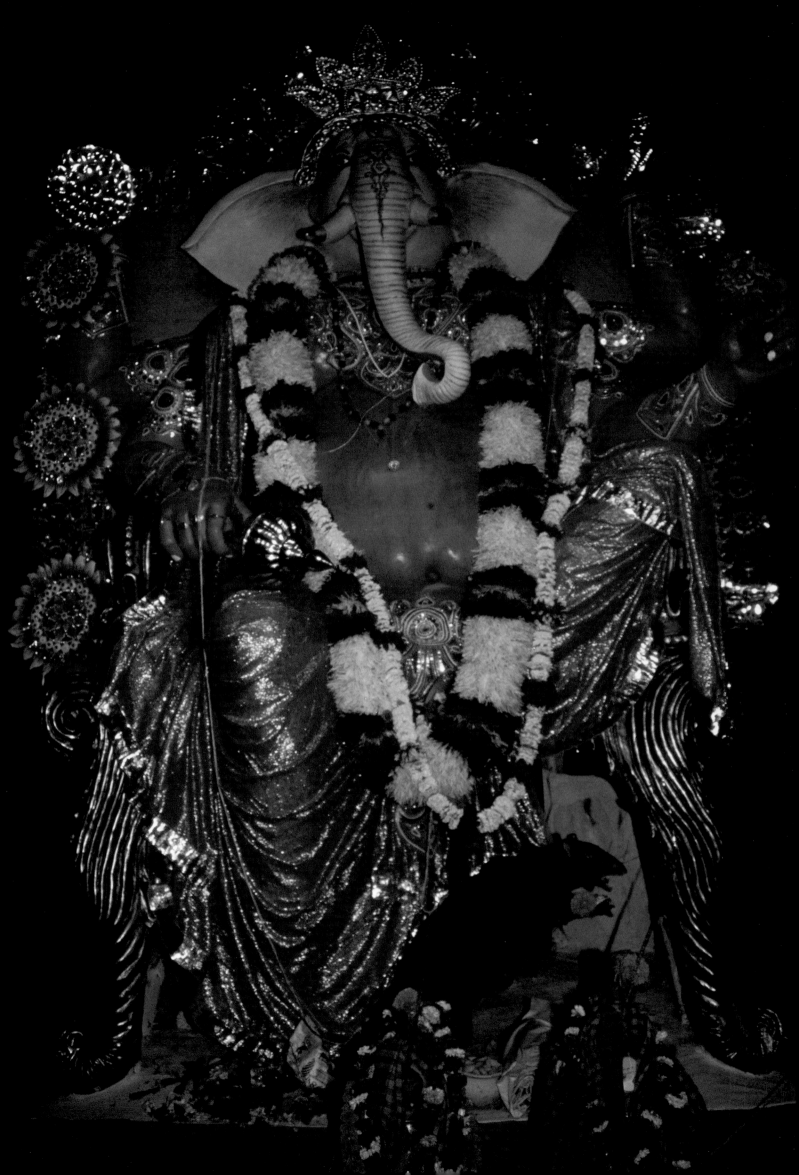

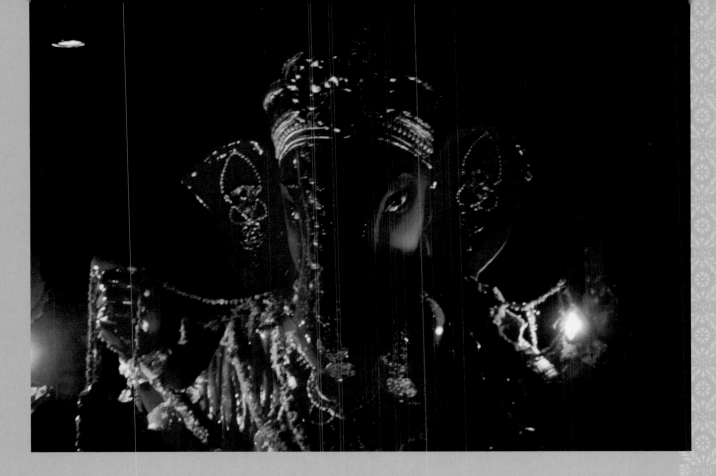

abroad, the demand for Ganeshas has gone up," Mr. Srinivas notes mournfully. "People would buy one or two earlier. Now we send these in bulk to countries as far as Australia by steamer."

Alas, poor Mr. Srinivas. His work does not end with producing bulk orders of "fancy-looking" Ganeshas. These days he is asked to produce "theme Ganeshas." Sport is a popular theme. If the country is in the grip of cricket fever, Ganesha is shown with a cricket bat in his hand. When the World Cup is played, he swings his trunk over his shoulder and lobs a football towards a Brazilian football star. The Olympics finds him in a track suit, a javelin in his hand. Sycophancy is another favorite theme, enabling worshippers to curry temporal as well as divine favor. So, plump limbs clad in homespun pajamas, a cloth Gandhi cap between his ears, Ganesha blesses easily identifiable politicians. Or, wearing a tie with a Windsor knot under his elephant trunk, he gives benediction to the well-known Indian tycoons kneeling at his feet, their eyes level with his mouse.

On Ganesha Chaturthi, under a full moon, the monstrous tableaux are immersed in the nearest bodies of water—seas, rivers, lakes, streams—accompanied by mounds of coconuts and pyramids of flowers and plastic bags filled with plastic offerings.

Opposite: Lord Ganesha; *above:* Ganpati; *overleaf:* Ganesha Festival Immersion, Mumbai, Maharashtra

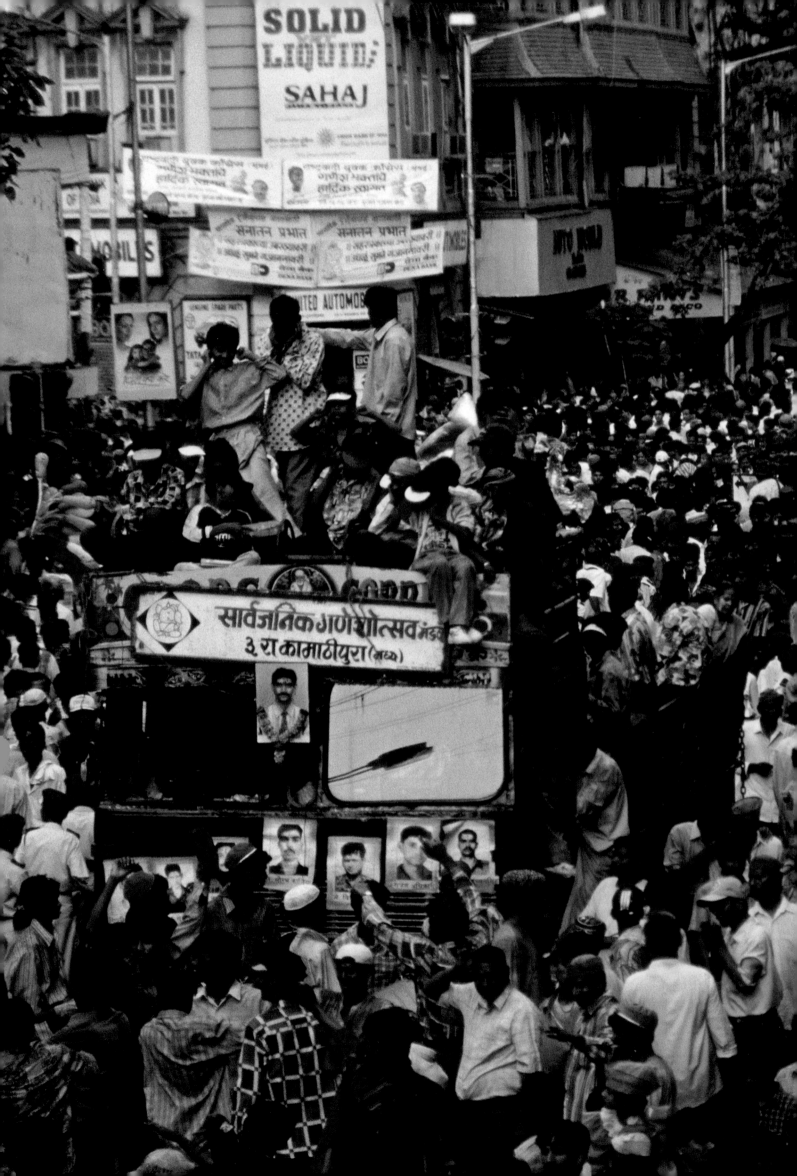

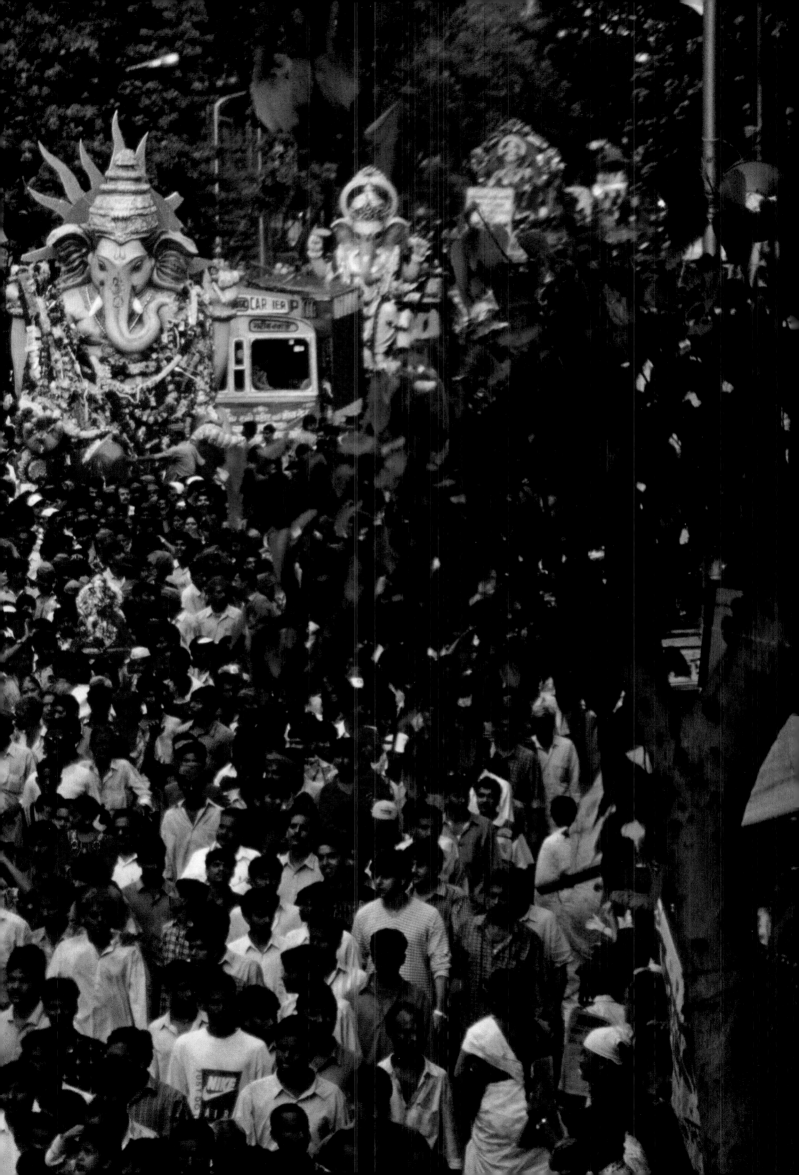

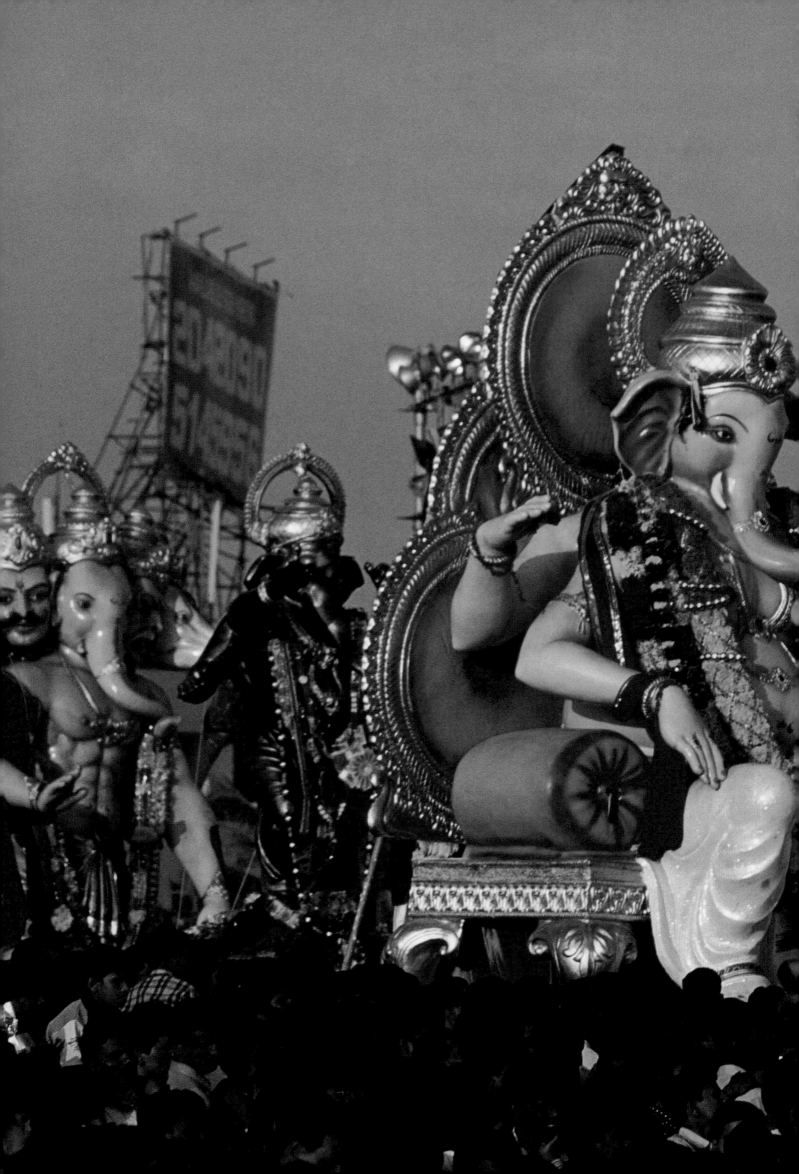

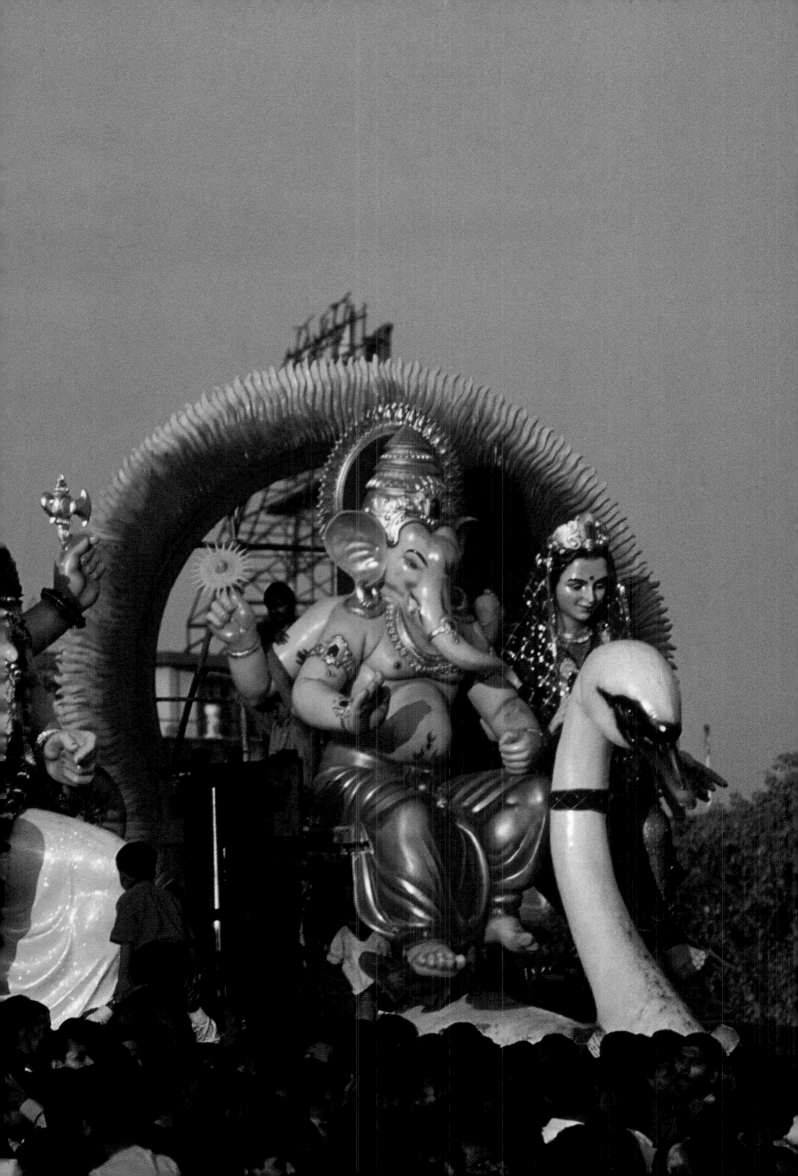

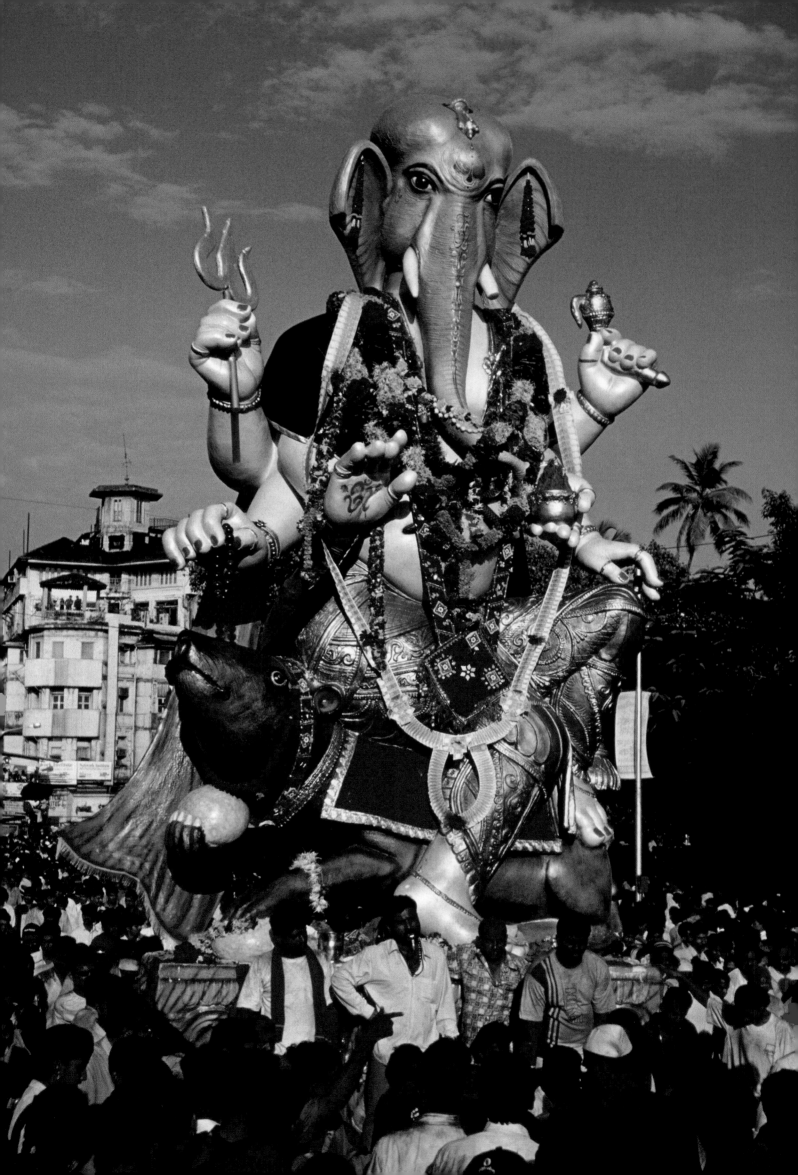

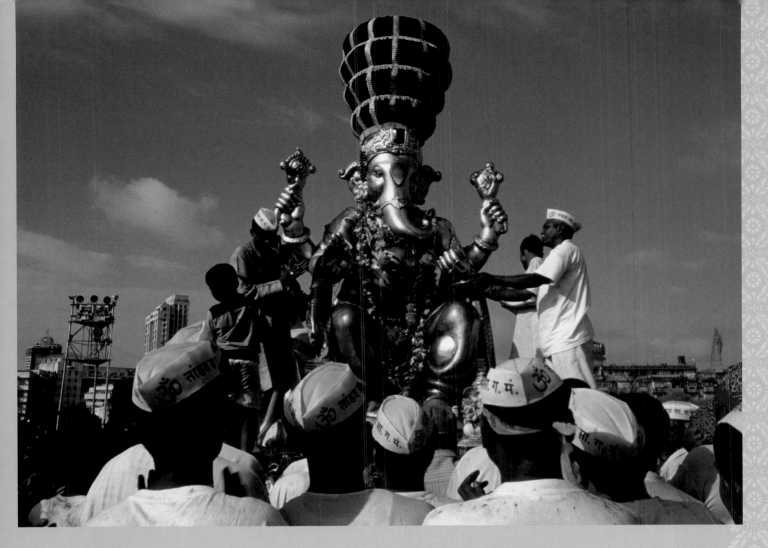

Each year the numbers of images go up, each year the water bodies get more clogged, and each year India's environmentalists grow hoarse as their warnings of pollution, of lead and chemical poisoning from industrial colors, of silting by non-degradable idols, of aquatic life choked by plastic, go unheeded.

The warnings might be more effective if environmentalists reminded devotees that Ganesha does not enjoy being viewed as ridiculous, and why there is no moon for fourteen days a month.

The moon once dared to ridicule Ganesha when his mouse reared up and threw him to the ground. Delighted by Ganesha's discomfiture the moon roared with laughter whereupon a furious Ganesha broke off his tusk and flung it at the laughing moon, casting it into darkness. Only after the moon had grovelled in apology did Ganesha relent and allow it to shine again, and then too, only partially.

The dark nights of the moon are supposed to remind both moon and mankind that Ganesha is a serious god, not to be treated lightly. What reparation will Ganesha demand of modern

Previous spread, opposite, above: Ganesha Festival Immersion, Mumbai, Maharashtra

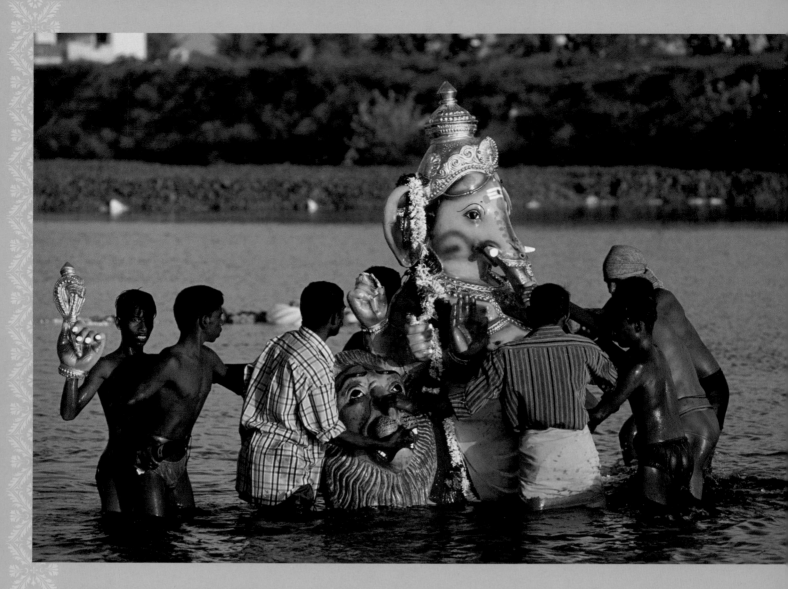

India for the "fancy-looking models" and "theme Ganeshas" which render him increasingly ridiculous? What retribution for the fortunes disappearing under water, watched helplessly by the poor? Indians seem to have forgotten that Ganesha is the Lord of Connections, the god of cause and effect, or else they would not be oblivious to the possibility that extravagant idols are unlikely to guarantee the future.

Perhaps Indians should concentrate their minds on Ganesha's name instead of concentrating their wealth on Ganesha's image. They might then recall that Ganesha's loveable form—the bursting belly, the benign smile behind the curling trunk—is only a visual diagram, "a superimposition and not a reality," but his reality is more demanding. As for devotees seeking miracles, if they parsed Ganesha's name they might discover a miracle has already occurred. It is a simple miracle, needing neither milk nor idols, but through it Ganesha dispenses with himself.

Above: Ganesha Festival, Tamilnadu; *opposite and overleaf:* Ganesha Festival Immersion, Mumbai, Maharashtra

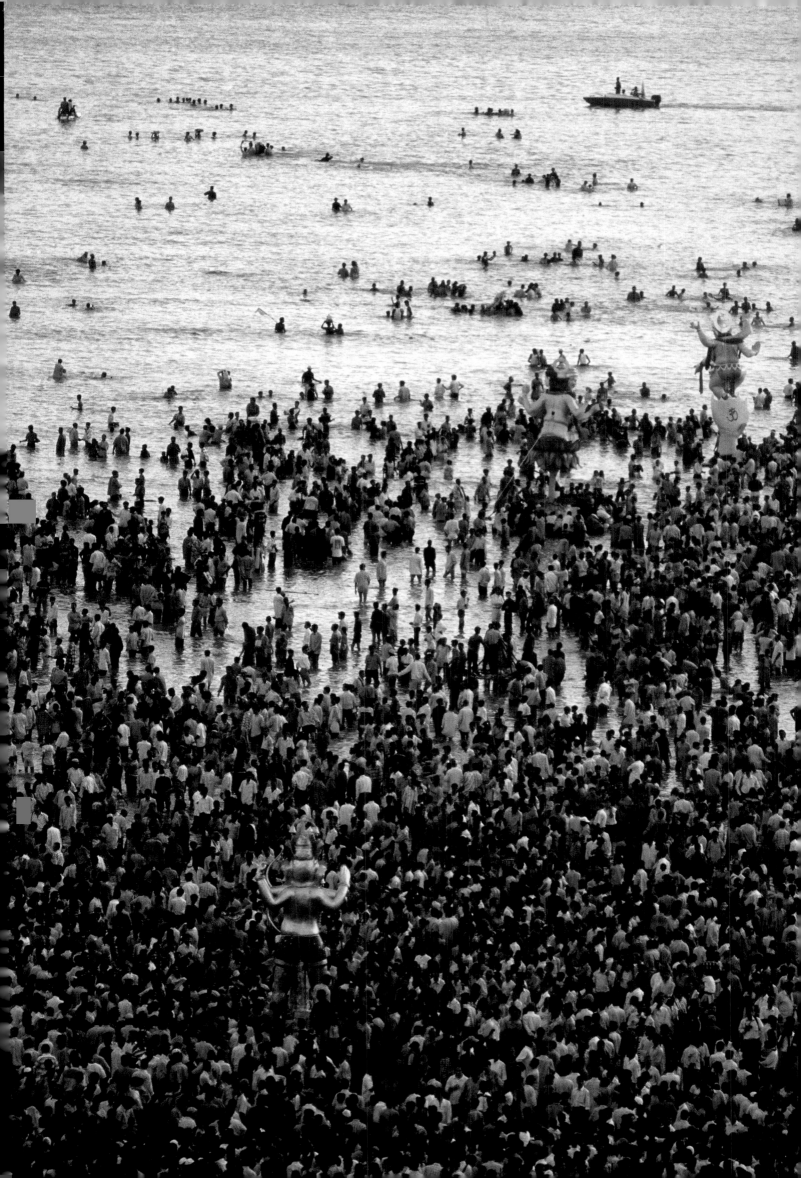

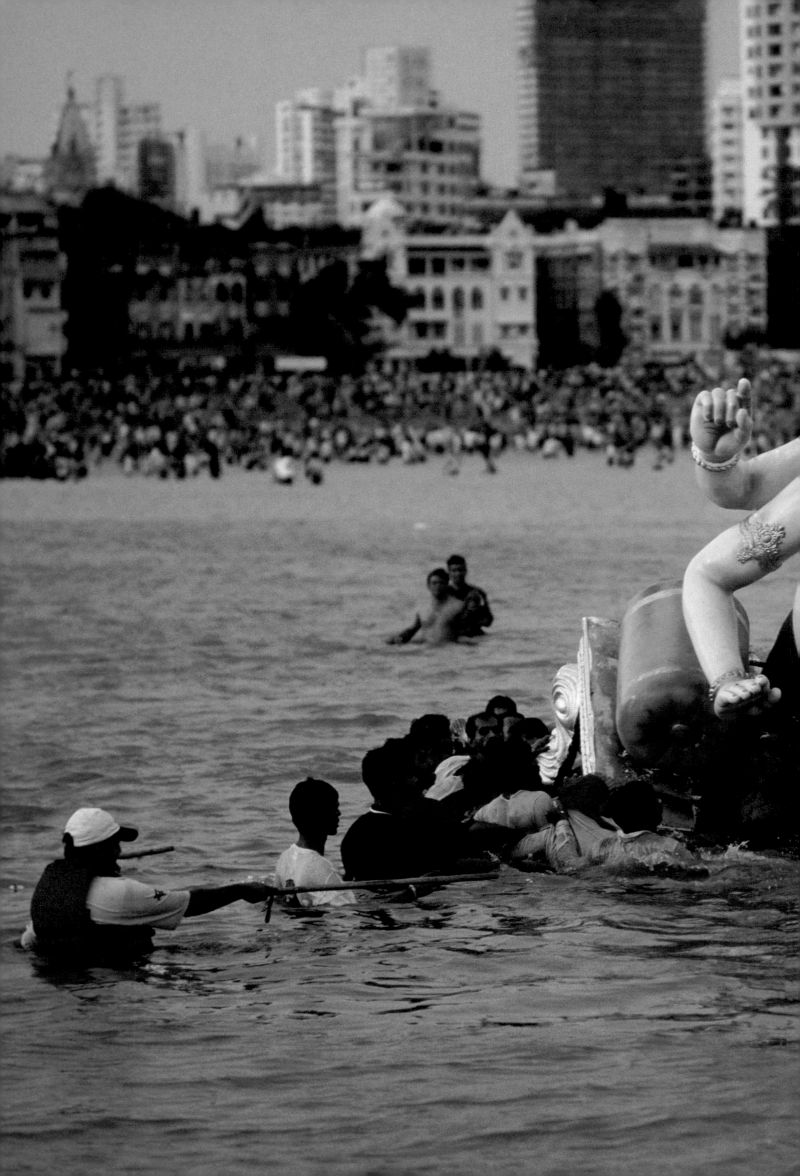

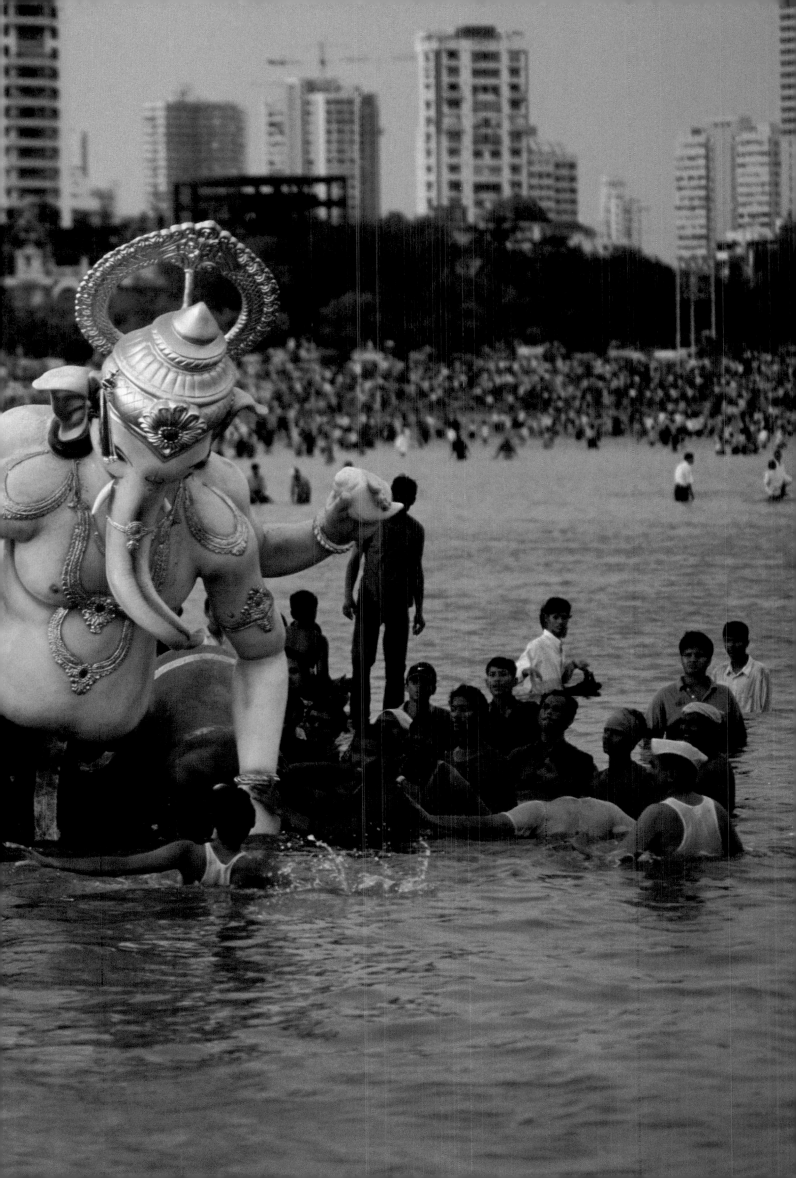

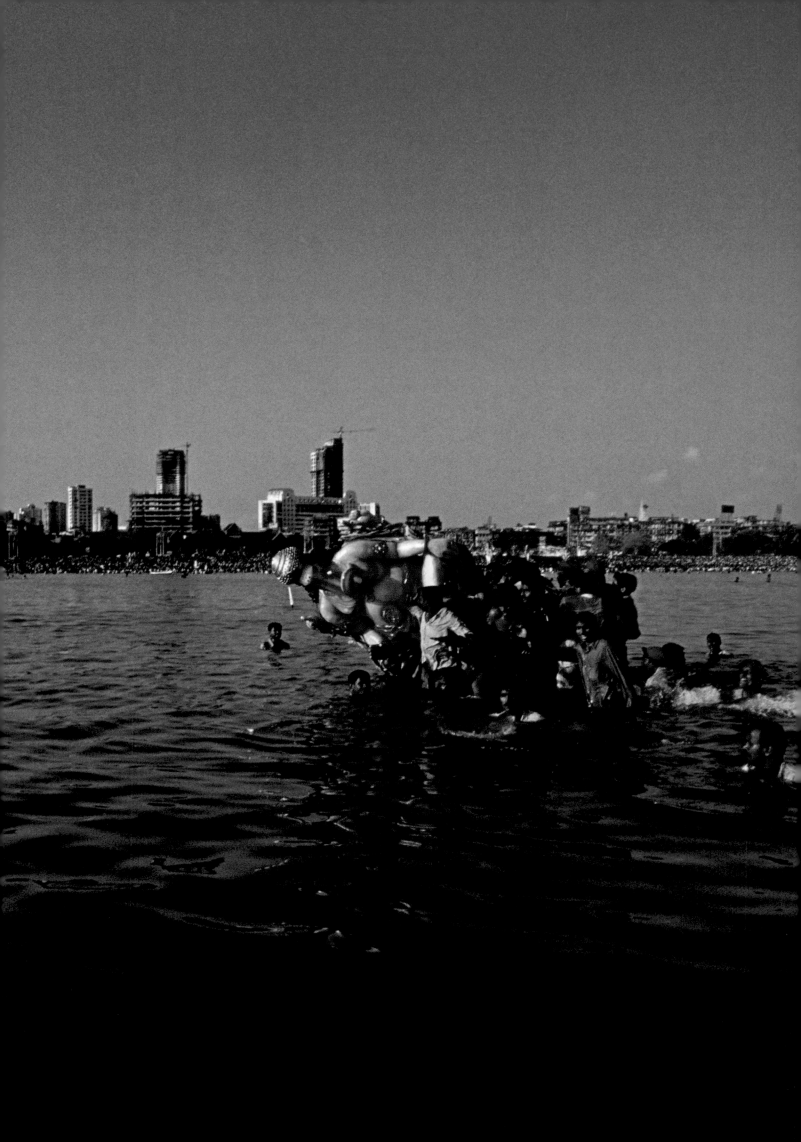

Ga-Na-Esha. *Esha*, the last syllable of Ganesha's name means lord. The first syllables, *Ga* and *Na*, mean the entrance and the goal; an entrance to the world of learning, the wisdom that is learning's goal. Together they become *Gana* or category, identifying Ganesha as the Lord of Ganas, the Lord of Categories.

A *gana* is the genetic code of knowledge. Names, numbers, concepts are ganas. Anything that can be counted, enunciated, or comprehended is a category. As the Lord of Categories, the Lord of Connections, Ganesha provides the tools of recognition without which there is no understanding of cause and of effect, there is no speech, there is no consciousness.

Thus grammarians acknowledge Ganesha as the power of language. He is the first word. Mathematicians acknowledge him as the power of numbers. He is the first cause. Philosophers acknowledge him as the power of thought. He is the first principle. He is consciousness.

The Sanatan Dharma of India, her eternal quest, is not an unending search for some higher divinity. It is for a higher consciousness, a self that recognizes the unifying principle of all life, known as the Brahman. By giving them the tools of comprehension, by replacing worship with awareness, Ganesha has enabled his devotees to reach that higher consciousness, that Unifying Principle, and submerge their individual egos in the greater self of the Brahman.

Perhaps this explains why Ganesha always looks amused. After all, Ganesha reveals that divinity is not to be found in gods, elephant-headed or otherwise.

Divinity, if it exists at all, is to be found in the self.

I bow to you, Lord of Categories.
You alone are the visible principle.
You alone are the creator.
You alone are the sustainer.
You alone are the destroyer,
You alone are the true Self
You are Brahman.

—Hymn from the *Ganesha Upanishad*

Opposite: Ganesha Festival Immersion, Mumbai, Maharashtra; overleaf: Ganesha Festival, Pune, Maharashtra

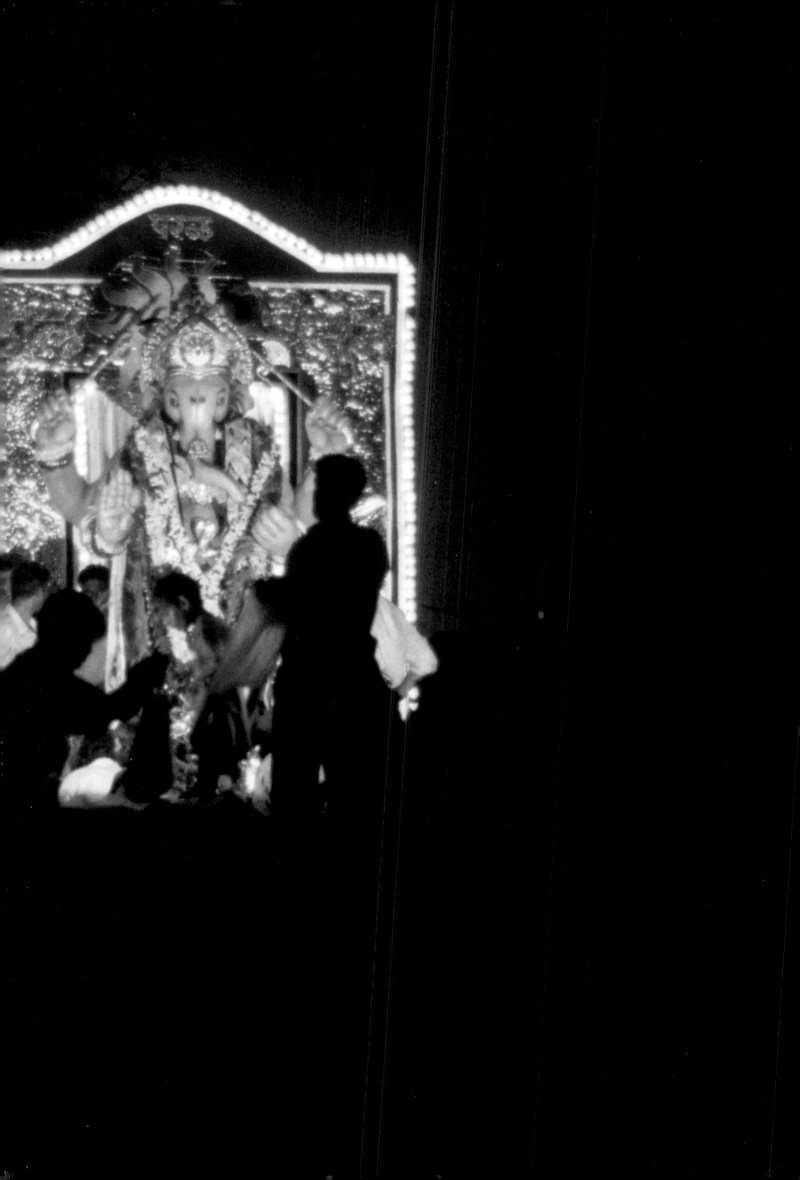

Design: Julio Vega

First published in the United States of America in 2006 by
The Vendome Press, 1334 York Avenue, New York, NY 10021

ISBN-10: 0-86565-169-8
ISBN-13: 978-0-86565-169-2

Library of Congress Cataloging-in-Publication Data

Mehta, Gita.
 Eternal Ganesha / text by Gita Mehta.
 p. cm.
 ISBN-13: 978-0-86565-169-2 (hardcover : alk. paper)
 ISBN-10: 0-86565-169-8 (hardcover : alk. paper)
 1. Ganesha (Hindu deity) I. Title.
 BL1225.G34M45 2006
 294.5'2113--dc22

 2006012953

Printed in China

Photo credits:

Photography research services provided by Mapin Publishing Pvt. Ltd., Ahmedabad, India.
The photographers whose work is reproduced in this book are all represented by Dinodia Photo Library, Bombay, India.

Numbers refer to page numbers.
R. A. Acharya: 79; Jagdish Agarwal: 11; M. Amirtham: 56 (top left), 78 (left), 94, 96 (left), 120; Debasish Banerjee: 44, 46 (left), 47, 64, 72 (left), 76, 90, 112; Bhudev Bhagat: 30 (bottom); Dayaram Chawda: 2, 78 (right); A. D. Cheoolkar: 104–105; Anil Dave: 14 (left), 34, 36, 40, 48, 72 (right), 121; Viren Desai: 30 (top right), 58, 70, 81 (right); Umesh Gogna: 12–13; Fawzan Husain: 17; N. M. Jain: 52–53, 114–115; Nihalchand Jain: 38; Sunil Kapadia, 54, 61 (left), 67; Nitin Kelvalkar: 1, 46 (lower right), 49, 57, 68–69, 74–75, 82–83, 86 (right), 103, 110–111, 116–117; Milind Ketkar: 20, 22–23, 24 (left), 60, 61 (right), 92–93, 108 (left), 118; Nrupen Madhvani: 73; B. P. Maiti: 32–33, 109; Shrikant Malushte: 113; Nirmala Mishra: 10 (both), 56 (lower left); R. M. Modi: 62–63, 66 (lower right), 84, 122–123; Sarla Modi: 39, 42–43; Rajesh Nayak: 66 (left and top right); Manoj Navalkar: 28–29, 31 (right) 59, 86 (left), 88–89, 106; Sudharak Olwe: 27, 124, 126–127; Satish Parashar: 18–19, 30 (middle left), 31 (left), 97; Ajit Parekh: 14 (right), 56 (right); Hemant Patil: 6–7; Mahendra Patil: 24 (right), 37, 46 (top right); B.D. Rupani: 30 (top left), 80, 87; N. G. Sharma: 8; Rajesh Sharma: 102; Suraj N. Sharma: 4, 50, 81 (left), 108 (right); Ravi Shekhar: 98-99; Madhusudan Tawde: 25, 41 96 (right), 100, 119.

Captions for photos on pages 1-7
Page 1: Lord Ganesha in neon light, Pune, Maharashtra; page 2: Lord Ganesha; page 4: Intricate embroidery on chatri at Tarnetar Fair, Surendra Nagar, Gujarat; pages 6-7: A humble offering to Lord Ganesha